PATRICK HUGHES

PERVERSPECTIVE

PATRICK HUGHES

PERVERSPECTIVE

John Slyce

momentum

Photography: Gareth Winters, Steve Ibb, Adrian Flowers,
Hugh Gilbert, Uri Lewinski, Sam Chatterton Dickson and Shaun McCracken
Back cover photograph by Steve Pyke

First published in Great Britain in 1998 by
Momentum, P.O. Box 12752, London E8 3UA

ISBN 1 902945 51 4 (paper)
ISBN 1 902945 63 8 (cased)

A catalogue record for this book is available from the British Library

Designed by Peter Gladwin
Coordinated by Kate Leese and Michaela Freeman

Typeset in Minion
Printed in London by Specialblue

Patrick Hughes is represented by Flowers Galleries

Flowers East
82 Kingsland Road
London E2 8DP
Telephone 020 7920 7777 Facsimile 020 7920 7770
gallery@flowerseast.com
www.flowerseast.com

www.patrickhughes.co.uk

THANKS

To my assistants Martin Kingdom, Ioanna Christoforidou, Lif Parker,
Jason Parker, Maré Oosthuizen, Estelle Norris, Chloë Edwards, Dan Faine.
For Jackie MacGabhann for making it all add up. To Andi Freeman for my website.
To Dave and Liz Cooper and their team.

To all at Angela Flowers Gallery: Angela Flowers, Matthew Flowers, Emily Bishop,
Bob Heller, Sam Chatterton Dickson, Ben Lawrence, Sophie Hall, Shaun McCracken,
Selva Sivakumaran, Lisa Bosse, James Ulph, Simon Miles-Taylor, Amie Conway,
Marianne Spurr, Emiko Tanabe, Brent Beamon & Cate Rickards.

To John Slyce for writing the best book on me, and for doing it with learning wit, and sensitivity.

To Kate Leese for seeing it through with devotion and imagination.
To Michaela Freeman for this new edition.

To Peter Gladwin for his faith in the project and for designing every page clearly and strikingly,
and to Ben Craze and all at Specialblue.

To Gareth Winters, Adrian Flowers, Steve Ibb, Hugh Gilbert, Uri Lewinski,
Shaun McCracken and Steve Pyke for fine photography.

To Dr Di for her profound suggestions and intimacy with my work, for
looking after us all so well, and for loving me. I love you back.

Patrick Hughes

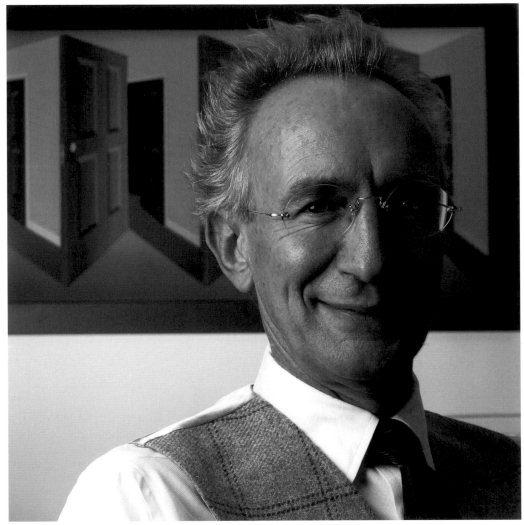

Photograph Steve Ibb

CONTENTS

PATRICK HUGHES: PERVERSPECTIVE
by John Slyce

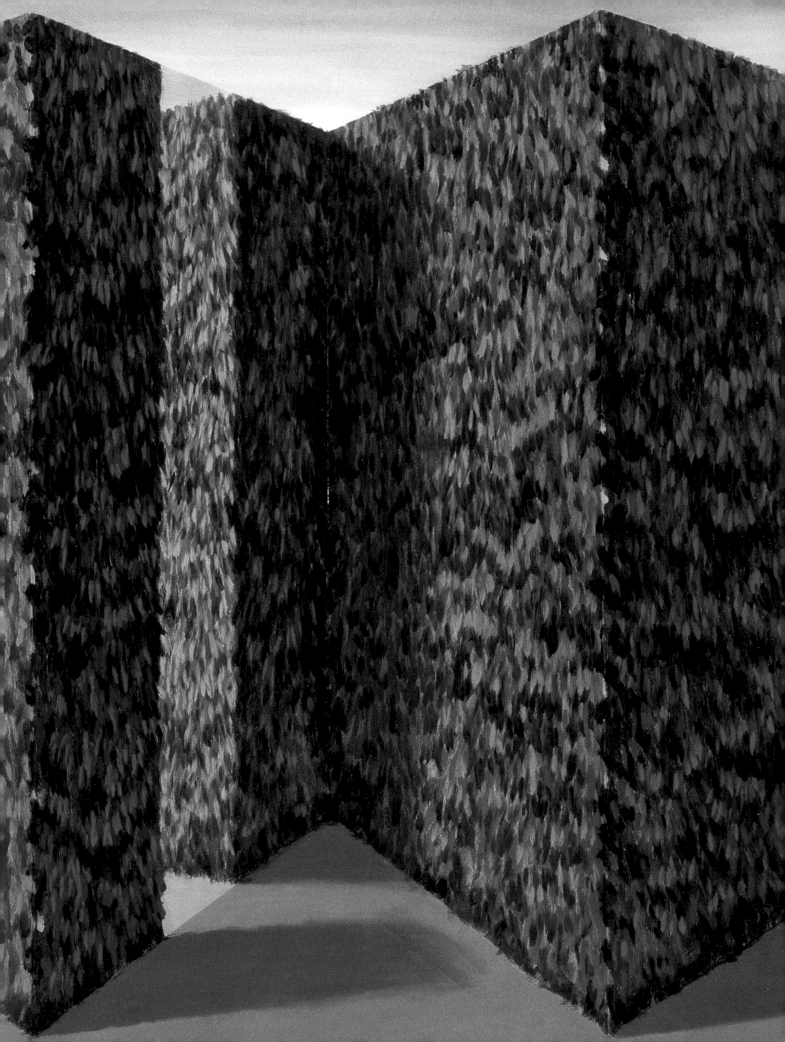

PERVERSPECTIVE: AN INTRODUCTION

perverse, *sb. Geom.* [f. next: cf. PERVERSION 2a] A figure or image in which the right and left directions of the original are reversed: such as the impression taken from any figured surface, and the image of anything seen in a plane mirror. 1895 in *Funk's Standard Dictionary*

perverse, [a. F. *pervers*, -e, ad. L. *perversus* turned the wrong way, awry, perverse, pa. pple. of pervertĕre to turn about, subvert, pervert.] *Oxford English Dictionary*

It has been said of self-taught artists that they paint not just what they see, but also what they know is there, often defying perspective and other conventions to do so. In this they are not unlike map-makers who must distort in order to be truthful. Patrick Hughes is among this breed of artist. The above definition of *perverse* is here to make clearer the spirit in which Hughes embraces the system of perspective that is implied in our title. "Don't be perverse!" – a parental rebuke to a son who insists on putting his trousers on back to front – shares in the sense of our usage. Patrick Hughes makes moving pictures. And Perverspective is a clue to grasping his operative device – reverse perspective. Usually objects that are nearer the eye appear larger, while those further away look to be smaller. Hughes reverses this optical logic, creating a visual paradox – the far points of the picture are nearer than the near points, which are far away. Perspective in Hughes' work is closer to what it is in life – not a rigid system of correct laws, but a spirit of looking creatively at things that move, be it the world, the past or a picture.

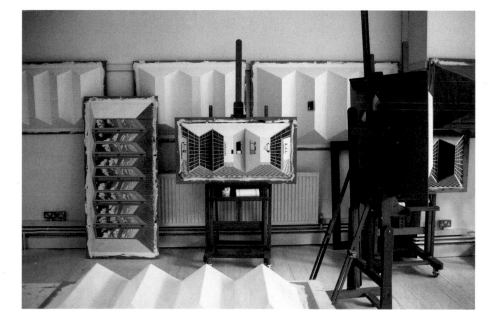

Patrick Hughes' studio

My first encounter with Patrick Hughes' pictures was as a pedestrian rather than a writer. Walking down Great Eastern Street on the way to another artist's space, I passed the large windows to the front of Patrick's studio. There I did what so many others have done: I walked past and noticed the movement in the pictures and then doubled back in disbelief and walked forward again repeating this absurd dance to my own delight. It is, as Patrick himself might put it, "a happy accident" that this chance meeting during a pedestrian moment is now a professional preoccupation in my life.

For a writer attending to the work of an artist, biographical details can amount to a rich and alluring archaeology of facts. Still, a subject is both more and less than the sediment that has accrued beneath their nails. Shelves already sag under the weight of biographies that represent lives full of facts, but left bare of context. As a writer, I am more interested in the implications of Patrick Hughes' art than those of his biography. This said, my aim is not to diminish the impact of the biographical, but rather bring to the fore what I see as the truly profound implications of Hughes' work, as well as its place in contemporary art. In this sense, the ideas that underpin the work constitute my archaeological site rather than the life of the artist.

Three very distinct pulses beat through Patrick Hughes' work: perspective, paradox, and vision. These themes are in turn linked conceptually by movement – namely the 'moving experience' of the viewer. The experience of much contemporary art renders the term *viewer* nearly meaningless and in need of change. The experience of viewing is too external, too passive and too – visual. A viewer sits all too silent in the audience, or on the sidelines. The art of Patrick Hughes positions the viewer in the fore. Hughes' art is, in itself, an elaboration of the viewer, see-er, or perhaps better – *seer*. His recent pieces are a metaphorical model of vision themselves in their fluid twists, turns and opening up of vistas. When taken as a whole – bringing together the work, the viewer or *seer*, and the experience of the encounter – Patrick Hughes' art constitutes not only a profound elaboration of a philosophy of movement and flux, but even more significantly, it points to the inner workings of art and the mind. Much of the strength of Hughes' art is that it wears this deeply penetrating philosophical enterprise lightly, all the while never failing to entertain and communicate.

Hughes is perhaps the most contemporary of those British artists working through the middle years of their careers – this said at a time when mid-career can mean an artist has hit their thirties! Patrick Hughes remains a young artist when placed in any generation. His approach to art, life and learning is still that of a student in its enthusiasm, energy and openness to experimentation and innovation. The sticking-out pictures – the body of work that Hughes has developed in the last ten years – really amounts to what is his most vibrant period. In many ways, Hughes has now arrived at the point he has been working towards all his career. It is fitting that this monograph, the first on the recent work of Patrick Hughes, will be published in 1998 – a year that serves as the centenary of both M. C. Escher and René Magritte. As we will see, these three artists already share much more.

One of my last interviews with Patrick ended with him repeating R. B. Kitaj's quote, that "Some books have pictures and some pictures have books." He then somewhat wistfully added, no doubt hoping to spur me on towards my deadline, that Duchamp's *Large Glass* has a book. I am now very happy to say that Patrick Hughes' pictures have one too – not that they need one.

John Slyce
London, summer 1998

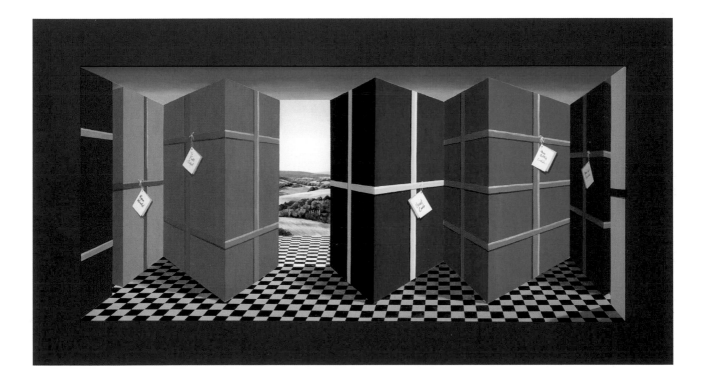

Complementary Hues 1998

Oil on board
66 x 122 x 20 cms
Private collection, Switzerland

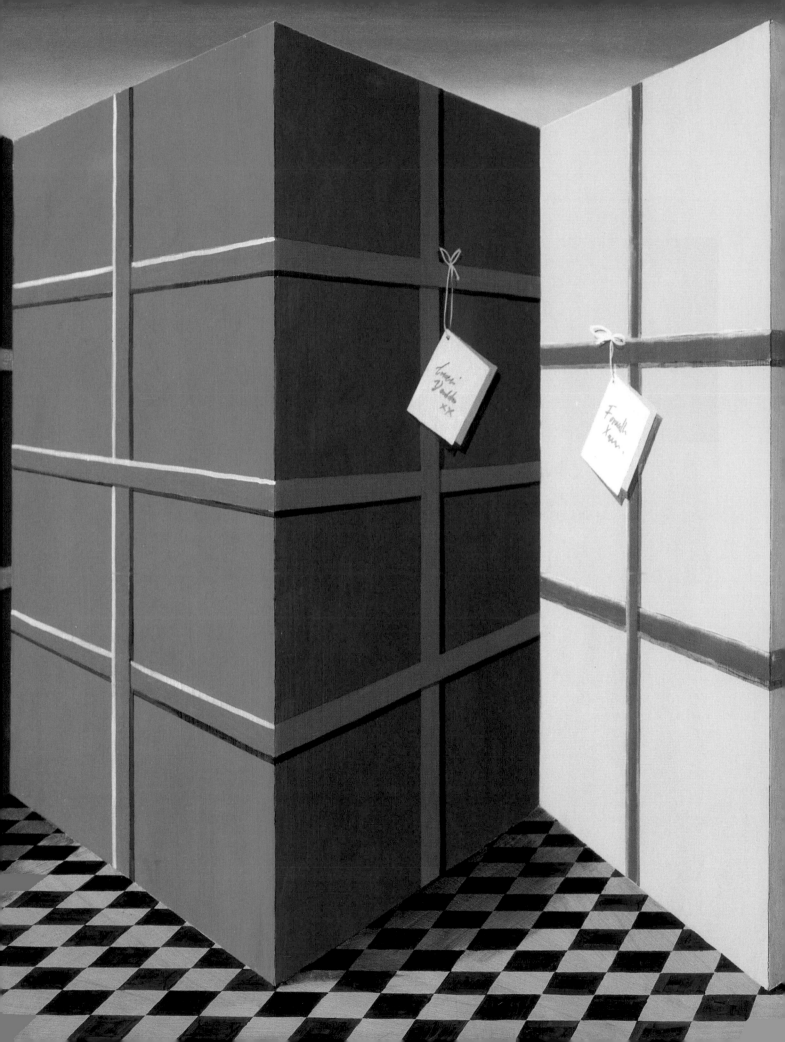

THEATRES OF MEMORY

Patrick Hughes shares in the Surrealists' faith in the significance and wonder of childhood, if not entirely in their fascination with dreams. "Nothing is more uninteresting than other people's dreams. When a person tells you their dreams you fake interest, but it's a bit like other people's holidays – you only pretend to be interested while you're waiting to tell them about your own." Ever the blunt, yet sharp conversationalist, the artist continues: "Having said that, there is a quality in dreams, as we remember them, of a stillness or seamless narrative clarity. It's a certain odd quality of a vividness and containment during their occurrence." Hughes has his own recurring dream. It is one of a solid, seamless field of baize that stretches to infinity. Suddenly, this perfectly smooth field goes scrunch and becomes a textured gradient of detailed wrinkles. As a dream, it deals with something both perfect and wrong, not unlike his pictures. And in its own way, this dream is a model of Hughes' initial experience of full vision.

Until the age of fourteen, Hughes lived solely in a short-sighted world, much of it papered in boredom. Hughes remembers the vivid scene in 1953 when he got his first pair of glasses: "It was on Beverly High Road and I saw the world on a wet evening for the first time. It was a remarkable moment for me – someone interested in vision and seeing, almost like being granted the gift of sight. I can still see the lights sparkling in focus on the wet street." His soft seamless world had suddenly turned into one comprised of clearly delineated space animated by the twinkle of light and perspective. For the short-sighted, the wider world is defined almost entirely by movement. Rather than the clear hard substance of objects seen in the distance, theirs is a field-of-vision grounded in the ambiguous movement of the unknown. From childhood, Hughes' response to these circumstances of vision was to creatively explore the monotony of his immediate surroundings and step into the wonder of the wider world through the sharp focus of books.

Few have encountered a childhood as resoundingly bleak as the young Hughes, though with the passage of time we all learn how to put a shine on the dullest of peerage plates. Born in Birmingham in 1939, Patrick's youth and adolescence took place on interchangeable suburban stages set first in Hayes, Middlesex and later on the fringes of Hull. The only reading material in these houses was an ever present edition of the *Radio Times*. The cast on both sides were descended from farm-workers whose children had moved into the cities and waged poverty during the Depression. Patrick's father, a potential, yet unaware variation on Willy Loman, was a commercial traveller in groceries and a salesman without a dream. In need of cigarette money, his father embezzled small but regular amounts in order to subvert the tight purse strings kept by his wife. When the sum reached £300 he was caught out and sacked, but sent off with a sterling reference in hand. This was, Patrick estimates, the only watershed, save death, in his father's otherwise unremarkable life.

For the young Hughes, reading – in the offerings of libraries and copies of *Lilliput* from the corner newsagent – provided an escape from the inevitable hostilities arising from such a domestic setting. "I've never been one for introspection, but I love reading books." Hughes remembers, "I would have never looked into anything except a book. I suppose it is in books that you can find yourself. A book is a kind of way out. They are like little doors – you open

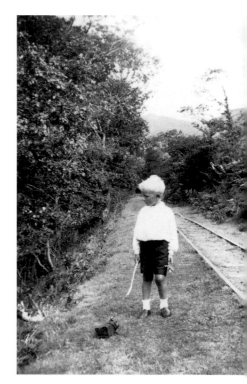

Patrick Hughes aged 5

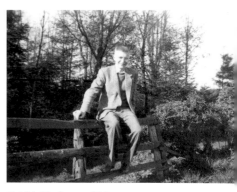

Patrick Hughes aged 14

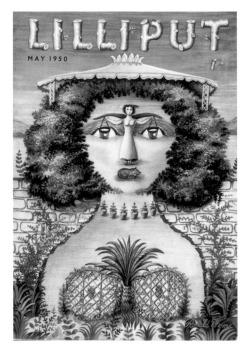

Lilliput (cover) Vol.26 No.5
Issue No.155 May 1950

the little hinged rectangle of the book and step out. I escaped from my suburban hell hole of an upbringing through the book." It was during this time that Hughes learned to live determinedly through the resources of his own imagination. This was a strategy designed for development as much as survival. Rather than an introverted retreat or escape from the clamour that surrounded him, imagination provided an interior exit that could serve as an entry into the world that beckoned beyond the bickering. The more immediate gain from this expansive escape was a scholarship to Hull Grammar School, won with those same skills that have carried Hughes through a life of learning and creating.

Crewe appears as something of a bright spot in Patrick's otherwise bleak young life and it was to his grandparents' home there that he often was sent in the summer months. For Hughes, much of the fodder that goes into our largely accidental formation – the things seen, heard, smelled and tasted by each of us while we are still pliable – stems from Crewe. Crewe was then, as it is still, located on the trunk route between Euston and Liverpool. As a boy in summer and during the war years, Patrick was packed off on the train, nearly with a label tied to his button hole, to be met by his Gramp. "I was very aware, as I sat on the train in the various stations, of the great train paradox. There I was, a very expectant young boy hoping to get to Crewe on the train and an adjacent train would take off in the other direction and I'd think: 'Oh, we're going now.' It's a rare, but splendid example of a paradoxical situation in real life." In later years, Hughes would paint a picture that alludes to this experience of contradictory movement, asking us to ponder whether the train for Crewe has left the station, or perhaps the station has sprouted wheels of its own and left Crewe and the train behind. Contradictory movement of this sort is a great part of Hughes and his work – he revels in the phenomenon of movement without allowing logic to destroy it.

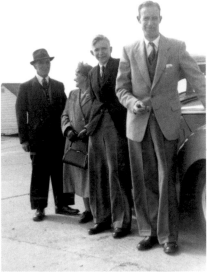

Patrick Hughes with his Dad, Nan and Gramp

Crewe, Paradox of the Senses 1972

Gloss paint on board
91.5 x 122 cms
Private collection, UK

'The Glory Hole' recreated for the
BBC series 'Oil on Canvas/Perspective'
Courtesy Windfall Films / © BBC

 The physical memory of his grandparents' house at 123 Warmingham Road provides
Hughes with perhaps his most significant formative experiences. The first is the nearly
legendary tale of The Glory Hole. At the tender age of three or four in the waning years of the
war, young Patrick spent his nights sleeping not under the stars, but the stairs. Crewe, a centre
of industry and an important rail hub, was under threat of German bombs. The safest
strongest place in a small cottage was under the stairs with his mother in the spot they
pathetically called the glory hole and there Patrick stared up at the strange sight of inside-out
stairs in reverse. "We were looking up at these stairs the wrong way round – up and down, up
and down – stairs that only a fly could walk up. It must have made a strong impression: being
bombed and in the dark and sleeping with my Mother and seeing everything the wrong way
round." In retrospect, this experience of reversible structures was the first sounding of a chord
that has played throughout Hughes' life and work: that something which is at variance with
itself still agrees with itself. This kind of dialectical harmony is most pronounced in Hughes'
sticking-out pictures where behind each corner lies a new direction in movement and space.
Though, such notes of counterpoint sound from the earliest moments in his work.

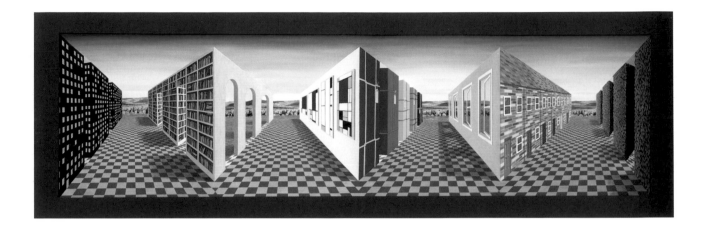

Inverspective 1997

Oil on board
75 x 229 x 25 cms
Private collection, USA

16

For the young Hughes, a future maker of paradoxical rooms, the most important room in the Warmingham Road house was its least used – the front room. This room belonged to the archaic magic of a bygone era when a front room was reserved for sombre formal occasions, high holidays and deaths. Such a room was more of a museum piece than a living space: "Their front room was like an art gallery and I used to love to visit the few oddities in it. I remember the clock was set ten minutes fast in that room. And there was a mirror over the fireplace and then a few feet away, a mirror over the sideboard. If you stood in the middle of the room you could see infinity. So the room presented a strange perversion of time and space." The visual image conjured by Hughes' memory of this room is a confluence of two of Magritte's best known works: *La reproduction interdite (Not to be reproduced)*, 1937 – a "portrait manqué" present only through a viciously circular reflection of a man in a parlour room mirror – and *La durée poignardée (Time transfixed)*, 1938, whose train engine, thundering out of a fireplace, arrests the movement of time in the room and picture. These paintings by Magritte are linked even more intimately in that they share the same Wimpole Street dining room as a model for their mise-en-scène. For Magritte as well as for Hughes, much of the psychological and philosophical space of their pictures is set on the suburban stage of the living room.

The Warmingham Road room held one other treasure that is even more difficult to describe than infinity. Within the room was a wooden speaker for a wind-up gramophone and it fascinated the young Hughes – not the music that came out of the speaker, but the speaker itself. "It was shaped like a tapered theatre: a long box-shaped square in perspective with an ordinary cupboard door that opened up with darkness at the end." This box of perspective space captured Hughes and behind its tiny door was a world in wait to explore.

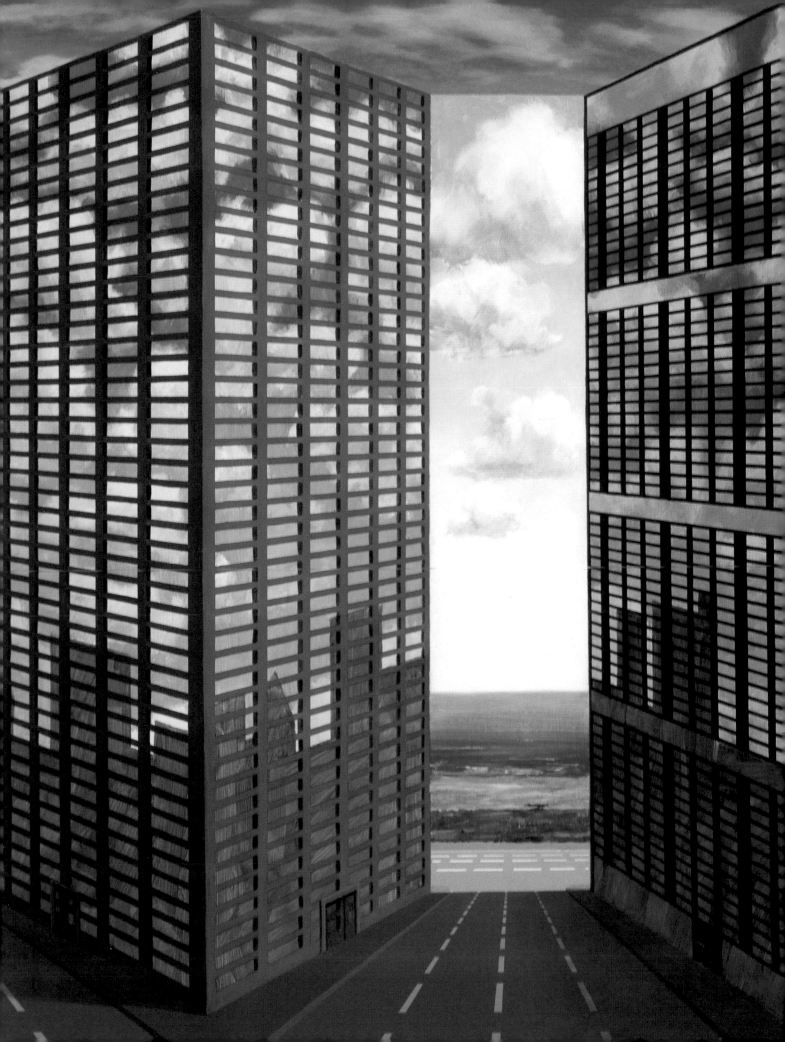

THE ACCIDENTAL ARTIST

For Hughes, books have had a tremendous influence on the shape of his life and work. The 1950s were a decade when clever young provincials – the budding non-U intelligentsia of *angry young man* renown – found words to express their outlook and angst in the form of books and plays. The same week in 1956 saw the release of both Colin Wilson's *The Outsider* and John Osborne's *Look Back in Anger*. While touched by both works, the latter was to mark a significant break between Hughes and his early life. "I lent *Look Back in Anger* to a girl whose parents complained to my parents that it was rude. Shortly thereafter I got a love letter. And essentially I didn't have much to do with my family after that. Another life started for me then." Ostensibly, the split was initiated by the rumblings of a sexual awakening, though this was only a symptom of a much broader and longer-standing movement by Hughes away from his family. What stood between them was the gap felt by so many – a generational, cultural, intellectual, and psychological divide that, at the time, felt as if it marked a threshold between one world and another. The hinge of an open book had pointed Hughes towards this threshold and now with the door clearly open, he stepped on through.

At seventeen Hughes left home, Hull and school for London. On arrival, he took a job in Maddox Street advertised for a window dresser and soon found himself a poorly paid shop assistant selling velvet to colour matchers. Across from the velvet shop was the Hanover Gallery – in 1957 arguably London's most innovative gallery. Hughes would return to this space with a solo show in 1965, but at the time it was simply part of the circuit of galleries to visit during his lunch hour. The Portal Gallery, run by the late Eric Lister, was another and this is where Hughes would not only see his first Magrittes, but also because of this, return four years later for his first solo show as artist. The excitement of London and its galleries nourished the hungry young velvet salesman and as Hughes was assembling his ideal museum-without-walls he read, absorbing the magic of Eugène Ionesco, Franz Kafka and Lewis Carroll.

Chance and accident are the wellsprings of flux and change and a large part of Hughes' formation owes to his open embrace of as much. After surviving the childhood that he did, Hughes knew he had a lifetime of material in his hands – the question was: to what ends to put it? He entertained thoughts of following those writers who commanded his interest and fascination by putting pen to paper. And he wrote, though Hughes himself admits that "it was like very bad Alain Robbe-Grillet. I would describe some dull event over and over again, each time even more dully." Hughes persisted, driven on in part by N. F. Simpson's *A Resounding Tinkle* which he saw at the Royal Court in the winter of 1958. Simpson's surreal logic and absurd comedy, however, proved an elusive model for Hughes to follow, at least in writing. Even given his desperate desire to write, Hughes recognised that there are two kinds of writers – those who are and those who are not. Suspecting himself to be in the latter camp, he began to have his doubts.

Events both staged and unplanned here forced his hand. During this time, Hughes met his first wife Rennie, then a student of art at Reading, and very soon thereafter found himself the father of one, two, and three sons in rapid succession. An event perhaps no less portentous to

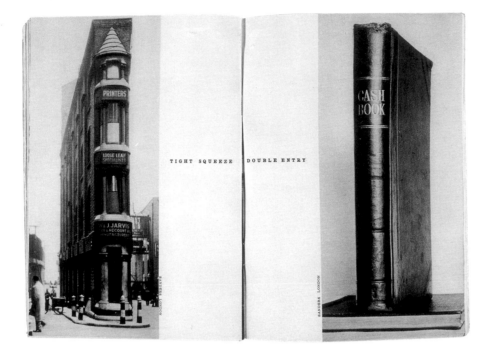

Lilliput Vol.26 No.4
Issue No.154 April 1950

TIGHT SQUEEZE DOUBLE ENTRY

the future of his writing career was the staging of Simpson's next play – *One-Way Pendulum*. Hughes considered it a masterpiece and better writing than even the best he could hope to produce. Given the weight of his responsibilities to his new family, Hughes decided to return to the North to live with his wife's parents near Leeds. In the day he would work as an unqualified teacher, at night a waiter and in the time in between, on being a father – all while continuing to guard hopes of writing.

In the autumn of 1959, Hughes enrolled in a day training college, the James Graham in Leeds, to study literature with a view to teaching English. The students' first task was to write freely on a group of six authors of their own choosing. Hughes wrote on N. F. Simpson, Laurence Sterne, Ionesco, Kafka, Lewis Carroll and Christian Morgenstern. As a group, these writers demonstrate profoundly individual visions of literature – mainly anti-Romantic in thrust and with each already straining to either advance or escape the strictures of a modernist style. Looking over Hughes' essay, the tutor's immediate and only comment was to tell him flatly that – he should do art! While far from ambivalent towards art, Hughes was somewhat perplexed. "I don't know what was wrong, but after this essay they said I must do art. And so I did what I was told. It wasn't my ambition to be an artist – it happened to me." In this Hughes is not unlike Sterne's eponymous hero, Tristram Shandy, who is similarly motivated by the accident of his own birth.

Hughes' choice of authors was pertinent in many ways. The department's view of literature was fixed on the nineteenth-century novel as supplied by the Brontës, Dickens and George Eliot. As a form of writing, this particular brand told you where you were, where you had been and where as a reader you were likely to end up. On the whole, the nineteenth-century novel did not ask anything of the nineteenth-century reader that would surprise or grate. And its success, or whether the novel worked, did not really rely on the active participation of a reader as such – the novel was there to serve, to provide order and clearly point out what was meant

to be significant. A reader did indeed have a role, but it involved that of consumption rather than taking an active part in the production. In his choice of authors, Hughes had already defined himself as an active reader and a willing participant in a work's wider construction. Here Hughes was at pace with the *nouveau roman*, if however frustrated by their interminable descriptions of sliced tomatoes. The department of English, on the other hand, wasn't so much waiting for Godot as for the arrival of Thomas Hardy.

Even if the divine voice whispering in Hughes' ear came down only from as high as that of Mrs. Hanson, a teacher of English, the idea of doing art quickly took root and flourished in practice. The programme of the art department at the James Graham College was based roughly on that of Leeds College of Art. After a short basic course led by John Jones and Muriel Atkinson, the students were left largely to their own devices. It is important to understand that no matter how suddenly and unexpectedly Hughes found himself in art school, he arrived already visually literate. Our London velvet salesman had earlier established a relationship with the work of Magritte and while visiting the capital's galleries he had taken in much of its then contemporary scene – Hughes remembers discussing the work of Eduardo Paolozzi, a central figure within the formation of early British Pop Art, with John Jones even before being put on the course in 1959. No less significantly, he was already a confirmed autodidact and no stranger to personal development.

Hughes is fond of quoting Constable in saying that "an artist who is self-taught is taught by a very ignorant person indeed." As true as this statement may be, the associate faculty he had assembled by this point amounts to a prodigious list of ignorance – his tutor, for example, in the foundations of modern art was no less than Ozenfant by way of the library at Hull Grammar School. And the aforementioned *Lilliput* played just as significant role as a visual primer. Hughes was raised on varieties of formal analysis that traverse both the high and the low: "On the one-hand there was Ozenfant's type as in his *Foundations of Modern Art* where he would compare say, the Venus of Willendorf with a plump lady or a piece of machinery with a Picabia. Then there was *Lilliput*. They would have these double-page spreads of a cross section of a tree compared with a clock, or a book seen on end and a picture of a flatiron building." As a new art student, the work of Paul Klee struck Hughes as a kind of formal analysis made in much the same spirit as those sources of his youth.

It was then, as it is still, Klee's immense resourcefulness – his ability to invent abstract equivalents and construct signs – that impressed Hughes. This sort of conjuring magic is evident in Hughes' sticking-out pictures where he reinvents the trapezoid over and again – this time as a maze, and now a skyscraper, then a library, a door, an arch or a scenic vista. Linear perspective is itself a means of representing equivalents in diverse ways. In Hughes' own invention of

Paul Klee (1879-1940)
Highways and Byways 1929
Oil on canvas
83 x 67 cms
Collection Ludwig Museum, Cologne
Photography: AKG, London
© DACS, London 1998

reverse perspective, the equivalent, the similar and the equal blend together in a dynamic relationship based not solely in perspectival symmetry, but in the seamless experience of unified movement.

Patrick Hughes is remarkably consistent in his habits of life and in setting up the conditions in which he works. His studio benefits from an established regimen of work that creates ample opportunity for much play and fun with assistants, lunchtime visitors and passersby. A regime or a routine is a means of embracing change and flux with a disciplining hand necessary for the creative mind. It is a ceremonial performance that gives shape to the artist's and writer's day alike. Hughes' patterns of work were already well on their way to being established at Leeds Day College. He worked very hard there and poured himself into the art and his studies with the same kind of rigour and obsessive passion he has brought to reading, or swimming, vegetarianism, wonderfully daft humour and perspective. The authors that had been with him to this point remained close at hand and the sense of paradoxical humour and play that was so much a part of their written work found life in Hughes' visual constructions.

In his student work Hughes examined figure-ground relationships and minimal representations. The heart was then his rhyming shape. Working with black and white paper cut-outs he made his first stab at constructing an abstract geometry that could build into incremental amounts of figurative information and space. From paper he moved to hardboard, producing a prototype of a northern angel made of hearts and with hinged wings. At the time, Hughes felt that "one shouldn't do the background. It seemed to me that the background was a part that you could cutout." The relationship between ground and figure is itself contradictory and somewhat paradoxical – we recognise one owing to the nature, as well as the exclusion, of the other. The cut-out provided Hughes with a vehicle to explore this dialectical exchange. He worked with iconic images and recognizable fragments – the comic book character Desperate Dan was a source for one proto-Pop piece. Hughes cut the figure of a dashing Desperate Dan from a large piece of hardboard. Once the piece was finished, he discarded the positive image and kept the template showing the negative figure of a running Dan bursting through a wall of wood. In his play with rhyming shapes and the reversibility of figure and ground, Hughes found that the act of cutting-out and taking away can convey a powerful sense of shape. Even more significant was Hughes' discovery that the operation of subtraction can add a sense of space and depth to an image.

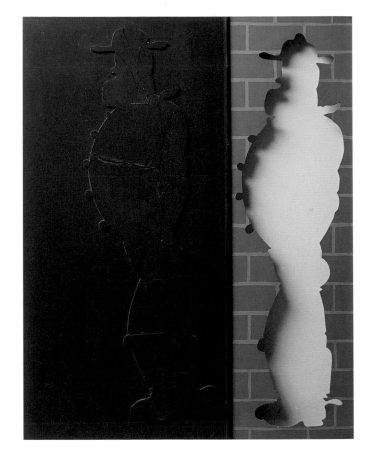

Desperate Dan 1961

Gloss paint on board
76 x 61 cms
Collection the artist

```
        imbs
    rds the loi
  ing swell of t.
  je, smooth, and
  rm, plump, round
  unripe budding b.
  hiteness andfir
  of my flesh w
      with a p.
      sighs th
    filling lo
    cizes one
  iided ny ha.
  eir soft cov
  de along nost
  soft warm hand
  vided lips whi
    pleasure, in t
  jorged me with s.
  oak away my breas
  e unnumbered kiss
```

One of the strong and recurring metaphors in his art is the keyhole. A keyhole is a piece of solid space that has the power to cast its own shadow. As a sign and minimal representation of the wonder and magic that lies in wait behind a door, a keyhole functions as a portal that invites the eye and mind to pass through. Hughes has returned to the keyhole a number of times since the hardboard cut-out he conceived at the Leeds Day College in 1961, even utilizing its form to give shape to a concrete poem he wrote in the early Sixties. For Hughes the keyhole comes ready-made as a potent signifier and a minimal icon that speaks volumes. He has always made a considerable effort to communicate in his work, often plumbing the depths of an arrant simplicity while refining all the extraneous bits out of the picture. Within such a strategy the iconic signifier is both a means and an end. While it can be said that such a picture is a product of a metaphor, in Hughes' art a metaphor always acts to refer us back to an empirical reality that says something about our experience of and in the world.

Moving from the cut-out, Hughes continued to work in household gloss and enamel on hardboard. While still experimenting with rhyming shapes and figure-ground relationships, his pictures became even more stripped down and minimal. A wonderful piece from this period is *Postbox*, a tall thin monochrome red field with a slot cut into the hardboard that carries the identity and function of the image. In taking up painting, his stated desire was first and foremost to "say things in paint, rather than wanting to paint, period." What Hughes was painting were paradoxes and the things he said were often contradictory and highly pertinent to the nature of representation – which is itself paradoxical. In this early work he occasionally dealt with the treachery of both images and language as in his wavering flag of equivocation *Tick Cross*, 1962. Hughes is at heart still as much a student as he is a schoolmaster and this picture, in being both "right" and "wrong", presents a contradictory and yet honest reply to a question stumbling on its way to enlightenment or a failure that leads to success.

Art in the service of ideas has at various times been labelled as literary and there was a period when Hughes felt stuck with this tag. More often than not, the academy or a critic is to blame for breathing false life into a hierarchical tug of war between word and image. It is an act of control and a project meant to maintain a division of labour between not only word and image, but artist and critic. *One Two* is an early piece by Hughes that contains a literary message in the word "two". But it is not a literary painting – it is an example of contradiction in language. The picture is based in the cloakroom ticket that tautologically refers to itself in both visual and verbal language to avoid any possibility of confusion. This system gave Hughes the opportunity to make a contradictory "mistake". We all agree that 1 will go into 2, but Hughes asks us to consider two going into 1. Here Hughes' use of language is really no different than the black paint that makes up the picture – each is a sign dependent on its varying context and use.

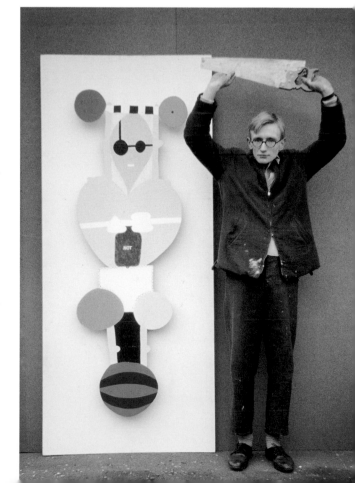

Patrick Hughes 1960

The artists so important to Hughes' formation – Paul Klee, René Magritte and Marcel Duchamp – each refused to draw clear distinctions in their work between word and image or even art and writing. Increasingly though, Patrick Hughes has. His art has always involved a high degree of contradiction, paradox and flux, but over the years his idiom has shifted from that of saying to showing. In his recent work this results in art that achieves a vivid experience of paradox and flux, rather than merely a clear reading or mapping of it. "I am a kind of purist," says Hughes. "I think it's comparatively easy to be impure and mix the media. I like the two, but I can't say I like the mix. I don't think one necessarily adds to the other." Though in his books on the vicious circle, paradox, and oxymoron, Hughes has shown that he does not regard the visual and the verbal as two distinct areas. He does perceive the shift in aspect between the two and this is what is all too often lost on the meaning-blind critic who rails against the literary in art. That Hughes is seemingly willing to contradict himself is a great strength in his art – both verbal and visual.

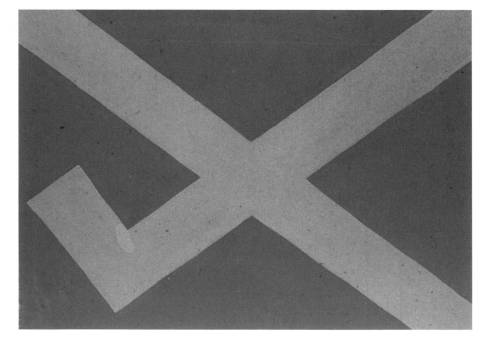

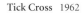

Hughes' relationship to painting is nearly as complicated as his relationship to the literary. Imagination, for Hughes, is the most important part of any human activity, while paint is the least important part of the picture. Both Magritte and Duchamp took joy in the French saying that this or that person was "as stupid as a painter" and Hughes would happily join in. Still, it could be argued that Duchamp maintained a relationship with painting via the readymade throughout his life. Magritte's relationship to painting is just as problematic. Louis Scutenaire's 1942 description of Magritte is one that could equally apply to Hughes: "Magritte is a great painter. Magritte is not a painter." Like Magritte, Hughes follows the maxim that "a painting does not express ideas, but it does have the power to create them." Patrick Hughes is not a lover of the empty form. He is an artist who paints pictures, the minimum description of which is: "The opposite of what you believe is true." He was drawn to the work of Magritte and Duchamp while a student at Leeds Day College owing to the high degree of contradiction and paradox in their work. But also because each artist speaks to our human condition while including in their work images and signs that embrace the high, low and the popular. The history of art for too long was traced exclusively along a trajectory of oil painting. This is something that Hughes rejects. Such a history leaves out far too much of the imagination that has made up the full story – erotic art, and illustration, the greasepaint of the music hall and theatre, set design, along with fairground conjuring and illusion. An early picture by Hughes is titled *A painting by a house-painter*. In both its title and execution this piece from 1961 acknowledges the craftsmanship and decorating skills of the tradesman over and above those of the professional painter.

Influences often advance and recede through the years, though in this respect Hughes remains consistently inconsistent regarding convention. Magritte has always held pride of place as what George Melly refers to as Hughes' "spiritual papa." Duchamp is still, as ever important, though now perhaps more in a conceptual role, particularly as Hughes' work turns on the viewer or seer's involvement. And Klee continues as something of a wild card in his hand. Hughes first discovered Magritte and then as a student fell in love with Surrealism. Always more a frame of mind

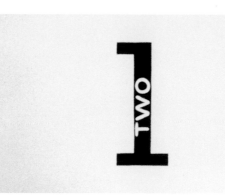

One Two 1962

Gloss paint on board
35.5 x 53.5 cms
Collection the artist

Painting by a House Painter 1961

Gloss paint on board
58 x 58 cms

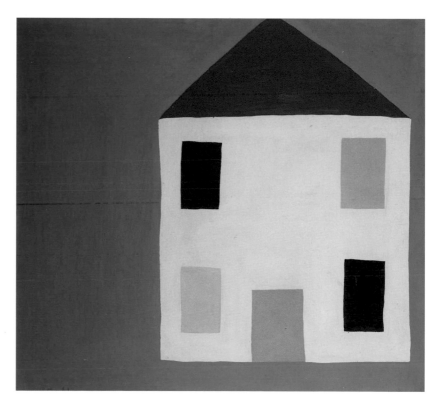

than a style in art, Surrealism melded well with the writers that Hughes then and now admires. A central source in his surrealist education was Marcel Jean's *History of Surrealist Painting*. While stocking the new library of the Leeds Day College, this book, along with *The Dada Painters and Poets*, edited by Robert Motherwell, was among the first that John Jones purchased. They added greatly to Hughes' faculty of adopted tutors and matched the visual abundance of Ozenfant and *Lilliput*, thus making the picture of the picture perhaps Hughes' greatest teacher.

On the Monday after the Friday on which he had completed his course, Hughes had a solo exhibition in London at the Portal Gallery where he had seen those Magrittes. He emerged from Leeds Day College an individual artist and budding visionary let loose in a short-sighted world. As he recounts the moment when he heard the retort from Mrs. Hanson "you should do art!", one of his lines goes: "Art wasn't my choosing. It chose me." As it turned out, Patrick Hughes was a well-assisted readymade.

Hughes has retained a childlike and naive vision – like Alice in her adventures, his is a way of looking at the world that allows the most commonplace things to take on a fantastic sheen. Christian Morgenstern, a purveyor of nonsensical poetry and himself a follower of the fantastic beyond even the borders skirted by Lewis Carroll and Edward Lear, wrote that the – "child in the human being is the everlasting creative power." It is a sentiment that certainly would find agreement in the work and writings of Paul Klee. A poem by Morgenstern that Hughes will happily recite from memory is *The Fence*:

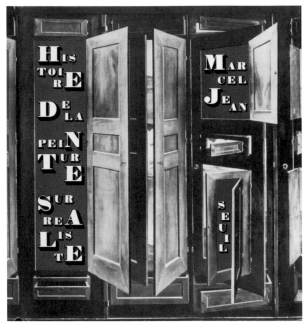

Dustjacket for *Histoire de la Peinture surréaliste* by Marcel Jean
© *Editions du Seuil, Paris 1959*

> There was a fence with spaces you
> Could look through if you wanted to.
> An architect who saw this thing
> Stood there one summer evening
> And taking out the spaces with great care
> He built a castle in the air.
> The fence was utterly confounded –
> Each post stood there with nothing round it.
> A sight most terrible to see –
> They charged it with indecency.
> The architect then ran away
> To Afrique or Americæ.

Such nonsense has the ability to take us beyond common sense along a circuitous path that leads back to our point of departure. We arrive there with a newfound ability to exercise our senses – both common and perceptive – more imaginatively. Patrick Hughes' art, from his earliest student days to the present, aims to lead us on a similar journey of imagination and perception.

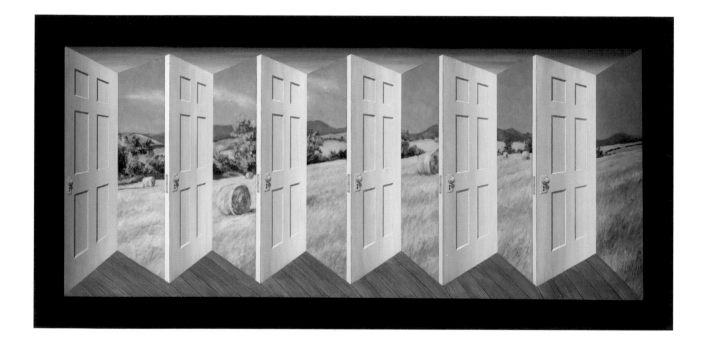

English Field 1997

Oil on board
83 x 168 x 17 cms
Private collection, UK

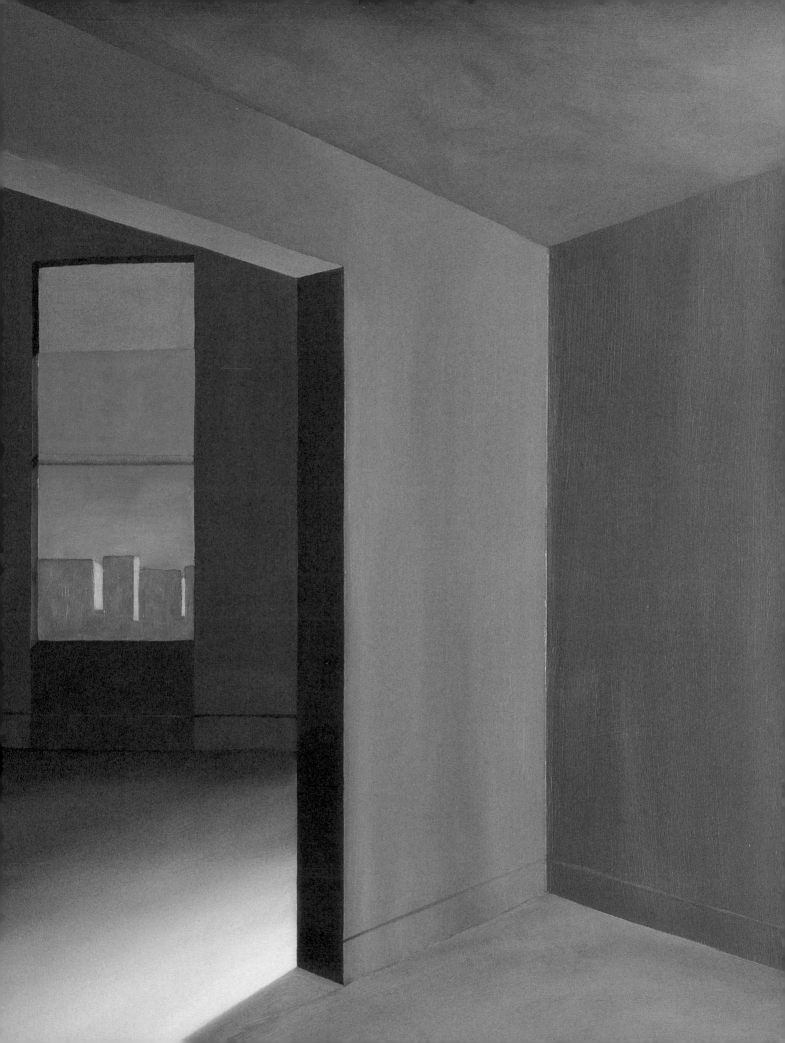

A VIEW WITH A ROOM

The Portal Gallery show was a huge success for the twenty-one year-old Hughes. E. L. T. Mesens was an early supporter, while George Melly and David Sylvester contributed to the catalogue. In effect, this was his student show and his final grade reflected the fact that the majority of his work was in London and not in Leeds for his final assessment. "I've always been disappointed in my final mark in college – it was an A-. The show was a terrific success... It was a strange feeling. There wasn't much money in it, I was still a schoolteacher living in Leeds and I had young children. So the show didn't make much difference to my life materially, but it did make me feel I was doing the right thing." In his catalogue essay, Sylvester welcomed Hughes' originality with unstinting praise: "This artist has the gift, synonymous with creativeness, of being able to be surprised by what the rest of us take for granted. Here is a painter who really has something to say, and his arrival on the scene gives me a rare sense of exhilaration."

Patrick Hughes at the
Portal Gallery 1961

The critics, on the whole, did an admirable job of linking Hughes with art as diverse as that of Harold Pinter, Paul Klee, Samuel Beckett, and Spike Milligan. His handling of the *joke* was the common currency and focus of much of this writing with critics choosing to place it in the context of the absurd, music hall, a Dadaist nostalgia or the nascent stirrings of what later, in their own hands, would become Pop Art. No-one properly addressed the *joke* as the main weapon in the arsenal of the anarchist.

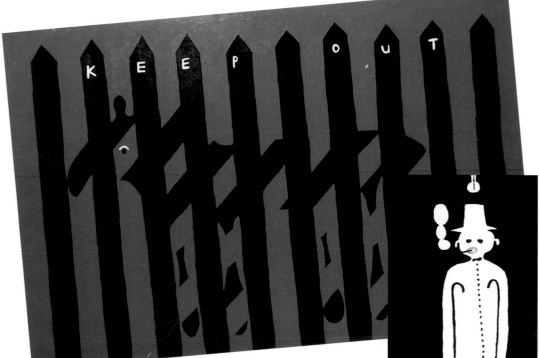

Portal Gallery catalogue
1961

In this they missed the chance to fully assess Hughes' proximity to Duchamp's position of radical rebelliousness and a wider tradition that included not only dada, but also the *Incohérents* of fin-de-siècle Paris as well as *The Goon Show*. Theory and criticism in London had already been exposed to art crossing over between the popular, architecture, and industrial or graphic design. Still, most lost their way in a cloud of confusion that rose up from their imposed division between art and language, or as they termed it – the literary. According to the strictures of modernist painting as handed down by Clement Greenberg, the most egregious violations of painting's areas of competence were found in literary and sculptural transgressions against the picture plane – for Hughes such infractions would increasingly become his stock-in-trade. The integrity of painting was intimately tied to the virginity of its vestal surface along with its two-dimensional shape. It was still possible to communicate in painting, but this had to take place inside the boundaries of purely expressive technical procedures. In turn, the critic's only sanctioned role was to describe and dramatize the technical wizardry of these mannerist actions. Abstraction was the goal of this recipe and painting would serve it up to a quietly contemplative spectator ready to delight in a disembodied optical experience – with no movement required. What Greenberg had in mind when he warned against literary incursions into painting were any and all narrative functions that the practice of painting may have employed in the past. If painting was to be looked on as a text, the only thing on offer to read was an epic of technical virtuosity. Such were the simplistic readings that Greenberg himself encouraged through the implications of his doctrine.

In Hughes' art "the literary" functions in a manner similar to that of the rhetorician or philosopher who works their magic invisibly. Rather than simply furnishing us with information, these rhetorical strategies draw on our own inferential propensities and ability to construct narratives – we follow their lead and insidious promptings only to arrive at paradoxical conclusions we feel we have reached ourselves. We are so strongly convinced of these conclusions because *we* have drawn them, albeit while guided by an invisible hand. A good number of visual and verbal puns were included in the Portal Gallery show, but Hughes' interests really did not lie in jokes any more than they did in painting pure. There was a rich depth to this work flowing beneath a naive and childlike surface – as in the art of Klee, a maturity of thought can be both concealed and expressed in an immature line. Hughes' real interest was in a system of representation that grounded the

Liquorice Allsorts 1960

Gloss paint on board
61 x 68.5 cms
Private collection

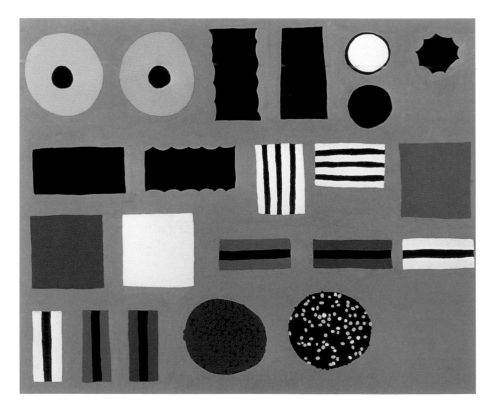

experience of art in communication. Q: In painting a joke, how does one know when the picture is complete? A: When you hear the viewer's laughter. In Hughes' art, laughter – or the involuntary smile that creeps across the face of someone moving before his sticking-out pictures – confirms the existence of an ineffable moment of shared communication between two equals. This is the ultimate aim of Hughes' rhetorical strategies.

Liquorice Allsorts was a popular picture in the 1961 Portal Gallery show. For Hughes, it was a rare satirical piece and a slight jibe at the abstract painters centred around Leeds. The picture is abstract – circles, squares and rectangles shift in serial permutations of colour and arrangement against an electric green field – but at the same time it is impossible for these geometric abstractions to shake their referent in the real world. These are after all, liquorice allsorts and while they may be basic shapes in nature, they are also basic shapes found in a box of sweets. *Liquorice Allsorts* is in a way Hughes' own target wrapped in a flag. Like Jasper Johns, Hughes was asking us to look at the paradoxical relationship between a representation and the actual thing. It is a Magrittean formula expressed in the syntax of the sign – *Ceci n'est pas une pipe*. We read such images against their grain – in order for these pictures to function our first reading must be: this *is* a pipe, this *is* a flag, or these *are* liquorice allsorts. Only because of this initial reading are we then able to move to the more discursive readings that reveal the treachery of such images. The sign is cast in the central role in such a proposition and acting as such, the iconic signifier constituted the cornerstone of much of the work that made-up Pop Art in its east and west coast American or British incarnations. A great accomplishment of dada, Surrealism and Pop Art – those areas of art banished by Greenberg to the realm of "homeless representation" – was to expand the spectrum of art and criticism. Often the use of metaphor or "the literary" in such work acts to refer the viewer back to an empirical reality based not solely in art, but in his or her own experience of the world. This opens the way for art and criticism that can tell us something about ourselves and our relationship to the world in which we live. In the case of Patrick Hughes, what we may learn is destined to be highly paradoxical.

The Portal show was a promising entrance for Hughes – it was in fact the first appearance of 'Patrick'. Christened Peter David after his father, his family referred to him as David while school friends called him Dai. Hughes received the moniker Patrick from Eric Lister who considered it a good name for an artist and Hughes accepted, reckoning "when if ever is a name of our own choosing?" The more important result of Hughes' early success was that it enabled him to move from teaching art in the local schools to the art colleges of first Bradford and then Leeds where he taught from 1964 to 1969. The north of England was then a haven for a widely dispersed, yet closely-knit cell of poets and artists who were absurdist fellow-travellers. A Dada-Surrealist spirit was enjoying a lively underground existence there, while in the seemingly cosmopolitan south it was thought to have been long dead and buried. Joining the staff at the Leeds College of Art gave Hughes the opportunity of an extended studentship and a chance to meet and mix with other artists – something denied him at Leeds Day Training College.

Rather than entering the artworld with a group of fellow graduates who could be easily recognised and moulded into a movement emerging from an art school, Hughes' contemporaries were a band of scattered northern accomplices. There was Adrian Henri and the Liverpool poets, while Jeff Nuttall and Albert Hunt were in nearby Bradford; in Leeds were the artists Anthony Earnshaw and Robin Page, George Brecht and a host of then students and co-conspirators – Trevor Winkfield, Glen Baxter, Les Coleman, Jeff Edwards, Les Evans (now half of Boyd & Evans), and Paul Hammond.

Patrick Hughes 1966
Photograph: Uri Lewinski

Hughes met Trevor Winkfield in London at his show at the Portal Gallery. Winkfield was interested in the work and Hughes, not letting on that it was his, recommended that he visit the artist at his home in Leeds. Winkfield arrived at Hughes' door a short time later and was greeted by the very same person who had advised him to visit. While a student at Leeds College of Art, Winkfield continued his weekly visits where he and Hughes pored over Robert Lebel's book on Duchamp published two years earlier in 1959. With Hughes then still teaching in the local schools, Winkfield was his first extramural university student. He would show up on "a small straight street called Alexandra Crescent" and enter Hughes' house, the hallway of which was papered in a job lot of Guinness posters laid out to proclaim "*the world's longest ddddd...*" Leeds was then a bastion of abstraction and Winkfield along with his contemporary Glen Baxter were influential as students in breaking the college's insistence that non-figuration or figuration define the parameters of the programme.

Anthony Earnshaw, still today disgracefully undervalued, was an influential figure on the scene. Hughes met Earnshaw in Leeds at the Wrens Pub in 1961. The two found they had much in common – while sharing an interest in Surrealist art, literature and anarchism, both were then bringing up young families and each had initially thought of becoming a writer. Though never having the gall to describe himself as such, Earnshaw had been painting in a Surrealist spirit since the late 1940s and continues to do so proudly to this day. Earnshaw and Hughes have shared many things over the years, from similar working class origins and an interest in Klee to their seditiously sexy senses of humour. During the early days in Leeds the two met regularly over the cover of Marcel Jean's *History of Surrealist Painting* with its turning wardrobe doors that open onto landscapes – cover art striking as a maquette and uncanny foreshadowing of Hughes' current work. Earnshaw was then still working in a factory and doing art in his spare time. Once Hughes was put on the staff at Leeds he worked to get Earnshaw appointed as well, which finally happened in 1969. A retrospective of Earnshaw's work shown at the college in 1966 did much to solidify his presence in the milieu and further spread his influence among those students and teachers already practicing a subversively humourous art.

When asked to teach at Leeds, it was hoped that Hughes – considered a lively example of what was then the new Pop Art – would help to combat the provincial in that provincial city. Pop, or neo-Dada as it was then sometimes called, was a wide net that covered as much ground as it did varied practices. Hughes has more often than not occupied the fringe of discernible movements and "isms" – this is where he is at home and most happy. As is the case with the work of many artists that critics place firmly within the rubric of Pop, Hughes' art is more popular and populist than strictly true to their sub species definitions. His work does have a graphic clarity that features an almost artless descriptivity which it shares with commercial and industrial design. And the questions that Hughes has been asking in his art through the years are similar to those asked by a generation of young painters who came out of London art schools in the early 1960s. What place is preserved for a spectator in painting? Does one paint space back into a picture or out into the area shared with the viewer? Already in 1964 Patrick Hughes had made his first sticking-out room. It was as much object as assemblage. A truncated pyramid served as a relief the sides of which – covered in doll's house paper – were transformed into the walls of a room, complete with a door, skirting boards, and picture rail. The three-dimensional surface of this picture was now an environment ready for an occupant.

One of Hughes' strengths as a teacher was in introducing diversity into the Leeds programme and faculty. Hughes came to know Robin Page at Gallery One's *Festival of Misfits* in London, 1962. Page, a Canadian who had lived in Paris and London, was a member of Fluxus – a loose international association of artists who produced individual and collective "events" that became the smallest units of a larger "situation" or "happening". At the *Festival of Misfits*, while Ben Vautier was living in the window of the gallery for a week, Page was exploring the concept of "useless work" a tangential variant on the Fluxus formula: "creative use of leisure: work=play." Hughes invited Page to Leeds where he began to teach in 1964 and in turn Page brought Fluxus cohort George Brecht there in 1967. Drawing on chance and the work of John Cage, Brecht composed "event scores" – simple textual notations that accompanied Fluxus happenings – an example is his

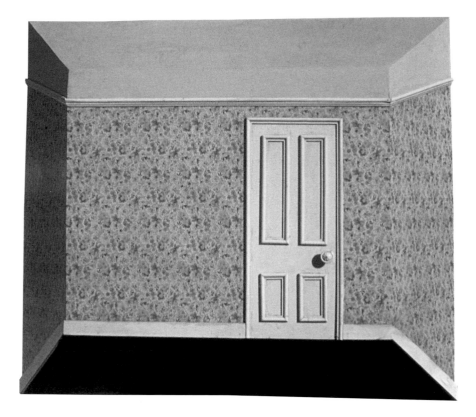

Sticking Out Room 1964

Mixed media
91.5 x 106.5 cms

CONCERTO FOR CLARINET, • nearby, G. Brecht 1962. While at Leeds, Hughes and Brecht found they shared a fascination for paradox which culminated in their book *Vicious Circles and Infinity: A Panoply of Paradoxes* first published in 1975.

Early in his career Patrick Hughes realised that in effect he was painting paradoxes. In fact it was his aim to do so from the start. "Since I didn't know what paradoxes there already were, I began finding them out; at first in logic and philosophy, in mathematics, then in verbal wit and literature, in pictures and the psychology of perception." The ouroboros, represented by a snake with its tail in its mouth, is a good visual definition of paradox. The image is also an energetic prototype of the vicious circle. While teaching in Leeds, Hughes began to explore the scope of this viciously self-referential image. *Short Circuit* is a practical vicious circle, if only in a limited sense. This tiny extension cord serves to illustrate the short circuit of logical paradox – the negative invites the positive and the inert circle is complete. Heraclitus, a pre-Socratic philosopher of paradox of the fifth-century B.C., said: "In the circle the beginning and the end are common." In pursuing paradox in his work, Hughes is not pushing paradox as entertainment, but as the meaning of life as he sees it. "I really think that reality is paradoxical, not realistic." Which is to say, that ours is a world full of contradiction and counterpoint. That much is clear and most would even agree that this is the case. Hughes, however, is in the company of those who go beyond the rudiments of a simply dialectical logic.

Short Circuit 1972

Mixed media
Approx 15 x 15 x 7.5 cms
Collection the artist

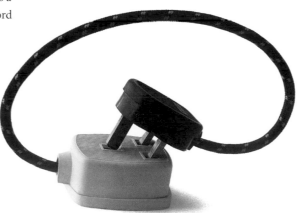

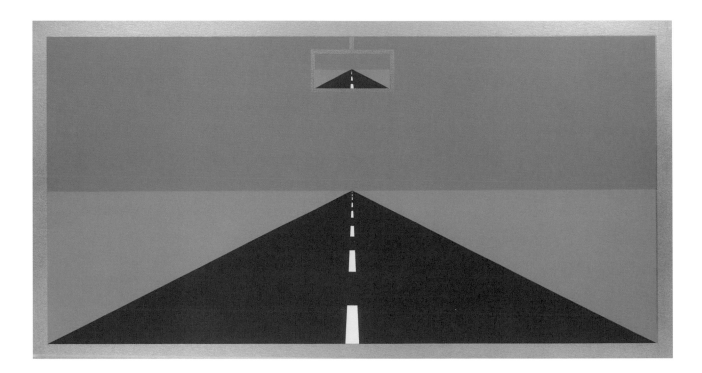

Déjà Vu 1976

Screenprint
Edition 60
68.5 x 101.5 cms
Printed and published by Coriander Studio

In Hughes' view – one which is shared in similar shades by Heraclitus and Zeno of ancient Greece, Nicholas Cusa and Giordano Bruno of the medieval world and in modern times, Stéphane Lupasco and George Melhuish – reality is paradoxically energetic and ordered through constant movement, flux and change. Essentially, it is as if the world were a deck of cards which are in a constant state of shuffle, with the shifting identity of any one card contingent on the value and position of not only itself, but the neighbouring cards in the deck. Such would be the dizzying experience of movement and change that your guess at the face value of any one card would be as likely to hit, as miss the mark – either way you would be both right and wrong. As in Hughes' own picture, in this you would achieve a state of two-oneness.

By virtue of its pure change, the primordial flux of experience eludes orthodox logic. Nonetheless, we are both surrounded by and a part of this movement – this is our world. A paradoxical logic, while no better at sketching a picture of the world either true or false, does capture the ineffable spirit of movement and change that escapes the purely logical. In Hughes' world, there is as much value in illogic as logic. In fact, it is not a question of valuing one over the other, but of stretching the limits of both to arrive at a third way which includes that which has been excluded from not only orthodox logic and philosophy, but also our experience of art.

For Hughes, humour has been a way to inject paradox into his work. It is not beyond his means to imagine Heraclitus and one of his followers Cratylus as a stand-up act. Heraclitus: "You cannot step twice into the same river, for other waters are continually flowing on." Cratylus replies with the punch line: "You cannot step into the same river once." Like Hughes, our comics raise the problem of the paradox of flux. At root this problem is a polemic on the nature of paradox, even more so than on the problem of flux. The paradox of flux is central to all of philosophy – it can be said that it is perhaps *the* pivotal philosophical problem. The paradox of flux can be restated as: How is motion possible?

The fact that motion is everywhere might lead one to wonder how this ever became a problem, but suffice it to say that for the better part of 2000 years philosophy has struggled with the obvious. Motion requires, by its very meaning, to be spread over space and time. Over a period of time an object can change its position, or move space coordinates. To observe that movement, or experience it, you the viewer would have to be able to observe time and its extension. The problem is we do not and we cannot observe the passing of time. If we ask ourselves: "how long is the present?" our reply is that it does not have a length – it is instant-aneous. So, how is it possible to experience something that does have a length of time when we, those of us experiencing an object in motion, cannot perceive the passing of time? By now it is likely already clear that this is a problem created in and by language rather than motion.

Some see the solution to the paradox of flux as parallel to the solution to the problem of philosophy itself – namely that the end of metaphysics carries along with it an end to the problem of flux. Certainly, those who wish to pass over in silence all that is paradoxical in life will dissolve the problems of both flux and philosophy as far as they arise in language. But increasingly this leaves much of our lived life and experienced world outside the limits of language. To be outside the limits of language does not have to mean that the mysteries of the world will remain outside our experience. Quantum physics is quickly approaching Alfred Jarry's definition of his own science of 'pataphysics. In 1911 the author of *Ubu Roi* set out the scope of this science of imaginary solutions in a statement that became a favourite text of Surrealism. 'Pataphysics would: "examine the laws governing exceptions, and explain the universe supplementary to this one; or, less ambitiously, describe a universe which can be – and perhaps should be – envisaged in the place of the traditional one, since the laws that are

supposed to have been discovered in the traditional universe are also correlations of exceptions, albeit more frequent ones, but in any case accidental data which, reduced to the status of unexceptional exceptions, possess no longer even the virtue of originality."

If language can come between and interrupt our experience of the world, then so too can logic. Quantum physics is energetically redesigning the axioms of logic upon which all of science has been based. A central prologue to a new quantum logic is expressed in another fragment left to us by Heraclitus: *People do not understand that which is at variance with itself agrees with itself. There is a harmony in the bending back, as is the case of the bow and the lyre.* The musical note that these new scientists wish to strike is one shared by Hughes in his artistic register, namely that it is possible to affirm the validity of a thing and its opposite at the same time. This Hughes does as he turns the logic of perspective back on itself. Hughes' invention of *reverse perspective* is at once both the strongest affirmation and attack on the system of perspective. Quantum mechanics is in search of a logic that can embrace the similar contradictions that the new physics advances. This is a new science open to multivalent levels of reality and it reaches for a logic of the included middle that is in turn a key to appreciating the implications of Patrick Hughes' art.

One of the strongest features of all Hughes' work – both that which is written and that which hangs on the wall – is that it wears its learning lightly. This is a modesty which I know and admire, but here can ill afford. I am stuck with the task of saying while Hughes has the ability to show. The role of time is a central component to this new logic. Classical orthodox logic is based on three axioms: 1. *The axiom of identity: A is A.* 2. *The axiom of non-contradiction: A is not non-A.* And 3. *The axiom of the excluded middle: There exists no third term T which is at the same time A and non-A.* Following from the work of Stéphane Lupasco on the logic of the *included middle*, a new logic could introduce the existence of a third term T which is at the same time A and non-A. These three terms

Collected Works Part II 1971

Gloss paint on board
122 x 203 cms
Collection Tate Gallery, London

would exist in a dynamic association along a triangle – one of whose vertices is situated at one level of reality and the other two vertices at another level of reality. At one level of reality, all manifestations appear as the struggle between two contradictory elements, say wave (A) and corpuscle (non-A). At another level, the T-state, that which appears to be disunited (wave or corpuscle) is in fact united (quantum) and that which appears to be contradictory is perceived as non-contradictory. The role of time sets out the difference between a triad of the included middle and a Hegelian dialectic. In a Hegelian triad each of the three terms succeeds the former in time, thus there is no reconciliation of opposites. In the logic of the included middle the opposites are rather contradictories – the tension between which builds a unity that includes and goes beyond the sum of terms that coexist in the same moment of time across different levels of reality. Such is the model of a quantum logic designed to serve the demands of a new physics. Hughes' *reverse perspective* is a similar example of a radically paradoxical system, where perspective is met by its abrogation and out of which radiates a new system based not in negation but sustained contradiction.

Language is perhaps the most seductive illusionist. Like painting, it does not have the power to fully express ideas, but it does have the power to create them. Patrick Hughes' art is one of perception and perspective. Science, as based in orthodox logic, is all about causes and it serves as a means of ordering the world along a number of pairs of mutually exclusive contradictions. Human understanding searches for reasons over and above causes in a fashion

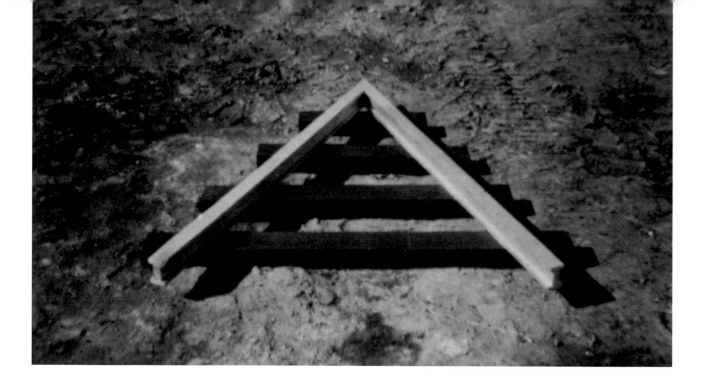

strikingly different from the way science views the natural world. We look for the meaning of what we see and perceive in a human manner that takes into account our own and other's positions in the world. This is a view filled with desires and expectations, aims, intentions, emotions, and especially movement. Predictive theories have very little impact on our understanding of the past and likewise, for us the future is made up of decisions that we make ourselves in tandem with others. It is a view from the driver's seat as in Hughes' picture *Déjà Vu* where the past is in the rear-view mirror and reduced so as not to obscure the future. Time in this picture moves and we move with it and in this, it is far easier for any of us – we humans – to change our mind and direction than it is for science to alter its logic. Our way of looking at the world is similar to the way we look at Patrick Hughes' pictures and there is movement in both.

Books have been Hughes' preferred means of travel, from *Lilliput* and Ozenfant in his early years to Melhuish's *The Paradoxical Universe* which he read while at the Leeds Day Training College. The printed word has been his teacher, means of escape and conduit to the outside – an exchange between two characters in Ionesco's *Amédée, or how to get rid of it* was what led him to read Lupasco's *Logic and Contradiction*. It was ironically while at Leeds College of Art – a time when Hughes was as much a student as a teacher – that he began to mature as an artist and in this, the shared company of individuals whose ideas ran so parallel to his own was a great encouragement. While standing at the train station in Leeds, Hughes looked down the tracks and followed their lines off into the horizon. Perspective misleads us to believe that parallel lines meet only a few miles away at infinity – itself represented in mathematics by an ouroboros, or the *huit clos* ∞. Infinity is always on the horizon – the nearer we get to it, the further it recedes. Hughes' first treatment of *Infinity* was a sculptural piece which dates from 1963 and it was inspired by his visit to those railway lines in Leeds. Made from wood these three-dimensional lines met within six feet offering us close inspection of a vanishing point that eludes us in life. Hughes returned to this image twice showing us infinity "from God's point-of-view" in gloss on hardboard in 1971 and then as a screenprint in 1976. In a very real sense he has been showing this scene to us ever since in his sticking-out pictures. *Infinity* – Hughes' first attempt to represent space – was a crucial stepping stone to that point.

Infinity 1963

Painted wood
Approx 183 x 183 x 15 cms
Private Collection

In the 1960s Hughes continued to explore the range of possibilities open within representational images. Looking back from the vantage of today it is hard to fully appreciate the stranglehold that abstraction vs. figuration held on art and education. Hughes was determined to loosen the grip of this dichotomy and from early on he played with the swirling line and expressive gesture mocking the effusive spontaneity of abstraction. *Clown* like *Infinity* belonged to the realm of the floor arrangement, then the advancing site of sculpture. With its seemingly poured and running colour, *Clown* appears to leap out from the gestural hand of a Pollock or de Kooning. Instead, Hughes had modelled a three-dimensional plasticine figure and then flattened it with a rolling pin proving that lines and shapes have implications which are difficult, if not wholly impossible to shake. He understood that "splashing colours about in a state of flux was not necessarily the best way to propose a philosophy of flux" through his art. His was a strategy of careful representation that sought to make the most use out of a minimal amount of figurative information. The abstraction was there in his ideas.

As sculpture was taking on the floating colour of abstract painting, painting in turn was making shape and three-dimensionality a province of its own. Increasingly space and shape began to find its way into Hughes' pictures. His sticking-out room had arrived and while this unframed picture was the classic window-on-the-wall, it too put forward the proposition of painting as environment. For artists then working along an axis supported by painting and sculpture, cutting into and away from canvas or the picture plane was a strategy to mark movement between or away from either medium. Instead of a means of escaping from the rectilinear conditions of painting's surface, Hughes used this strategy to create representational information. For Hughes art was already a general activity and not tied to a specific medium – the challenge was to communicate his ideas rather than define the limitations or scope of either painting or sculpture. *Three Doors* with its serial repetition and forced perspective from

Clown 1963

Mixed media
Approx 122 x 244 x 0.3 cms

RIGHT:
Chair in the house 1965

Mixed media
Approx 91.5 x 61 x 61 cms

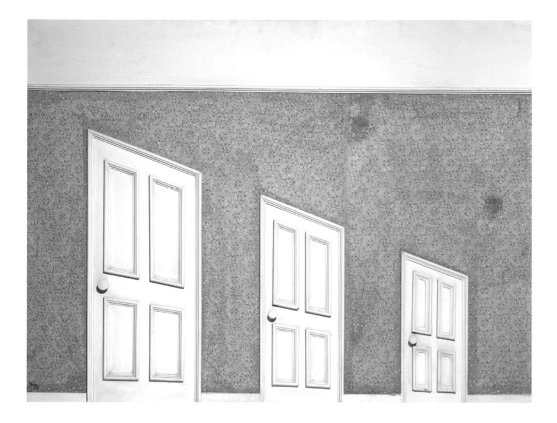

1964 looks ahead to a Patrick Hughes of the 1990s. Like his first sticking-out room it is a non-painterly construction made from doll's house wallpaper with miniature picture rails and doors brought together in a collage of ready-made materials and gloss paint.

1965 brought further directions in space and depth to Hughes' work. His use of wallpaper as a ready-made representation in his pictures here took a turn of Magrittean proportions with *Chair in the house*. Wallpaper is decorative – it functions to line walls that demarcate space; while like painting in this sense, it departs from a picture in that with wallpaper the relationship of figure to ground is completely flat. In this piece a feature of a room becomes the supporting structure of the house and figure and ground are reversed in a representational geometry of scale. Hughes would return to this shape in a row of sticking-out terraced houses some thirty years on, but at this point the reversal of figure and ground was still strictly tied to paradoxical representation and not yet movement. *Brick Door* is a more formal treatment of these issues and it is a pivotal work in the development of Hughes and his art. While teaching at Leeds, Hughes had brought in Richard Hamilton to lecture on the work of Duchamp – Hamilton was at Newcastle University at the time and working on the reconstruction of the *Large Glass*. In 1964 Hamilton coordinated a project with the Institute of Contemporary Arts where a group of artists, working with Chris Prater, produced a screenprint to be included in a benefit portfolio. This was an introduction to making screenprints for a number of artists – the portfolio contained the first efforts by Hughes, Patrick Caulfield, and David Hockney. Then essentially a commercial process for reproducing posters, *Brick Door* was Hughes' first screenprint. Hughes made a small wooden door and then papered it in doll's house

Three Doors 1964

Mixed media on board
93 x 123.5 cms
Collection Angela Flowers

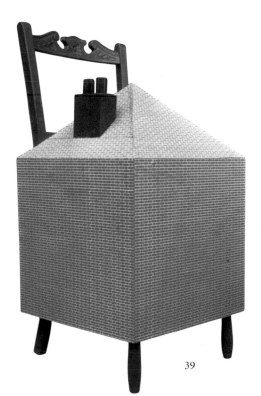

39

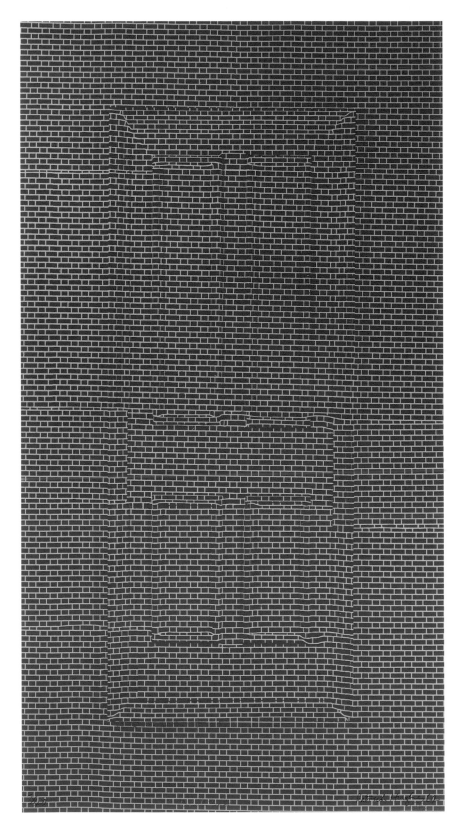

Brick Door 1964

Screenprint
Edition 40
85.7 x 47 cms
Printed by Kelpra Studios
Published by The Institute of Contemporary Arts, London

brick paper for Prater to photograph. As with wallpaper, in this image figure and ground are joined as one and the oxymoronic brick door advances and recedes as one's eyes shift focus between these two components of the picture plane. It is a rare moment when still photography is able to communicate the depth of Hughes' three-dimensional enterprise. In addition to marking Hughes' developing interest in depth and opticality, *Brick Door* caught the eye of Angela Flowers – then only a collector with a dream of running a gallery – and while her number did not come up early enough at the ICA auction, she later acquired the piece and the artist too.

Foot Print is a picture from the period whose surface is entirely made from sand. Here representation is stripped down to its origins in the impression of an object into a soft material. Like a camera backfiring and instead capturing an image of the photographer's eye, Hughes has reversed an indexical relationship – his footprint negates its impression creating a positive as it rises up from the sandy surface. This image maps out an absurd reversal of figure and ground and the foot print speaks to us as a sign which allows us to read the paradoxical reversal contained in the picture. This is a moment when Hughes is "saying". A major shift in his work comes with the sticking-out pictures where he begins "showing" the paradoxical to us by making it a manifest part of the whole artwork. This shift introduces a crucial difference for the viewer as they move from reading a paradoxical map or blueprint to fully experiencing paradox. Space, depth and perspective were the materials that Hughes used to initiate this shift in the communication of his art and *The Space Ruler* was nearly as significant as his sticking-out room of 1964 in moving his work in this direction. Like Duchamp's *Standard Stoppages*, Hughes' *The Space Ruler* is an idiosyncratic measuring device designed with an invented

Foot Print 1964

Mixed media on board
60 x 75 cms
Private collection, UK

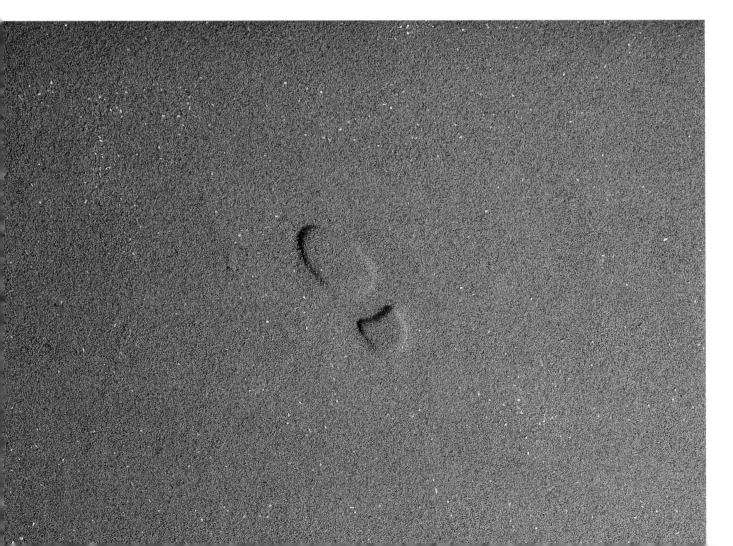

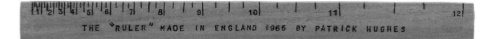

function in mind. Duchamp relied on chance to dictate the design of his *Stoppages*, Hughes did not and there his apparatus departs from its associates. While looking deceptively like any other, this ruler is made to measure pictorial space – its calibrated marks are graduated in perspective and stretch to clearly show that the corner of the cube nearest to the viewer is larger than the smaller far corner. Hughes' ruler not only measures the perspectival depth demonstrated by the Necker cube, it pins the cube down and forces these flat lines to become real depth fixed in pictorial space. Normally the eye cannot determine whether one point or plane of a Necker cube is closer or further away than another. With the ruler affixed along the cube's line running from front to back, our eye is not free to shift its focus from one plane to the next. Hughes' ruler turns the ambiguous illusion of the Necker cube into measurable space – the cube is real and generates the illusion that it sticks-out from the flat picture plane.

In the late Sixties Hughes moved to London and began to commute in order to fulfill his teaching duties. As much as he got from his time in Leeds, he found it difficult to produce the amount work there that he would have liked. Teaching is a system of patronage that is not suited for all artists and while Hughes is a natural teacher, he found the demands of a full career in both art and education meant that one had to give way to the other. During the period of this realisation, he was making viciously circular objects that verged on the impossible in their pursuit of paradox. His ouroboroses came forth in extruded ceramic along with balls with wheels and even multiple wheeled wheels. *Duck Soup*, included in the ICA mixed show *Play Orbit*, stems from this period and with its waggish reference to the mirror standing in for a lake in shop window dressing, it typifies his playful touch with objects and representation. Hughes put a formation of plastic ducks on a glass-topped table and beneath the table top, the ducks' mirrored reflections were attached by magnets – these real reflections followed the ducks above with hesitation.

Another ICA show in 1970 saw Hughes construct his largest room to date. In *Ten Sitting Rooms* the ICA turned its galleries over to ten artists – each having a room to do with as they liked. Hughes doubled the area of his space by constructing a 12 x 8 foot sticking-out room within his room. This was perhaps the most ambiguous of Hughes' many paradoxical objects. Neither painting nor sculpture, his room was an extension of architectural space. Visitors could look in, but also more importantly, enter and move about experiencing his room as it coincided with and grew out of the "real" space. This feature made the piece an installed environment more than anything else. "The room was also viewable, I am ashamed to say, from a peephole in the door," says Hughes. For the viewer, this peephole made for a bifurcated experience split between a frozen

RIGHT:
Man Looked Through 1970

Gloss paint on board
91.5 x 122 cms
Collection the artist

ABOVE & BELOW:
The Space Ruler 1965

Mixed media on board
123 x 92.5 cms
Collection the artist

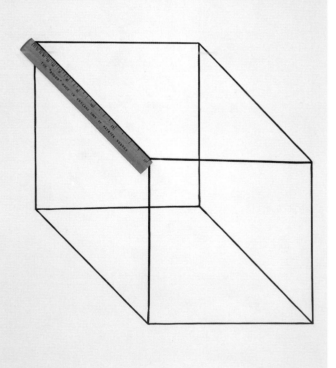

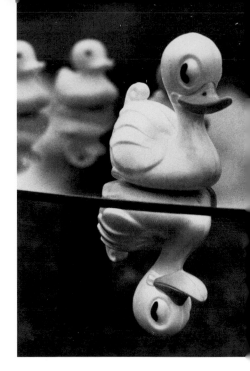

monocular view of illusory space on one side of the door and a full-bodied experience of articulated space on the other. The challenge that this piece put forward for Hughes was – how to combine these two halves into a radically paradoxical experience of the whole?

Hughes' room at the ICA came six years after his first sticking-out room and seven after his floor piece *Infinity*. Around the time of his ICA room he painted a small sticking-out version that in a way documented his intervening invention and then he put the idea away. It would be 1988 before he would combine the viciously circular nature of infinity implied in the convergence of parallel lines at a vanishing point with the sculptural presence of his rooms. The ground which covered the time in between was fertile and Hughes continued to plow it in circular furrows producing record yields of paradoxical crops. *Man Looked Through* is a picture from 1970 that shows where those parallel lines do finally meet – in the infinity of the eye. A reverse perspective in itself, this spirit was to imbue Hughes' further explorations of infinity, circularity and the popular throughout the 70s and 80s.

David Sylvester was insightful when he marvelled early on at Hughes' ability to be surprised by what the rest of us take for granted. But this is only half of what makes an encounter with Patrick Hughes' art truly unique. The balance of Hughes' creativity is based in his subversive acts of conformity. When faced with a new avenue to explore, his response is generally a willing acceptance to function within the conditions of, say – art, painting, perspective, this or that name or even the suggestion of a profession. But while doing so, Hughes creatively twists what we all accept and assume to be those given conventions. The surprise that results from this strategy is our own inclusion and place in the work. Far too often what the viewer of modern art rightly takes for granted is that he or she has been left out and can only gain access to work by following the coded suggestions of the critic or gallerist. Patrick Hughes cuts out the middleman – his art is as much for as by the viewer.

Duck Soup 1969

Mixed media
Approx 61 x 122 x 46 cms

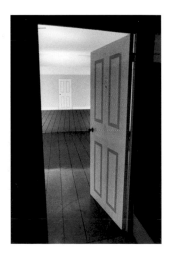

Installation, Institute of
Contemporary Arts, London 1970

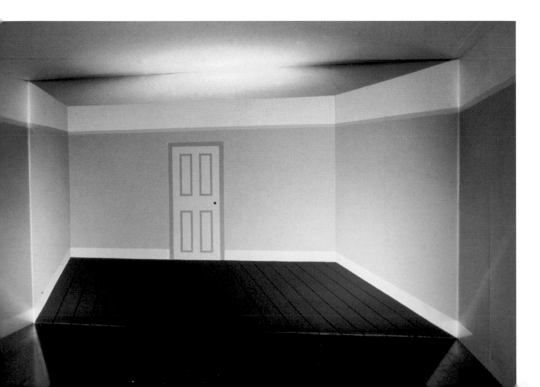

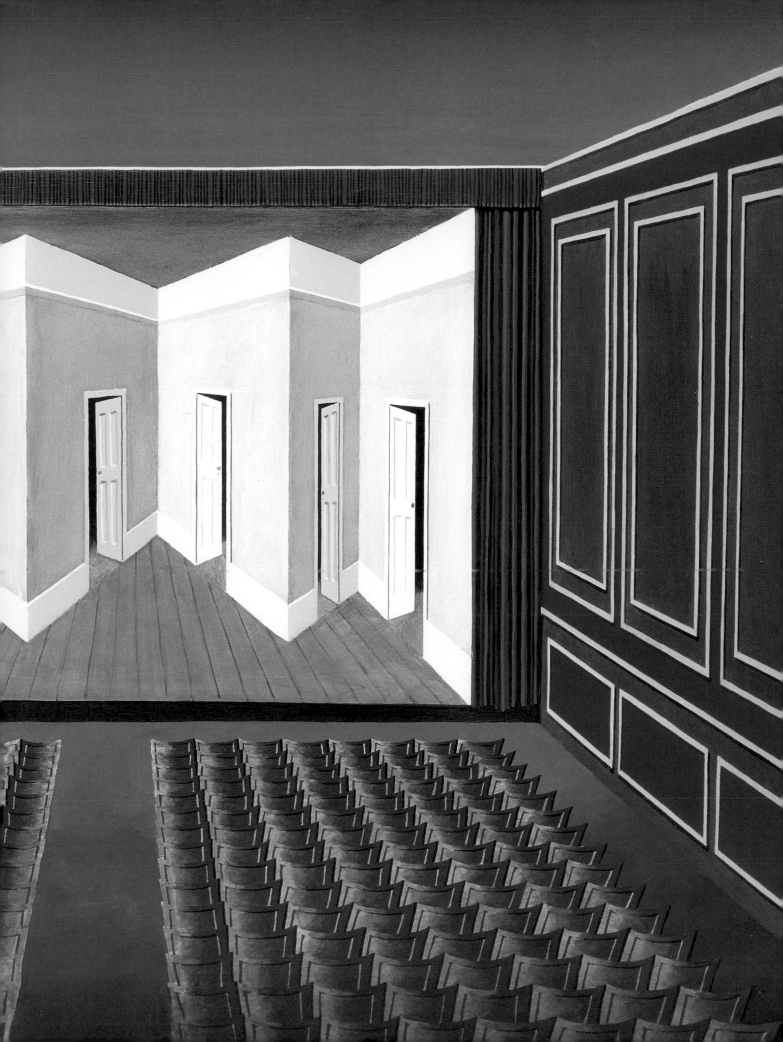

THE HIGH, LOW AND THE POPULAR

Almost a decade passed between Hughes' first print *Brick Door* and his next in 1973. His return to the screenprint came with *Pile of Rainbows* and it was an unknowing hint of what was to follow. Hughes painted his first rainbow in 1962. *My Own Rainbow* was typically Hughesian in that it was "wrong" – redesigning the spectrum in an idiosyncratic arrangement, he left out one or two colours and jumbled the schoolhouse schematic *R-O-Y-G-B-I-V*. For Hughes – an artist in pursuit of the paradoxical, the impossible, the enigmatic and ambiguous – the rainbow was a perfect model. Its fixed and minimal geometry was ideal and it took on a role in his work now occupied in the sticking-out pictures by the trapezoid.

Throughout his career Hughes has been drawn to the manipulation of geometry as a means of building-up figurative information. Paul Klee's strategy of constructing a picture in a geometry and then using that graphic sense of shape to represent something has had a tremendous impact on Hughes and his work. Along those lines, *Revolution of the Viaducts* provides the visual context in which to place Hughes' manipulations of the rainbow. In Klee's picture the constituent parts of a bridge have broken away and march off as an army of legs towards the viewer. The rainbow provided Hughes with a geometry that was equally malleable and as an object of representation it was uniquely challenging.

A popular and thus lowly icon, the image of the rainbow is so well known that it is rarely if ever well and properly seen. "A rainbow is a transitory event composed of water, air and light," explains Hughes. "I tried to give them mass, permanence and persona." Bending the rainbow

Pile of Rainbows 1973

Screenprint
Edition 75
77.5 x 103 cms
Printed by Advanced Graphics, London

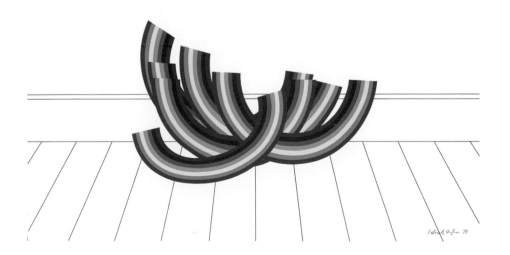

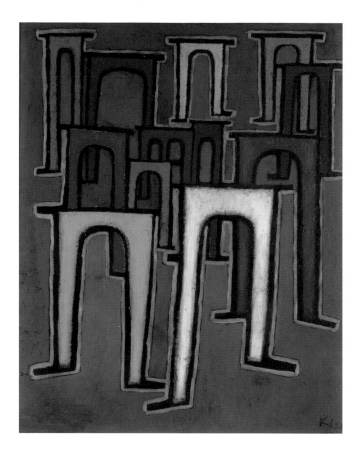

Paul Klee (1879 - 1940)
Viaducts Breaking Ranks 1937
Oil on cotton
60 x 50 cms
Collection Kunsthalle, Frankfurt
Photography: AKG, London
© DACS, London 1998

to his will, Hughes took the view that the cultural meanings associated with the physical phenomenon could be disregarded given the fact the prismatic bow is in itself so remarkable.

As it happens, the actor's adage, "never work with dogs or children" is similarly true of rainbows, for Hughes was upstaged by his partner in paradox. "People misunderstood – they thought they were jolly and I thought they were contradictory and to paint them was an oxymoronic attempt. I enjoyed the flux and the flow of it, mine was an ironic position. They were incredibly popular. It was a great solecism: the Pop artist who gets popularized – it's the strange gift of the popular touch."

Like the villanelle for the poet, the rainbow was for Hughes a given matrix which he enjoyed returning to time and again. Working with a repeating form or shape is both a challenge and seduction – as an artist, one finds a measure of palpable freedom within such limitations. Hughes' attempt to show an experience as a thing makes the body of work that involves the rainbow the nearest he has come to transposing a function of language onto that of art. Taken as a whole, his rainbows stand as a long prose poem on the ambiguous and contradictory nature of representation. A conventional view of the painted picture is that it acts as a cage for the real. Given the nature of the rainbow, it is not difficult to see the irony in Hughes' efforts to keep an occasion in captivity. The rainbow paintings were pictures made up of contradictions. Once Hughes made the rainbow into a "thing" he could give them shadows and form, as in *Leaning on a Landscape* where the imagined mass of the rainbow casts a shadow as it leans against the titled perspective of the sky. The serial repetition of such logic-defying acts made the rainbow the star of his paradoxical circus.

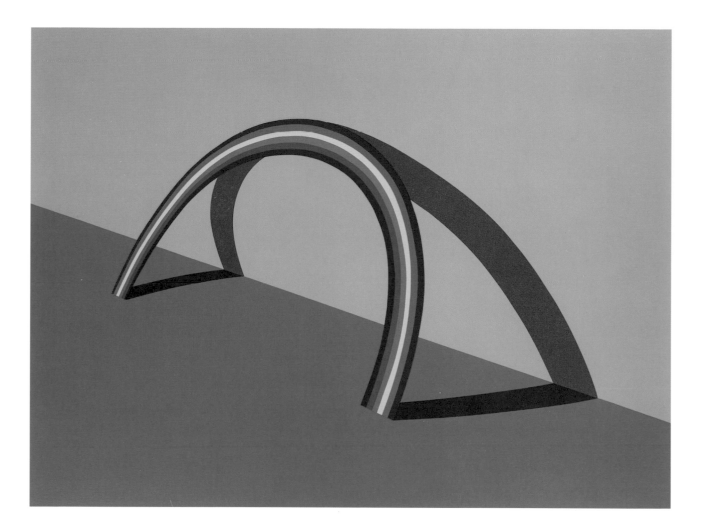

Leaning on a Landscape 1979

Oil on board
91.5 x 122 cms
Collection The Arts Council

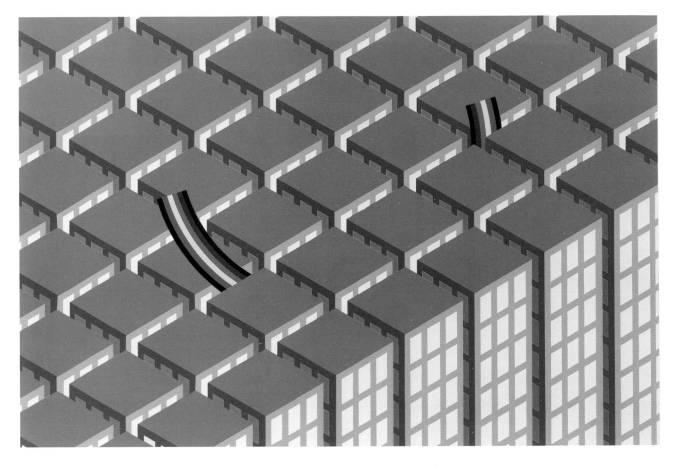

It is important to grasp that Hughes took on the rainbow as a representation and object rather than embracing it as a cultural icon of the period – in a sense his approach can be seen as one prolonged attack. The mechanical manner in which they were drawn bleached the emotionality from the rainbows and gave them substantial form in their six solid bands of colour. In his own approach to representation, Magritte employed a number of strategies to introduce various "crises of the object" in his pictures – isolation, modification, metamorphosis, scale changes, accidental encounters, double-image puns, paradox, and multiple viewpoints. Hughes sampled these lines of attack on the rainbow as he put it through its paces. *Crash Landing* employs contrasts in colour and a shift in context as an upturned rainbow rests in the heights of a grey and densely packed city grid. Hughes recognised early that after the exhaustion of trying and ultimately failing to capture the real, the continuing problem for representation is to find other functions. As is the case with all his work, Hughes' rainbows are a graphic demonstration of Klee's tantric aphorism that *Art does not render the visible but renders visible*. Hughes used the rainbow's rhyming shape and figurative geometry to communicate that the mysterious and magical in the world is not invisible, but visible and there to be seen – be it in the natural phenomenon of the rainbow or in movement, paradox and flux.

Increasingly in the seventies the print became the most appropriate means for Hughes to realise ideas before the widest possible public. It has been argued that when taken alone, the rainbow prints exaggerate Hughes' populism. This opinion confuses a significant feature of

Crash Landing 1981

Screenprint
Edition 200
57 x 76 cms
Printed by Coriander Studio
Published by Brian Smith Fine Art

Patrick Hughes and his art. The rainbow prints did overshadow other work with their popularity, thus offering an unbalanced view of the totality of his production during the period. Still, Hughes' populism is an important given in his art. He cares and makes an effort to communicate, entertain and involve the viewer or seer in his work. The rainbow connected Hughes with a public that is essential for his art to function – be it through a painting, a print, or a postcard.

M. C. Escher, an artist equally involved with the depth of perspective, perception and the impossible object, was largely ignored by the art establishment despite his imagination and ability to communicate through the reproduction and print. In Hughes' eyes all media and formats are equal and any opinion that seeks to advance the fidelity of one over another, is as he says, "commerce masquerading as connoisseurship." Equally, Hughes views culture as a continuous whole across time and place that operates irrespective of any class divisions. "Being brought up on Ozenfant and *Lilliput*, I would always include all the brows possible – high, middle and low. These brows are continually crossed. I don't accept those divisions. Especially in visual work, who's to say what drawer it belongs in?"

Patrick Hughes is a contributing member of the ever-expanding public whose artistic and visual culture belongs to *le musée imaginaire* – the museum-without-walls where the copy lodged in the mind of its receiver precedes the original. That this same public will partake in Hughes' work as they glide through the exhibits gathered under the millennium dome is testimony to the democratic and popular state of visual culture at the end of the twentieth-century. Hughes offers a form of populism in his work that is inclusive and tolerant as it seeks to entertain, educate and include the viewer. His positions on the high, low and the popular grow out of the fact that Hughes was made literate by visual and verbal culture in all its varieties.

The type of formal analysis that he recognised in the work of Klee is not far removed from the double panel comparisons that he followed in *Lilliput* as a youth – each highlights the rhyming shape as an elementary component of visual rhetoric. *Lilliput* was started in the late thirties as a pocket-size publication with a radical anti-Fascist platform. As it contained some winsome images of nude women, it was suitable for quick concealment by men on sentry duty and resourceful youths alike. Emphasising photographs and art work, it featured photo-essays by Bill Brandt, Robert Doisneau and *Picture Post* photographers with innovative design by a team of refugee artists from the continent. With its serious message presented in a popular and accessible format, *Lilliput* is a prime example of the to-ing and fro-ing between high and low that Hughes finds so seductive.

Few artists focus on the systems of visual or verbal rhetoric they use intuitively and fewer still make detailed studies across the pages of three books as Hughes has done. This is a surprise given that rhetoric can be seen as the sum of a repertory of various ways we have found to be 'original' over the course of time. My focus on the rainbows is not to prove that it made sense *for* Hughes to do them and so many at that, but to show how they made sense *to* Hughes. As a visual gag, the rainbows were a crucial step towards his discovery that a pun may find expression in any dimension – one, two or three. And coming as they did alongside and out of Hughes' research on visual and verbal rhetoric, they are documentation of his growing understanding of how one reads a picture and image.

Of those artists who actively seek to communicate and entertain as well as educate, perhaps the most talented in the skills of rhetoric are the cartoonists, the music-hall performers, and the comic. Humour – especially the short form of the joke – is their bait and hook all-in-one.

In Hughes' pantheon of admired artists Charles Addams and Tex Avery – a pioneering talent of animated cartoons who was influenced by, and perhaps equally influential in Surrealism – share space with Arcimboldo, Magritte, Meret Oppenheim, Escher and Duchamp. For Hughes, one way to be original in art is to take something from the low and raise it to the high, which in itself is a chiastic reversal. "Humour added to high art is wonderful. It's the best thing that the art of the twentieth-century has done. Humour is tragedy elevated to the level of art! The wrong way around is more revealing. Tragedy is always the right way around, just worse. Humour is terribly important – Magritte's pictures are funny. Heraclitus' philosophy is funny. And the best teachers are terribly funny." Humour adds an acoustic effect to the gentle silence of the still picture. Magritte introduced elements borrowed from the cartoonist and sign painter into painting that changed its function. With words and sound in the picture, all that was left out in order to create a full cinematic effect was movement.

The recognised master of the acoustic drawing is another of Hughes' favoured artists and not surprisingly, also one who is both an insider and yet maintains a position outside the world of art. Like Hughes, Saul Steinberg's best work would be impossible without the tradition of Surrealism. Surrealism created an audience – and a popular one at that – able to read an image obliquely. In this, those "excommunicants" and "Surrealists in spite of themselves" – Bosch, Arcimboldo, William Blake, Giorgio de Chirico, Dali, Magritte and Klee – played the most significant role. Steinberg provides a clear and telling view into Hughes and his art. As with Hughes, there is the strong influence of Magritte and Klee in Steinberg's work – though it is not the work that is so telling, rather the ideas behind it and the practice out of which it comes. Hughes is remarkably unreserved in praise of the artist: "Saul Steinberg is the greatest living artist. He can't draw a bad line or think a bad thought. I can't say I have got particular things from him, but I have got joy and invention. He's a tremendous artist who uses all the resources of modern art and communicates to everybody." Steinberg's drawings, published regularly in *The New Yorker* for the better part of fifty years, make visible the life of the mind and senses. In his drawings Steinberg seeks to give shape to what our senses perceive as they cross over one another: for example, to hear colour, or see a smell. Psychologists refer to this phenomenon as *synesthesia* and in some measure we all possess the ability to make these associations between our senses. Hughes creates the opportunity for us to see and feel the workings of vision in the mind and body as we move about his sticking-out pictures. What Steinberg and Hughes truly share is the place of humanity in their work as each recognises and makes an effort to restore the humanising effect that art can create for not only a viewer, but a participant. That work of this sort should be popularly received is a necessary precondition to its existence.

As far as Patrick Hughes knows, he is not really an artist's artist. Those that are so thoroughly popular rarely are and this says more about the institutions of art and criticism than their work. Marcel Duchamp is rightly referred to as *the* artist of the twentieth-century and given his allotted place in contemporary writing and practice, he now belongs wholly to the artist and critic. Duchamp's historical position, however, obscures the decidedly popular touch he employed as a living artist. And in no small measure, this facet of his practice has had an impact on Hughes. It is enriching to try to focus on Hughes' work through the prism of Duchamp with his ubiquitous puns, and fusion of alchemy, art, science and eroticism. Just as Hughes' work is informed by his relationship to Heraclitus, Duchamp was shaped by an equally cryptic pre-Socratic thinker in Pyrrho of Elis. Pyrrho was a painter who abandoned art for philosophy and then left the world two sole aphorisms: *Nothing really exists, but human life*

is governed by convention and *Nothing is in itself more this than that.*

Duchamp – today viewed as the consummate artist's artist – gleaned from these statements the *indifference* that both fuelled his "departure" from painting and guided his choice of readymades. Surviving mainly in reproduction and refabrication, the readymade is the quintessential object in the museum-without-walls. Duchamp's readymades only make sense as they pronounce their statement *this is art* given a public reception that includes all brows. *Rotoreliefs* and system of *Roulette Monte-Carlo* were popular efforts designed for mass consumption and enjoyment – indeed, the ideas Duchamp filled his *Boîte-en-valise* with came from a mind open to the joys of the popular. It is too easily forgotten that as Duchamp sat in his booth at the Inventors' Fair during the Concours Lépine he twirled in his hand a business card that read: *M. Duchamp – Precision Oculist.* He sought a direct contact with the crowds streaming through the aisles of the fair and hoped for the widest possible success and distribution for his *Rotoreliefs.* However, Hughes is wary of what he sees as the negative influence of Duchamp that also grows out of the work. Hughes particularly dislikes snobbish and exclusive art – art full of secret meanings available only for the initiated and there is plenty of this in the work of Duchamp – the condition of which is often only made worse by the writing that seeks to serve it. It is useful to balance the influences of Duchamp on Hughes against those of Magritte. While dealing no less with ideas and objects that were complex and ambiguous, Magritte endeavoured to communicate those ideas clearly even if their ultimate meaning was elusive.

Hughes continually honed and clarified his idiom in the rainbow paintings and prints as well as the work they somewhat overshadowed. Subsequently, vicious circles, infinity and the ambiguities of representation took on a resounding presence in his work of the seventies. *"Good Painting will be Wall-Coloured" (Jacques Brunius)* contains all three as this picture of a painting on a wall creates an image of the floor and wall of the room it inhabits. The picture of a picture is a circular regression that contains infinite variations and in this painting the mirrored perspectival lines of the floorboards add up to a map that offers a proposition of space and depth in the flat picture. Hughes' rainbows stood in their relation to the actual occurrence just as a cartographer's map relates to a land mass. Maps and mapping were a great

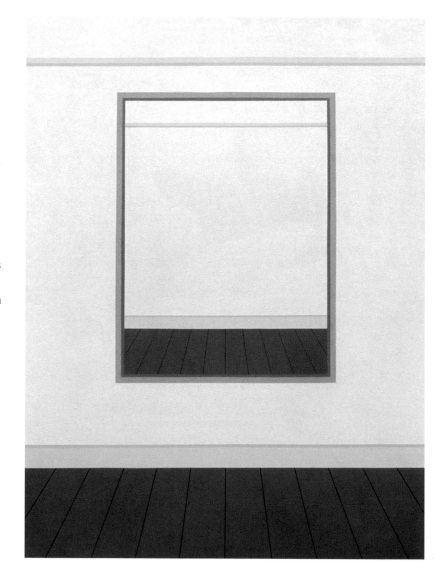

"Good Painting will be Wall-Coloured" (Jacques Brunius) 1972

Gloss paint on board
122 x 91.5 cms
Private collection

preoccupation of art in the seventies and Hughes poked fun at himself and others in the *Endless Case* which is no less a profoundly clear statement of infinite regress. This painting was also treated to an unstaged play written by Hughes in March of 1973 that serves as the only possible correct description of the picture

"The Unfinished Case"

A Drama in an infinite number of Acts
by Patrick Hughes

The scene is a room

PROLOGUE

A person comes into a room. Another person comes into the room. One of them shoots the other dead. The murderer leaves the room. A detective enters the room and draws a line around the body. He then drags the body from the room. He takes a sheet of paper and a pencil and

ACT I

he makes a map of the room, including his map, on which

ACT II

he makes a map of the room, including his map, on which

ACT III

he makes a map of the room, including his map, on which

(and so on, in an infinite number of mapping acts).

The act of mapping, and of course the map, is limited only by the infinite possibilities of included detail and flexible scale. Like language in its attempt to describe the world, the map is an approximation that succeeds most surely in drawing a map of itself.

The Endless Case 1973

Gloss paint on board
183 x 122 cms
Collection the artist

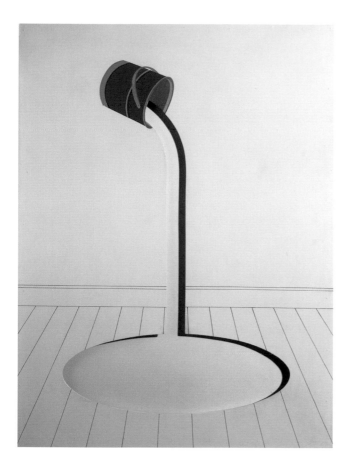

Realistic Paint 1977

Gloss paint on board
122 x 91.5 cms

Leaf Art 1975

Screenprint
Edition 50
82 x 61 cms
Printed by Charlie Holmes

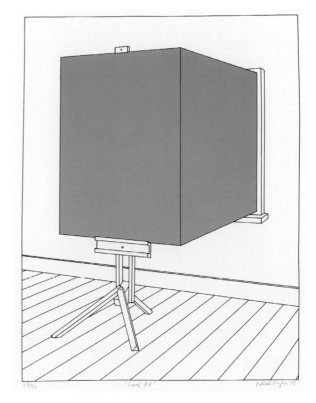

In part, space and depth accrued in Hughes' work through his repeated treatment of the ambiguities of representation, as in *Realistic Paint* where the image of poured paint is created by cutting through the picture plane to reveal the real painted wall behind. His long-standing strategy of cutting into and through a surface – an approach tied to Hughes' interest in a minimal figurative geometry – implies a notion of space and depth in a picture. To a large degree though, the sharp lines involved in creating prints clearly helped lead to Hughes' increased involvement with perspective, just as those railways lines led to infinity and the horizon in Leeds. Not having gone to art school, the iron laws of perspective then largely escaped Hughes. At a time in the seventies it was even possible for him to say "I enjoy art because I never learnt about perspective." Had he learned properly we might have been without his sticking-out room, which was among the first screenprints he made after returning to the format. Clearly someone who knew the rules would not have had the courage, nor the naively impertinent genius to reverse perspective and make something right by doing it wrong. *Leaf Art* is a print whose lines lead to perspective as it brings the space and depth of

the outside world in through the window and onto the easel. The graphic clarity of prints and pictures of this type, set within an architecture of the line, were nascent signals of his emerging courtship with the space and depth of perspective.

In 1976 Hughes singled out the ouroboros in a suite of etchings that explored metamorphoses. Like his *Self-reference* of 1973, these prints acknowledge the masturbatory quality of paradoxes in the play of the mind with itself. The drawing of a drawing hand that draws a drawing hand is echoed in *Pencil Drawing* and *Co-ordination* both of which ask which came first – the line or the line which draws the line? *Fear Itself* belongs to Hughes' work with the shadow as solid and here circular – it is one of the most poetic of his self-

LEFT:
Co-ordination 1976

Etching
Edition 30
24 x 25 cms

BELOW:
Fear Itself 1976

Screenprint
Edition 75
46 x 54 cms
Printed by Coriander Studio
Published by Ruby Editions

referential images. Less an off-shoot cast by an object, here the shadow is substantial and an equal object of representation intimately tied to its source. The shadow stands as counter-point to our own self and underscores the circular nature of our fears of betrayal.

Ultimately the rainbows became a myth and for all but the most ardent followers of his wider work, his name and that of the rainbow became interchangeable. Hughes has been markedly consistent in his formats. From 1961 to 1979 he painted with household gloss and enamel on hardboard, and from 1965 to 1985 the dimensions of his pictures were almost invariably three by four feet. Geographic changes have had little impact on these recalcitrant invariables. For some artists a period spent in the windswept beauty of St. Ives in Cornwall, where Hughes lived for a time, would have had a visible influence on their art. Nearly the only trace in his work of what he refers to as "lonely Cornwall" is *On Reflection* – a wonderful painting distinguished by its provenance because Hughes found the larger and reduced sailboats that make-up the picture at a seaside tourist shop so typical of the location. He did begin to paint with gouache on paper in New York while living at the Chelsea Hotel, in order to work quickly on pieces that were easier to transport. And later, Manhattan's ordered chaos in its grid of skyscrapers became a repeating subject in Hughes' isometric representations that continues today in the sticking-out pictures. Patrick Hughes is always very willing to take chances and when he does he remains steadfastly loyal in his newly formed allegiances. Angela Flowers admits that he did so when he agreed to open her newly formed gallery with a show of his work in 1970, and there he remains nearly thirty years on. Equally, the rainbow was a friend and format to which Hughes was loyal and he is still enamoured of its prismatic wonder. Eventually though, he believed he had to wean the public off rainbows and on to something else. In a way, Hughes felt that their joke was not funny anymore, even if the audience was still laughing.

To a large degree the joke satisfies Hughes' lust for the arranged. As a form, the joke is a small thing that explodes showering the recipient in surprise that opens the way for insight. Hughes' jokes are more complex and knowing,

LEFT:
Self-reference 1973

Etching
Edition 45
79 x 59 cms
Printed by the Print Workshop

RIGHT & BELOW:
On Reflection 1978

Mixed media
122 x 244 cms

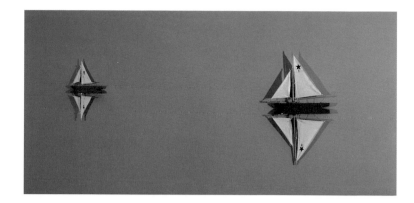

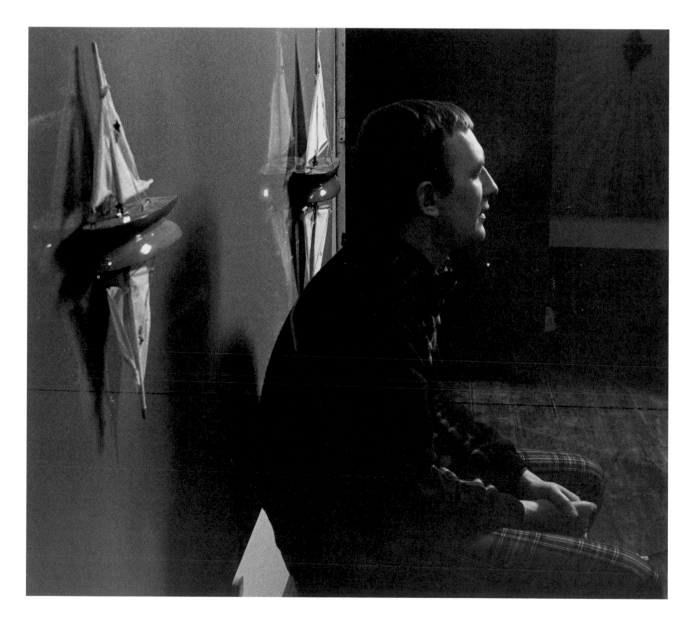

particularly about the conditions of representation, than may appear on initial impact. As a child, Hughes would watch his grandfather James Watson plant seeds in the garden. After he was finished with the planting, he would then plant the seed packets. "To my eye," says the grandson, "the naive gardener planted pictures of flowers." *Hope* recreates this scene from his grandparents' plot in Crewe. Hughes painted pictures of three seed packets floating on a white ground and then stuck real twigs through the canvas and seed packets as a reminder of the special relationship between reality and the representation. This relationship provided a way out of the self-sprung trap of the rainbow for Hughes.

My Sun's Holiday proposed an oblique view of the sun as it rested its rays against a night sky in the right panel of this diptych and against the day on the left, just as the rainbow had earlier. The round sphere of the sun is seen as an oval and from the side as it follows the tilted juncture of the sky and earth along the horizon. Hughes shows the sun in a forced perspective native to the theatre set. The spoked sun rests there as if he had reached into a flat picture of the daytime sky and cut it out, borrowing its

Hope 1982

Acrylic and wood on canvas
91.5 x 122 cms

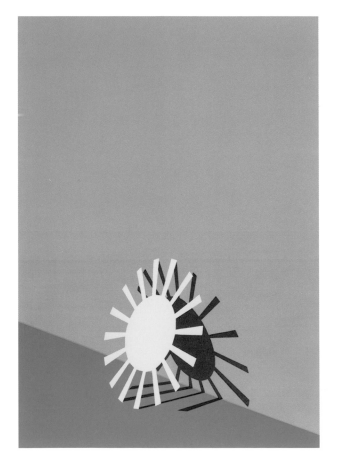

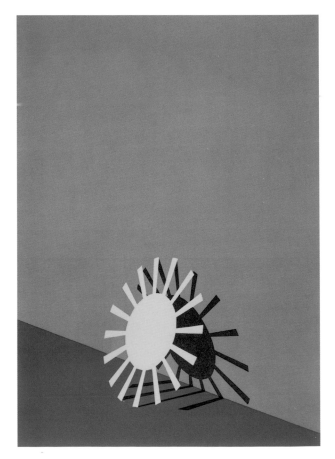

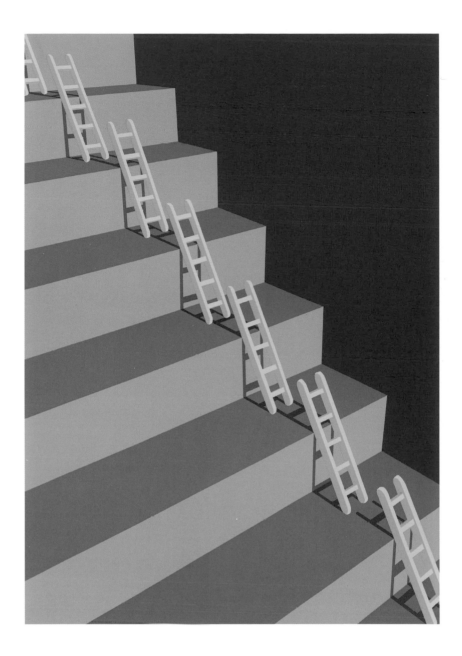

LEFT:
My Sun's Holiday 1980

Screenprint
Edition 150
55.5 x 76 cms
*Printed and published
by Coriander Studio*

Steps and Ladders 1981

Screenprint
Edition 200
76 x 57 cms
*Printed by Coriander Studio
Published by Coriander Studio
and Thumb Gallery*

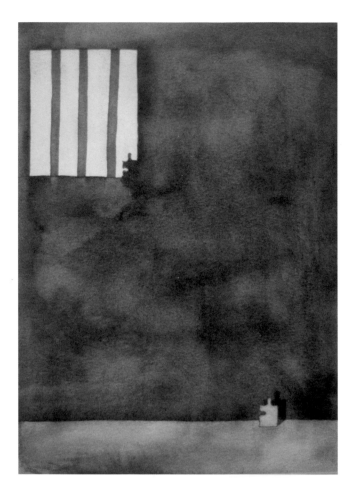

Prison Jigsaw 1986

Watercolour
28 x 20.5 cms
Private collection

Escape 1986

Watercolour
20.5 x 14 cms
Private collection

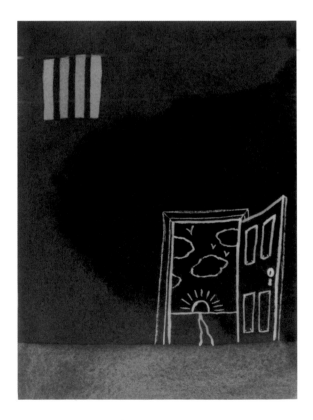

shape for his own tilted re-presentation. *Steps and Ladders* is an even more significant spatial representation. In this picture Hughes makes use of a variation on Schröder's steps – a long-standing and straightforward rendering of concave steps which becomes ambiguous in our mind's eye. The eye prefers simple solutions – with pictures or objects of this type, the inverse or convex image in our mind is more stable than their actual concave form. This ambiguity is partially concealed in *Steps and Ladders*. As with his use of the straightedge to pin down the rotation of the Necker cube in *The Space Ruler*, here Hughes uses the ladders to partially fix an outward edge of the stairs. If we ignore the ladders with their substantial shadows and implied three-dimensional form and fix our gaze on the stair's junction with the wall, Hughes' stairs reverse their stable and more probable shape, offering us a vertiginous view from an opposite angle and above. With stairs and ladders, the way up and the way down are one-and-the-same – just as the ambiguities of representation were for Hughes the way in and out of the rainbow.

All pictures are in a sense self-portraits and on occasion Hughes referred to his rainbows as such. There he was discarded and in jail, pushed through a letter box and hung out to dry. Hughes is very critical of his own work and he knows when it connects with his original ideas and is right and when it is not. There was a period in the early eighties when he was, as he says "tunnelling". Mining is a metaphor he uses for what he does – like a miner digging for coal, Hughes is a miner surrounded by contradiction. In this dry period, he could find no vein and was simply tunnelling on. During this crisis in his life and work he reached out for change. Until then, each day he had sat on a typist's chair at a white desk in a white room with a small sketchbook and a black biro and pondered ideas of what to make. He would wonder his way through variations until he had worked it out and then he executed the piece. It was a long and lonely process that took-up much time and subsequently created a limited amount of work.

Change came with watercolours – significant not so much because of the new format and media, but because of the speed and routine the watercolours brought to his day. These watercolours are more autobiographical than the rainbows. At his best Hughes would do about three a day. He would work out an idea, draw it out in pen and ink and then colour it in. If it worked, he would make a frame for it. Hughes' watercolours are deeply involved in exploring the communicative power of the sign. Emasculated telephones, hearts broken and barbed, and life belts cast adrift fill this body of work with an optimistic skepticism towards human expression. *Buried Cross* shows the inability of the sign to shake free of its signifying act even when going underground. *Prison Jigsaw* is part of a long-running suite of watercolours that isolate the gap between that which falls inside and outside of the scope of language, communication and representation. *Key in Jail* is lost, lonely and separated from its lover the keyhole. *Abstract Jigsaw* is perfectly arranged and yet fluid space that nods to Klee's *Highways and Byways*. *Escape, Ghost on a line* and the shimmering mirrored return of *Boat*

Buried Cross 1986

Watercolour
20.5 x 28 cms
Private collection

show Hughes at his quick-witted best. After Hughes had made a hundred watercolours, he turned his studio into a gallery and his bedroom into a bar and showed them – they were well received. This way of working freed Hughes from the tunnelling. He had found a way of getting ideas out quickly – it was a return to the way he had worked as a student and it was fun again. In itself, this would be significant enough, but the watercolours initiated a greater turn in his work. Space and perspective came through strongly as in his *Shadow on stage* and *Book Door*. Evidence of these

developing interests is even more pronounced when viewed in a piece from the same period executed in another medium. *Moonlight Askance* borrows its technique and image from the sentimental scenes offered in paint-by-numbers kits. Hughes twists this Pop art standard giving us a 45° view of the image as we stand directly in front of the flat canvas. A real light source takes the place of the artificial glow of the moon – its cord dangling out from the white ground against which the image turns. It was through the watercolours that Hughes realised he had the ability to fully exploit the sticking-out space upon which his work of the nineties turns. After the period from 1985-87 when he was doing the watercolours came a looser, freer

Abstract Jigsaw 1985

Watercolour
15 x 28 cms
Private collection

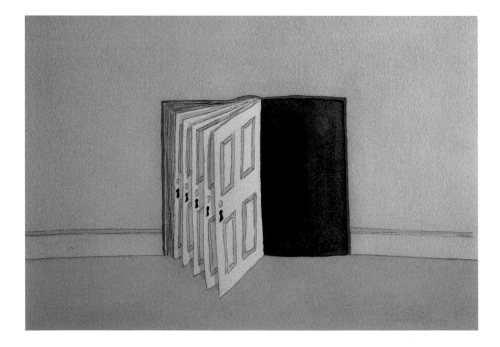

Book Door 1986

Watercolour
20.5 x 28 cms
Private collection

Hughes that showed itself in equally loose acrylics and oils on canvas. These more painterly pictures were still concerned with space and perspective and yet they could be, as he says "a bit daft." The idea was growing and Hughes was readying himself to feel his way through to the shapes.

When pushed to define the often exclusive movement over which he reigned, André Breton offered this notably inclusive statement: "Above all, what qualifies a work as Surrealist is the spirit in which it was conceived." With no mention of look, nor the technique in which such art is to be executed – this could be the template for a good working definition of art that deals with concepts and ideas as well. All art is in some degree conceptual. Art without ideas is as ridiculous as theory without practice – both propositions are destined to be in turns either blind or impotent. The role of both Duchamp and Magritte in the formation of conceptual art is substantial. What exactly conceptual art *is* remains a distraction for both its supporters and detractors. Hughes is neither – he is for an art of ideas. While they were living, Marcel Mariën and Meret Oppenheim were the artists he singled out as the greatest. Both Oppenheim and Mariën – Magritte's youngest confidant and collaborator – were artists of independent minds and an intelligence that could stand without any recourse to theoretical justification. In writing about influences on Hughes, I take it as a given that the concept of *influence* in no way explains everything that shapes an artist and their work. The methods of traditional art history exaggerate the importance of influences, as if to suggest that a general law could be designed to chart the evolution of an artist along a path marked by conformity and departure from cited references. Thankfully things are more complicated than that. Hughes put it best when writing about the influence of Magritte on his work: "My work has never looked like his. I do not particularly like the way Magritte's pictures look: I like the way he *thinks* and *imagines*."

Moonlight Askance 1985

Acrylic on canvas and electric goods
122 x 91.5 cms
Collection the artist

Marcel Mariën L'introuvable 1937

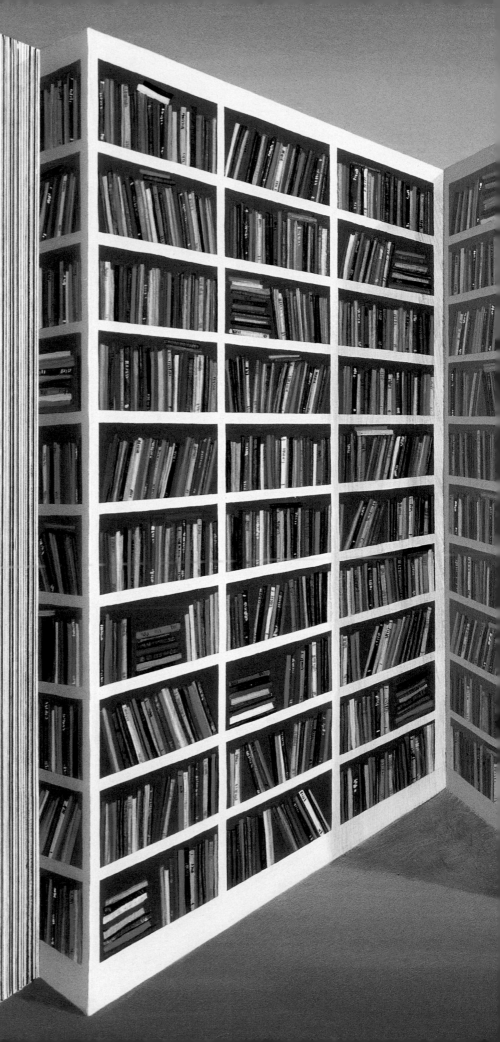

FROM SAYING TO SHOWING – PATRICK HUGHES IN THE 90'S

In his writing, Walter Benjamin characterised surrealism's moving spirit as an aesthetic attempt to transmute time into space and to transform the inevitable flux of history into a world of mystical presents. While *in* time, a person is determined to be just who he or she is, or has been. In *space*, the imagination can move and spread out in all directions, offering the single self a variety of options to explore. Surrealist space presented Benjamin with an ideal source through which he could exercise the *art of wandering*. It was in following the ghost of Baudelaire – one of the progenitors of surrealism – through the streets of Paris that Benjamin was initiated into the secret rites of the *flâneur*, or visionary wanderer. Patrick Hughes is a *flâneur* who rarely has the need to set foot outside his studio – like books, his sticking-out pictures provide ample space in which to wander and wonder. Benjamin and Hughes – each a lover of the arcade – are as well, collectors of fragments in the form of aphorisms, quotations and lapidary phrases. Friends and contemporaries report that it was Benjamin's great ambition to write a book made up entirely of quotations and this Hughes has done in his collections on vicious circles, the pun and oxymoron. A collector of fragmentary objects – words, ideas, or even rainbows – acts to redeem the things collected by returning to them an intrinsic value lost or squandered by the utilitarian routine they may have fallen into. Walter Benjamin has never been an influence on Patrick Hughes or his work. *Wander* and *Wonder* – two words so near in orthography and very dear to Hughes made me reach into my own imaginative library for reference to Benjamin and the influence his writing has had on me. The confluence of surrealism's project of a transmutation of time into space taken together with the notion of a visionary wanderer – so complete in the life and writings of first Baudelaire and then Benjamin – provides the context in which the surrealist space of Patrick Hughes' sticking-out pictures operates.

Next to Murray McDonald, George Melly is the critic who has the longest-standing relationship with Hughes and his art. Writing in the late seventies, Melly described Hughes' art as it stood between the two poles of Duchamp and Magritte. He recognised that Hughes' work, like that of Magritte, was dealing with paradox. Where they differed was in their presentation, or how they offered paradox to the viewer. He rightly described Hughes' practice as one of presenting a "blueprint rather than a photograph of the event" which is how Melly interpreted Magritte's means of presentation. He went on to write: "In this, Hughes' conceptual approach towards the problem is closer to the Duchamp of the *Large Glass* than to the Magritte of *The Human Condition*." Melly's descriptive proposition was probably the most important statement on Hughes and his art at the time of its writing. In a retrospective view, one that takes in the Hughes of the sticking-out pictures as well as an earlier Hughes of the rainbows, vicious circles and infinity, Melly's statement allows us to witness a significant shift in the way Hughes communicates his paradoxical art. With the sticking-out pictures comes a reversal of Melly's descriptive proposition. Now Hughes' conceptual approach to the means of presentation is nearer to that of Magritte's *The Human Condition* than to Duchamp's *Large Glass*. What happens with this shift is that Hughes moves from *saying* 'this is paradoxical' to *showing* the paradoxical in a way that makes itself a manifest part of the experience of the

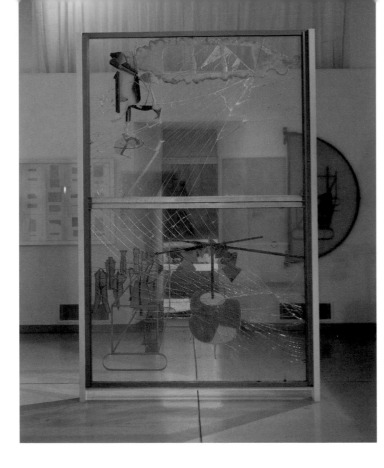

Marcel Duchamp (1887-1968)
The Bride Stripped Bare by her Bachelors, Even
(Large Glass) 1913-23
Oil and lead wire on glass
272.5 x 175.8 cms
Collection Philadelphia Museum of Art,
Pennsylvania, USA
Photography: Bridgeman Art Library, London/New York
© Succession Marcel Duchamp/ADAGP 1998

artwork. *Saying* may not seem that far removed from *showing* until you consider the difference between telling someone that you love them and then all the manifest ways in which you show them that this is the case.

In order to better grasp this distinction, let us look at the ways one received the *Large Glass* and *The Human Condition* implied by Melly's description and my own reformulation. Put in succinct terms: we <u>read</u> the *Large Glass* while we confront the <u>experience</u> of being in *The Human Condition.* Magritte's picture is an environment set in the familiar scale and mise-en-scène of the living room. But this in itself does not explain why one feels the overwhelming sense of being *in* the room and even more, why one desires to walk around to the other side of the easel to compare the scenes inside and out. To be fair, Duchamp's piece is designed for an entirely different effect and we cannot have the *Large Glass* as he fully wished. Duchamp intended to reduce the glass to a concise *illustration* of all the ideas included in the *Green Box* – the glass was not to be looked at for itself, but read according to the complete catalogue that Duchamp never made. This piece belongs to the definitively unfinished Duchamp. The *Large Glass* succeeds in spite of Duchamp's squandered intentions thanks to the reconnaissance and archaeology of others who have gathered up the fragments and redeemed the whole. Thus instead of a *picture* as we have with Magritte's *The Human Condition*, in the *Large Glass* we have a *delay* spread over a series of cross-references in books, reproductions and further documentation. With both pieces *the viewers make the picture.* But with Duchamp, the viewer regards the process of looking as a delay that interrupts and retards the acts of Benedictine diligence – all the reading, re-search and reference – that the piece requires. Still, it is the viewer who controls this delay. Magritte's picture, however, works in a different way.

Melly suggests through his statement that *The Human Condition* exists as a "photograph of an event". That the original painted in 1933 in oil on canvas is taken for granted and should not confuse us. This picture works as a photograph following the conventions that we bring to

it. The enigma of Magritte's image begins with the window. The window is a picture of a certain very real type – we stand inside looking out and we see through a pane of glass the world and its reality before us. A photograph has this same indexical relationship to the event or image that it 'captures'. All of this flows into the conventional assumption that a picture is a cage for the real. In Magritte's picture the scene appears to be both inside on the easel and outside in the reality beyond. In effect what we have here are three windows, or three pictures: a picture of a painting set in the context of a picture of reality that is framed by the window.

The window is Magritte's metaphor for the ambiguous nature of representation. But in itself it is just that – a floating metaphor and a dangling modifier of the picture. What animates this metaphor is his artless descriptivity in the painting of the scene. Magritte's technique is that of an *illustrator* – remember Duchamp's intention to reduce the glass to an illustration. Magritte uses illustration to harness the force of the real – there is no flowery ornamentation, nor trappings of painterly style to get in the way between ourselves and the scene. Illustration imbeds an idea in an image and it is this feature which provides the possibility of a metaphorical re-description of the scene. We believe in the picture and its setting both inside and out – so much so, in fact, that we would gladly step in and enter the room to confirm our assumptions that the tree is really there. That the tree concealed behind the canvas is also a painted backdrop speaks equally to the paradoxical nature of our human condition and of representation. We see the world as being outside ourselves through a mental representation of this experience on the inside – this is the conceptual model, or the idea, of *The Human Condition*.

These two teasingly enigmatic pieces stand as the sphinx-like calling cards for their respective artists. The distinction of both works and artists rests in their uniqueness of thought. Duchamp's piece is no less an attempt to sandwich reality between two panes of glass, just as the earnest painter or photographer believes they can do. The crucial difference lies in how one decides to present the mysterious found in the world before a viewer. Like Magritte, Hughes makes use of the real to access the sur-real. Hughes is not a fantast – the world is already wonderfully paradoxical and mysterious as he finds it. The challenge in the sticking-out pictures is to re-present that wonder in the most direct and inclusive way possible. Hughes says, "The funny thing with being short-sighted – I don't like really big surprises. Because in a short-sighted world, one that in a way I still inhabit, the world is already full of surprises." To embrace paradox is to see reality from different angles at once and to keep all the conflicting options open, as Hughes does. In surrealist space – the kind travelled by Benjamin through the streets of Paris and that offered to the wondering wanderer by Hughes' sticking-out pictures – one must expect the unexpected.

René Magritte (1898-1967)
The Human Condition 1933
Oil on canvas
100 x 81 cms
Private collection
Photography:Bridgeman Art Library,
London/New York
© ADAGP, Paris and DACS, London
1998

Hughes' shift from saying to showing is in effect a honing of his communicating idiom. Earlier his works stood as icons full of words and signifiers – they were loud whereas the sticking-out pictures possess a captivating silence. The metaphor was a flexible and compliant voice and it provided Hughes with a wealth of ways of *saying* 'this is a vicious circle'. With his shift of idiom, Hughes has moved away from relying on metaphors to create meaning and act as signs or signifiers that point to the paradoxical. He now creates an experience of paradoxical reality itself. "I have found a way of giving a paradoxical experience rather than a paradoxical lesson. Not everybody used to get my paradoxical lessons," says Hughes. "But I think most people get my paradoxical experiences."

Metaphor still has an important function in Hughes' recent work, but it is more a generalized *spatial metaphor* of movement between inside and out. The libraries, mazes, arcades, and vistas *can* be read as metaphors, but this is optional and at the viewer or seer's discretion. Hughes is interested in the relationship between these things – not the maze itself or even the search for a way out, but the unsayable experience of the maze as a journey through space and time within a picture. "The thing I've come to realise is I'm not really interested in libraries or mazes or arcades and, come to think of it, I'm not *actually* interested in perspective. My real interest in the end, what I find sublime, is the flux and the flow of it all. The library and the perspective are just means of enabling the strange relationship between the spectator and the picture – that state of flux. I love the ineffable part of it, the motion and the movement – the reciprocal relation like there is between people having a conversation. That's the interesting thing – the dialogue. I'm not ultimately interested in skyscrapers or picture galleries, they are just means – not necessarily to an end, but I would rather say to a beginning. The beautiful thing to observe is when people

The Exploration of Space 1988

Oil on canvas
91.5 x 122 cms
Collection Angela Flowers

Bedroom Tragedy 1989

Oil on canvas
91.5 x 122 cms
Private collection

are looking at them and moving and, I suppose, thinking and wondering."

Subsequently the sticking-out pictures have no reducible meaning. They are not about libraries, and mazes and doors – they are a meaning in themselves. They possess meaning through their link to the world of movement and this link is supplied entirely by the seer. Like the room with a window at play in Magritte's *The Human Condition*, the space in Hughes' pictures is a fictional space that draws on the familiar scale of the rooms and world that we inhabit. The metaphors that we fill these spaces with are our own. We carry a bundle of experiences with us when we enter the sur-real space of Hughes' sticking-out pictures: experiences of seeing the world and its movement, of viewing art and moving through the space of a gallery. These everyday and worldly experiences – the conventions which we amass around our experiences and then the interpretations we build from the resources of both – are in operation as we creatively see one of Patrick Hughes' pictures. As a model of vision and the workings of the mind, his pictures demonstrate that much of our life is taken up with an interpretative guessing game. Surrounded by movement, motion, flux and change we fall back on safer, more stable assumptions about the world and our place in it. Hughes shows us another world where the mind and body are one, where vision is whole and imagination is allowed to inform our bodily sensations. As his pictures show us that the opposite of what we may assume is in fact the case, they remind us that we *do* have the ability to change our minds and, perhaps, everything else.

top of
easel..,
showing

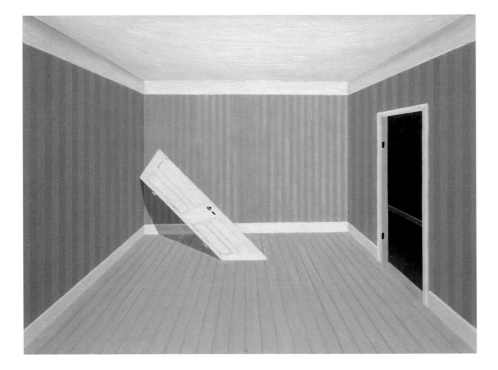

Self-Criticism 1988

Oil on canvas
91.5 x 122 cms

A group of fine pieces document Hughes' transition from pictures predicated on words and saying to the silent invitation of surreal space. These pictures are the hinge that swings between his first sticking-out room, then *Infinity* and now his current work. *The Exploration of Space* combines the perspectival lines of rails leading off towards the horizon with the illusion of substantial space found in the sticking-out room. A gilded frame sets off the cubic space of the far room within the picture while the floor boards tease our eye and lead us in as we reach out for the door. These pictures are flat and rendered in oil on conventional canvas. The sensation of space and depth in these images is entirely an illusion based in perspective.

In *The Bedroom Tragedy* a family of doors peer into a bedroom aghast – the room's window has come down off the wall, but being a resilient bedroom window it maintains its picture of the nighttime sky. *Self-Criticism* depicts perhaps the most cogent criticism one can place on oneself – that of failing to adapt to changed circumstances. A door, appearing to be shown in forced perspective, has come off its hinges and now rests against the far corner of the room. It retains its shape as if it were still set within the perspective of its hinged frame – if we could cut it out and put it back on its hinges it would fit perfectly into the picture without being forced.

These pictures are poetic and metaphorical just as Hughes' rainbows and watercolours are. The difference is that they draw on spatial metaphors to elaborate the poetics of space. Vision and visuality became a great interest for Hughes around the time of his increasing involvement with space. The lines of perspective neatly connect space and depth to vision. *Some People See Things Differently* is an attempt to show exactly that. A keyhole's shape delimits the scope of an eye as it peers in showing the monochrome view offered by this monocular act.

Such pictures pointed to the direction Hughes was taking as the eighties turned into nineties. Still, these pictures were wholly flat paintings that drew on the lines of perspective to animate their two-dimensional picture plane. The sticking-out pictures are something very

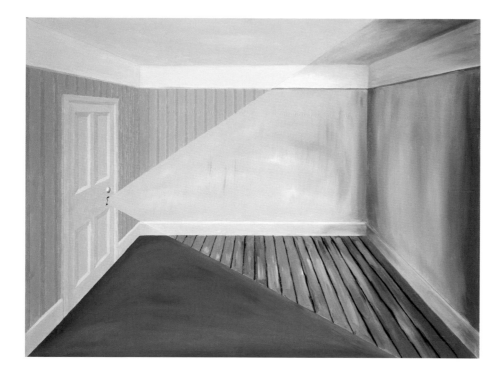

Some People See Things Differently 1989

Oil on canvas
91.5 x 122 cms

different. They work largely because we see them as pictures that hang on walls set within the context of a gallery. We view a window set within a room in much the same way. But as a form, Hughes' sticking-out pictures are closer to sculpture than painting and as we interact with them, as we move about and negotiate the space we share with them in the gallery, they function more as installation than anything else. What Hughes' sticking-out pictures are is an open experience with limitless possibilities. Meaning in these works is no longer a given residing or waiting in the object or artwork until discerned by the more or less perceptive viewer. Meaning is made by the seer and animated through the moving encounter of the experience as it takes place *in space* – both that of the gallery and that offered in the picture.

This type of surrealist space is not without precedent. Imaginary wanderings through time and space can be offered in many forms – from the architectural drawing and existing architecture to city streets and country lanes as well as an installation. The form is not the crucial component – imagination is. Max Ernst constructed similarly open-ended opportunities, where anything could happen, in his collages and overpaintings. *The Master's Bedroom* is a wonderful place to spend the night. As we follow the lines of the floorboards we are struck by the incompatibility of what we see and what our vision already knows – the scale is all askew. Ernst has collaged his found images onto the perspectival ground of the bedroom. The point of this enterprise is to show that one may expect the unexpected and also use any means necessary to realise as much – even if it means getting it wrong. Giorgio de Chirico's metaphysical paintings had a profound impact on Max Ernst and his work. When René Magritte first saw the displacement of de Chirico's forced perspective it reduced the artist to uncharacteristic tears. The surrealist space of Patrick Hughes' sticking-out pictures extends these traditions in novel directions.

The history of modernism can be viewed as an attempt to mitigate against a long series of diametrically opposed poles – elite and popular, high and low, art and science, avant-garde

and kitsch, and individual versus mass production. These poles are a mirror reflection of a primary gap felt between the province of art and the social space of life. Part of the project of modernism was occupied with an attempt to close this gap. Ironically, this aspect of modernism's larger "unfinished project" is in some measure now realised in this indeterminate period we call the postmodern. Patrick Hughes belongs to this wider tradition of a blending and bridging between the high and low, interior and exterior, surface and substance, and art and science. Spanning the modern/postmodern divide, this is a realm of tradition where solid and firm categories melt away and become less the branded labels that lead us through a supermarket of compartmentalized cultural consumption.

Hughes is a populariser and his sticking-out pictures, like Duchamp's readymades, challenge the basis upon which we distinguish the world of art from all that lies outside it. The populariser is held in dubious regard even at the end of a century that in a large measure has been shaped by their significant efforts and substantial accomplishments. We both desire their cultural production and doubt its authority due to their cross-disciplinary mix of high and low and art and science. Hughes' art is part of a wider historical and cultural context that emanates from aspirations to return art and science to its source in the life world. This mixture of art, science and life includes work as diverse as Arthur Koestler's popularizing efforts, the surrealists' lust for research and theory applied to the forces of life, and the *lebensphilosophie* and critical and cultural work of artists and thinkers centred around Vienna at the start of this short century. In contemporary art set free from the domain of the specific medium, this mixture is perhaps its only overarching characteristic.

Wheel with Wheels 1970

Mixed media
12.5 x 12.5 x 12.5 cms
Private collection

The mix of social, scientific and critical theory let loose in the context of the popular is what makes contemporary art at times so compelling and relevant to life, but also such hard work. As an artist and thinker, Hughes belongs equally to the world of art and its ideas and no less as well to the topsy-turvy world of popular images. Hughes' art is part of the excitement of the fairground – a place where science, art, and entertainment create a spectacle of wonder for the viewer. His is a popular open-air gallery where the early motion studies of Eadweard Muybridge hang alongside Max Ernst's

collages of juxtaposed images found in the surplus of popular scientific journals from the Victorian age like *La Nature*. Duchamp's rotoreliefs spin there too – not far from the hall of mirrors and very close to the pleasure dome. Hughes' own sticking-out pictures operate very near the space reserved for the strongman in Magritte's *Le mouvement perpétuel*.

Our cultural memory of such fairground wonder and entertainment is now dim and nearly lost. Virtual reality may leave us cold, but surely with imagination we can relate to the wonder felt by those first witnesses to the movement of the zootropic illusion and the depth of the stereoscopic projection? Perhaps not. No doubt today we can hardly believe that a fifteenth century Florentine would resist his wife's summons to bed with the rejoinder "Oh, what a sweet thing this perspective is!" For us, film is a more resounding metaphor of the wonder that comes from a fusion of art, science, entertainment and the movement of life. Moving pictures, movies and even talkies started their life as fairground entertainment and were dismissed as surely yet another passing fad. Patrick Hughes' sticking-out pictures soften our jaded exteriors and appeal to the wonder we retain within – we believe in their construction because to a large degree we have made them and *we* make them move.

The ironic result of Hughes' shift – from a strategy of mapping and making of paradoxical blueprints akin to those of Duchamp to the opening of surrealist space nearer to that of Magritte – is that Hughes ends up arriving back at Duchamp! This circular journey is sponsored by the viewer. In his lifetime, Duchamp let loose a number of statements on the division of labour in artistic production: "I sincerely believe that the picture is made as much by the onlooker as by the artist. Therefore the spectator is as important as the artist in the art phenomenon." And here, slightly more pronounced: "This aesthetic result is a phenomenon with two poles. The first is the artist, who produces, and the second is the spectator. Like electricity, there are two poles: the positive and the negative. The one is as indispensable as the other. I even attach more importance to the spectator than to the artist." Finally, in its shortest and most definitive form: *"It's the viewers who make the pictures."*

As noted, Hughes stands both with and against Duchamp. They share many interests: the viewer, vision, a fusion of art and science, erotic puzzles, a will to reconcile art and the people, and paradox and contradiction. Where they differ is over the instruction sheet. Many if not most of Duchamp's pieces require and include one. Those that do not are buttressed by an industry of critical literature. Duchamp's *Large Glass* indeed requires a book in order to function – Hughes' sticking-out pictures do not in any way, not even the text you are reading at this moment. The seer not only makes Hughes' pictures work, but has an equal hand in authoring the missing instruction sheet. Hughes met Duchamp during the elder artist's visit to London in 1966. The two spoke at a dinner to mark the occasion of Duchamp's retrospective at the Tate Gallery. After talking for some time Duchamp asked Hughes, "What do you do?" Hughes replied, "I am an artist." Duchamp delivered the punch line, "Oh no, not another one."

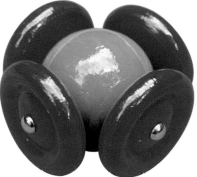

Ball with Wheels 1970

Mixed media
12.5 x 12.5 x 12.5 cms
Private collection

Circular Train 1970

Painted wood
30.5 x 30.5 x 30.5 cms

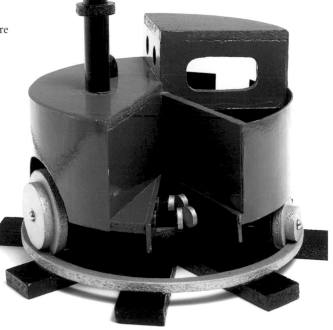

PERSPECTIVE STRIPPED BARE BY ITS CONVENTIONS, EVEN

The pane of glass that hangs in the window of Magritte's *The Human Condition* and those that make for Duchamp's *Large Glass* are linked with the work of Patrick Hughes through the system of perspective's own reliance on the pane of glass, the transparent vertical screen, and the window. For Magritte the window was an opening with the significance of the eye in the body – the point from which one experiences the world. The meaning of the word *perspective* in the fifteenth-century – the century which saw the birth of scientific or linear perspective – was "seeing through a transparent plane on which a scene is traced from a single fixed eye-point." If you hold your head very still and shut one eye, with a steady hand you can trace on your sitting room window a perfect likeness of the scene across the way. Perfect that is, as long as you admire your construction always and ever from the same point-of-view in which it was rendered – meaning also with one eye shut and your head very still. This is not a comfortable position in which to encounter art and not surprisingly, one rarely finds a visitor to the National Gallery striking this requisite pose before a Renaissance painting. Rarer still is the occasion to witness someone foregoing the snapshot of instant photography in order to capture a picturesque scene on the other side of a window. Reworking an illustration from a manual entitled *Perspective Made Easy*, John Baldessari depicts the empty and frozen act contained in the pictorial convention of establishing an eye level. The consequence of this convention is the rigid stance of the dead stare.

THE SPECTATOR IS COMPELLED TO LOOK DIRECTLY DOWN THE ROAD AND INTO THE MIDDLE OF THE PICTURE.

The window figure described above is generated by our contemporary understanding of perspective. This is an understanding that to a large degree is reduced and fossilized. Perspective *seemingly* does not belong to us. It is in the hands of ancient Florentine figures like Brunelleschi and Piero della Francesca, it is locked in the treatise of Alberti and frozen in the planes of Euclidean and Cartesian geometry. Perspective speaks to a world of order and certainty in science and logic where its formal qualities fill the sweet air of ideal cities and give shape to heavenly architecture. This is a Latinate perspective – *perspectiva artificialus*. It was designed and constructed to stand in contradistinction to older more humane forms of perspective – *perspectiva naturalis* or *communis*. Already contained in this ancient bipolar formula is the foundation of our modern understanding of the concept. At one pole we have a perspective that is a rigorously defined branch of mathematics. It is cold and calculated and the sum of various equations, points, lines, angles, and geometric operations. Such a perspective freezes and excludes the viewer and feels wholly foreign to the touch. A second very different perspective occupies the other pole. This is "our" perspective. And while the first could be said to be without meaning, this second metaphorical perspective is evident in the way we see ourselves and others' place in the world. It informs all our

John Baldessari
The Spectator is Compelled...
1967-8
Acrylic and photoemulsion
on canvas
149.9 x 114.3 cms
*Collection Robert Shapazian,
Los Angeles*

movements and positions, opinions and understandings – it shapes how we see not only pictures, but the world around us – our past, present and projections into the future. It is through this metaphorical perspective – one that indeed belongs to us and is of our own making – that we become ourselves viewing subjects.

The impulse to organize our understanding of concepts around such poles is a strong one. We take what is before us and split it along a razor's edge into two opposing camps that exclude any middle positions. Thus we are left with true and false, inside and out, near and far, native and foreign, or if A then not B. This will to reduce seems typically modern, but at the same time it is as old as perspective itself. The principle of reduction is a convention – a behaviour that is learned by force of habit. We hold such conventions to be self-evident and carry them with us everywhere we go – they are our prefabricated points-of-view. So when we approach linear perspective we give it a single birthplace in Florence and a designated inventor in Brunelleschi. We fix a Renaissance date and standardize its canonical method. The unity we see in this single act of discovery is governed by convention. That a few contemporary historians tell us that no unified origin of perspective was perceived in the Renaissance, or that Renaissance artists and writers saw a plurality of techniques available to depict space and depth where we now impose one is of little consequence. We have made up our minds. Enter Patrick Hughes. Hughes' perspective is a paradoxical perspective – it allows us to see reality from different angles at once and from multiple points-of-view while keeping all the conflicting options open. Rather than fixed and frozen, the seer is free to move, to wander and wonder through the surrealist space of his pictures. There the ruling convention is that one must expect the unexpected.

While the story of perspective belongs equally to the history of painting and geometry, its origins are tied directly to the study of optics by way of the visual ray. A reticulated network of light rays connects the eye with the object it sees. The rays of this network converge, forming a pyramid with its apex or point stuck in the eye. Western painting started to develop along optical lines first in Greece and it was through an association with the classical optics of antiquity that perspective absorbed its strong geometrical bias. Initially though, perspective emerged as a practical application of scenic art in the theatre of Dionysius and the plays of Aeschylus rather than a purely theoretical investigation. *Skenographia* was a term that covered any and all devices employed to regulate the effects of space between the observer and the thing observed – be it on stage, or in painting, sculpture or architecture. The ability of this practice to respond to the demands of elaborate scenic arrangements for the stage and produce convincing representations of interiors relied significantly on the central convergence of visual and light rays and the resultant single and fixed focus. Thus the practice of a scenic art returns to its home in geometry and emerges as a system of perspective based in and of interiors. Geometry, to follow, not only defines our understanding of perspective, it selects the subjects that it will depict – what better to show in perspective than other man-made objects defined and shaped by classical geometry? Geometry also wields a profound influence on our understanding of vision – through the visual ray geometry locates vision solely in the eye and centres visuality on a mechanical model made up of deceptively straight lines. But where exactly are these straight lines? The only straight lines are those idealized in geometry.

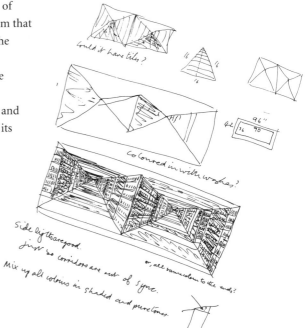

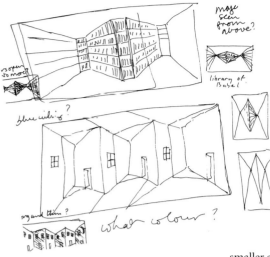

Perspective is a cultural artifact and a set of conventions. This said, one must also grant that these conventions are not limited in variety nor are they arbitrary in their invention – to omit these salient facts does as much violence to the concept of perspective as does the imposition of any other reduced point-of-view. Perspective is a construction based in verifiable observations: things do look consistently smaller as they diminish into the distance and given the apparent convergence of parallel lines into a vanishing point, it is possible to join these lines and unite the observer with that observed across the screen of the picture plane. Linear perspective was and remains an approximate translation of reality, or in other words – a lie which aims to speak the truth. We lose sight of the fact that while perspective is the child of classical geometry, it undermines two fundamental principles of Euclidean space – that parallel lines never meet and that congruent figures stay the same shape when moved. From such a vantage point it is hard to believe that a practical device used in the service of an art of representation could be conflated with a science hard and firm, and yet it has. Renaissance perspective, linear perspective, central perspective – these are its various names – is still regarded in dictionaries of art as the "scientific norm of pictorial representation." This has a strange nineteenth-century ring of positivism to it.

Ironically, the nineteenth-century is also the point at which we begin slowly to forget perspective and allow its living practice to become a fossilized memory. Perhaps the eyes of the observer grew tired from standing still so long, or maybe they were distracted by the apparent verisimilitude of early photographs. J. M. W. Turner is said to be the last modern painter fully literate in this ancient science or art. He was made a Professor of Perspective at the Royal Academy in 1807, but Turner was a reluctant teacher of his subject. His painting showed elective affinities to other highly developed pictorial traditions where spatial values are paramount. As the Western tradition of perspective flowed out of the interior, Chinese approaches evolved principally from the landscape of exteriors. The Chinese system of parallelism took for granted a "travelling eye" and while ignoring the optical principle of a convergence of receding parallels, such representations of buildings and landscapes allowed the eye and mind to glide freely from scene to scene. Turner himself exploited the qualities of aerial perspective based in the permutations of colour, light, and shade as perceived in the distance and density of the atmosphere. Like Turner, Hughes explores the visual effects of light and shade – both real and artificial – on colour values in the infinitely extended space of his pictures. This is a hugely significant feature of his sticking-out pictures and equally, one that can be lost in the graphic clarity of his illustrational style. Hughes' approach, like that of Turner, has little to do with rigorous and scientific techniques grounded in perspectival geometry. Both are artists immersed in full-bodied observations – contradictory and paradoxical as they may be – of visual, if not visionary, experience. In Patrick Hughes' art truth is in the making rather than contained in the scientific proofs of a ready-made system – it is observable and there in the world, but equally contingent as it rests in perception.

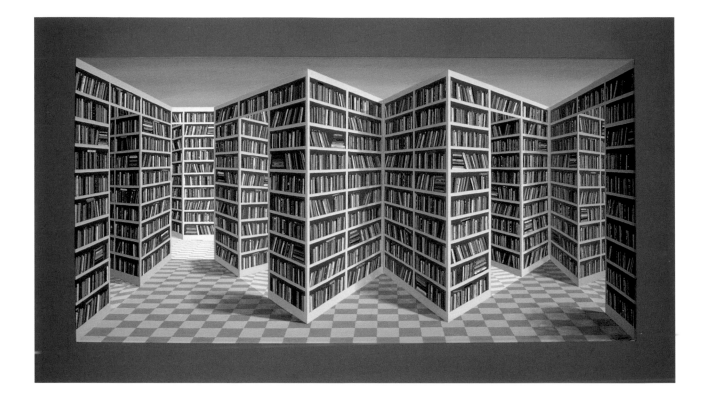

Paradoxymoron 1996

Oil on board
78 x 138 x 28 cms
British Library Collection

The camera and perspective share a special relationship – what holds for one is more or less true of the other. The camera obscura was present at Filippo Brunelleschi's discovery of pictorial perspective through his depiction of the Florentine Bapistry of San Giovanni. There the camera – or room – took its place among the long line of interior spaces from which linear perspective has emerged. The status of the camera and that of perspective are linked in dynamic ways. Both have at times been vaunted as an exclusive road to visible truth. In return, both have been attacked for their faulty claims of providing unique or privileged access to reality – it is argued that each obscures exactly what it pretends to reveal. The camera is a Pandora's box – one opens the back and instead of film, out jumps the perspective of geometrical optics. Rather than trace the fortunes of perspective along a plotted line of Euclidean geometry – or even its optics – one may better recreate the historical context of modern painting's estrangement with perspective through the lens of the camera.

The short story of the photograph is a metaphor for the long history of perspective. Each is a tale that recounts the rise and fall of technologies of truth. In the nineteenth-century a photograph was a "picture that never lies." It was linked to science and progress as it captured the visible light of truth. Today we look at a similar picture and doubt its ability to show us reality. A palette of painterly tools found in computer software has stripped the photograph of its analogue fidelity to truth and replaced it with what are perhaps the digital hopes for painting's future. The photograph has always had the ability to lie, but what frightens some is its ability now to do so deliberately while leaving little trace of its seamless acts of montage. This is one aspect of our skepticism. Another is our growing ability to look at photographs critically. All pictures are a framing or selection of reality – what a photograph allows into frame is as significant as what it leaves out. To look critically at photography is to recognise that the camera's way of seeing is shaped by time, accident and contingency. In this, the photographer's monocular view through the viewfinder is mirrored in the static point-of-view of linear perspective. Both are ideal perspectives – one built upon a lens that does not move and another on the static and staid position of a viewer.

As painting moved closer to modernism it began to look critically at perspective, asking questions not dissimilar to those we now confront the photograph with. Study changes our vision. Early modernist reactions to linear perspective were informed by a detailed knowledge of both its principles and its limitations. Perspective left too much out of the frame: the viewer, three-dimensionality, movement, binocular vision including the body, subjectivity, and all the psychological space of life irreducible to mathematics. The distortions, compressions and errors of scale in Cézanne's pictures are only seen as such by eyes habituated to the conventions of perspective. Newly opened naive eyes set free from the web of linear perspective can search for a vision uncorrupted by convention. Modern painting was indeed a child born of linear perspective, but it was an unruly one. Perspective's claims to truth and its mimetic competence raised painting to the point at which it could embark on a parricidal departure. The Cubist project can be described as an attempt to show everything at once that central perspective could not: movement, motion, nudes descending and violins frantically churning out atonal notes to accompany the shifting relationships of fractured planes. Whether viewed as a school-house revolt or a flight from the academy, perspective was left behind on the desk as artists reached out for the fuller stuff of life. Today demonstrations of linear perspective are relegated to the academic diagrams of art historical journals.

A truth – scientific or any other – is one that stands when tested from different angles. Photography fails to capture and communicate the truth of Hughes' sticking-out pictures, given that a camera only offers one fixed angle and a static point-of-view. Shown here in this

book in still photography his pictures do not move – they are trapped in perspective. To say anything original about perspective is difficult and it is even harder to teach such an ancient dog new tricks. But Hughes has done it. The surrealists realised the revolutionary energies that appear in the "outmoded" – theirs was an attempt to reverse decadence and aestheticism into an explosive force. This is the segue, or more appropriately the door, through which steps Patrick Hughes, a surrealist. Hughes walked into the empty classroom and picked up perspective as it lay abandoned on a desk and then reversed it.

Perspective – obsolete, discredited, ephemeral and neglected – fell into the surrealist cult of the found object like a relic deposited by the recent past. Baudelaire, Rimbaud, Lautréamont, Appollinaire – these were the French symbolist and decadent poets invoked by the surrealists on the road to profane illumination. Aestheticism favours the creation of art about art by stressing the self-referential dimension of aesthetic forms. Surrealists protected their art from spinning off into a solipsism of form – or art only for art's sake – by grounding the aesthetic moment in a regeneration of primal, or archaic experience. For example, the illuminating experience of spending a *Season in Hell* or a night in the *Master's Bedroom*. Hughes' sticking-out pictures, while distinguished by their substantial and repeating shapes, never retreat inward into a fetish of pure form. The focus of Hughes' art is not on these aesthetic forms in themselves, but on the relationship of everyday perception and experience to paradoxical movement, flux and change. This shift of focus turns on the redemption that Hughes brings to perspective. Like the collector who redeems a lost intrinsic value in fragmentary and discarded objects, Patrick Hughes restores a human dimension to perspective.

What relegated linear perspective to the ash-heap of outmoded practices in art was its inability to draw experiences emerging in the modern world into the frame of its system. The strange atmosphere that perspective breathed was not our own. The ideal city of modernist experience was made up of de Chirico's forced and fractured planes. His was a disquieting and very different view of the same Florence that Brunelleschi looked on at the time of his

Giorgio de Chirico (1888-1978)
Piazza d'Italia
Oil on canvas
25 x 35.2 cms
Collection Art Gallery of Ontario,
Toronto, Canada
Gift of Sam and Ayala Zacks 1970
Photography: Bridgeman Art Library,
London/New York
© DACS, London 1998

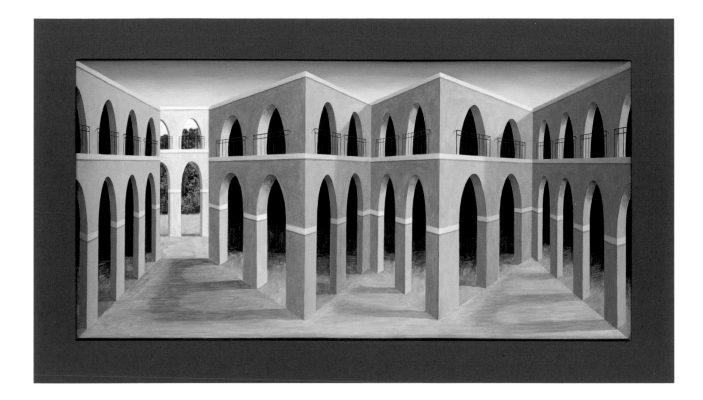

Hyperspace 1996

Oil on board construction
80 x 138 x 25 cms

discovery. Rather than order and coherence, de Chirico saw these same squares and arcades, the piazza and towers as incoherent and pointing to a world of doubt, uncertainty and multiple points-of-view. We live in space which is configured and mapped by perspective – it is as inescapable as the air we breathe. We negotiate our positions in this space through movement. A vision divorced from mobility and placed statically outside the body can hardly be said to be vision. Perspective – our own metaphorical perspective or any other – describes the relationship between an observer and the observed. In order for this relationship to be read there must be movement – just as your eye has moved from the opening words of this sentence to the point here at its end. Perception and cognition are temporal processes that depend on a dynamic amalgamation of past and present. Every viewing subject is first and foremost a historical subject that relies on memory and knowledge of previous positions and prior information when taking in the new. In this, time has a great hold on us.

"When you start attacking space itself, then you're attacking something very basic – something central to our perception of the world." This is Hughes referring to de Chirico's use of forced perspective in his metaphysical paintings. Hughes' own invention of perverse perspective is equally an attack on space, but also significantly on time. The aspect of time in his pictures is partly what makes their space so compellingly inviting. Pictures have their own temporal sense. In painting, the picture is not in "real time" – it is frozen in time, more or less as in still photography. We bring our own time to those pictures, but there is not much we can do with it other than put it on pause as we look at them. The cinema's moving pictures bring a different notion of time. Their narrative time flows from the past and unfolds before us in our present as the movie screen radically foreshortens the reality of clock time in its compressed flow of scenes and dialogue. Hughes' pictures draw on notions of time from both the cinema and still pictures with a novel twist. Rather than suspending the temporal dimension as still pictures do, there is time in Hughes' pictures as in the cinema. However, unlike the flow of time in film, in these sticking-out pictures the seer has control of the tempo and can adjust the flow of time through his or her movement. This displacement of time through the movement of space is a gentle surprise for the seer that emerges as they make these pictures work. It lends these works a temporality native to the dream that unfolds as the seer wanders through these vast fictional spaces.

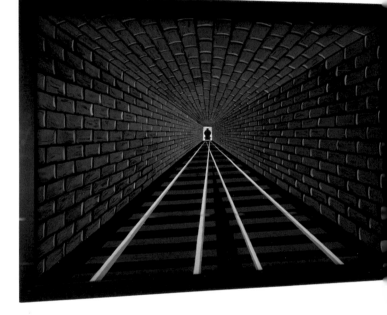

Up the Line 1990

Oil on board
112 x 142 x 53 cms

The question of how Hughes makes these pictures is intimately tied to another question – how do we make them work? In a sense these questions are one and the same. They share an answer that is comprised of three components – the paradoxical reversibility of perspective, shapes, and perception. These components are woven by the seer into a tapestry that is almost impossible to unravel while still retaining any sense of either the meaning of the individual strands or the totality of the original design. For the moment let us focus on perspective, mainly putting shapes and perception to one side. Hughes' unique perspectival system relies on the fact that his pictures are not made on a flat surface. The support, or what generally would be the canvas, is a three-dimensional wooden structure of truncated pyramids. This construction of angular cones is a series of trapezoids made in perspective – the geometry of

their peaks and troughs adheres to the conventions of linear perspective. Hughes then reverses this perspective in paint making the far points in the picture actually nearer than the near points which are farther away. "The basic perspective shape implies a stage very much. And I love forced perspective in theatre," says Hughes. "Half of my thing is forced perspective – that is to say something made in perspective. Then the second half is to make it the wrong way around. I do like the theatrical sense – it's a way of bringing clarity to things. It's a straightforwardness, a staging quality that is ambiguous but sharp. Ambiguity need not be vague."

There is a Heraclitian harmony to the dialectical joining of these contradictory systems as Hughes shows it is possible to affirm the validity of perspective through its inverse. Perspective – human, natural, linear, or artificial – is a very strong and resilient system. It is able to bend and flex without breaking under the weight of Hughes' application of relentless contradiction. At the same time, it is amazingly simple. Said as only Hughes could say it: "With perspective the lines meet up and things get smaller – that's all. It's really all bollocks. Only someone who has gotten it all wrong would do pictures like these." Hughes strips perspective bare of its conventions and creates a new set of rules that include a mobile and constructive viewer, multiple points-of-view and paradoxical motion. Disregarding the letter of the law, Hughes preserves its spirit in a more dynamic form. While his reverse perspective runs against the grain of linear perspective, it relies no less on its straight lines. "Every little line is another plank in the coffin of the observer. Every time I draw a line or plank, it leads your eye back. And as these lines build up they will drive you back and suck you into my web." This is the trap of linear perspective. Ironically, Hughes employs this snare to set the stereoscopic seer free in surrealist space rather than holding a monocular observer prisoner in a frozen stance.

Hughes' perverse perspective both affirms and negates the system of linear perspective while committing wholly to neither position. Philosophically it embraces the concept of an included middle and is neither this nor that. Like a fugue it is both at variance with itself and agrees with itself – such is its systemic harmony. A door in Duchamp's Paris studio at 11 rue Larrey held a similar position. A refutation of the Cartesian proverb – "A door must be either open or shut" – it was neither. When it closed one doorway another opened. The doors which turn in Hughes' pictures swing on the same perspectival hinge.

Marcel Duchamp
Door, 11 Rue Larrey 1927
Wooden door
220 x 63.5 cms
© Succession Marcel Duchamp/ADAGP
1998

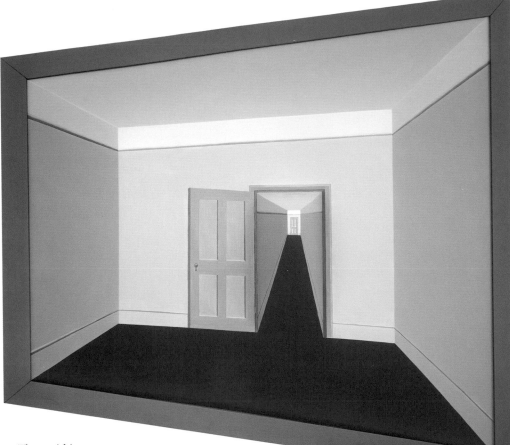

The vanishing
point of infinity was Hughes' introduction
to perspective and this spatial metaphor was the first resounding
form in his sticking-out pictures. It led to *Railway Line* – the first piece to realize the
infinity of the railway line with the actual space of his sticking-out room from 1964. Hughes'
techniques and strategies develop through his pictures, allowing one to follow this evolution
in the change of shapes and his handling of objects. This story in part belongs to changes in
the structure of the support, but a very large part belongs to colour and shading which are in
turn building blocks of perspective. His earliest works were flatter and showed a more
schematic handling of colour – as his work evolves, so too does his treatment of layers of
colour and shade. Hughes' work can be broken down into two main groupings: spaces that are
open and those that are closed. The closed spaces are interiors that have a cozy claustrophobic
quality of containment. Two early pieces that point to the promise of interior explorations are
Down the Corridor and *On the Easel*. These pieces show hints of the containment and spatial
juxtapositions so prominent in the later work. Open spaces are provided in pieces that blur
and blend the threshold between inside and outside. In these works the mind can turn and
open doors, or windows, take a passage through a maze, slide through a slot between
skyscrapers or presents and move between inside and out. The arch is a special case, being
neither open nor closed, inside or out – within a cloister one can stay perfectly dry and watch
the rain fall at one's feet.

Down the Corridor 1990

Oil on board
125 x 125 x 65 cms

82

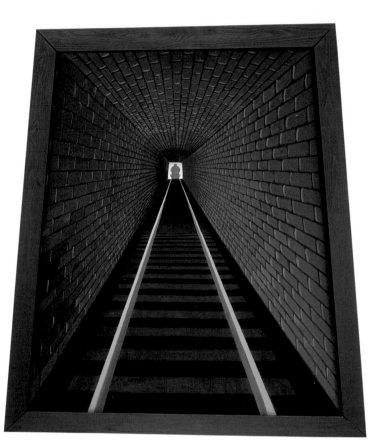

The Light at the End of the Tunnel 1990

Oil on board
126 x 115 x 40 cms
Private collection, USA

The Point of Infinity 1989

Oil on board
63 x 80 x 25 cms
Private collection

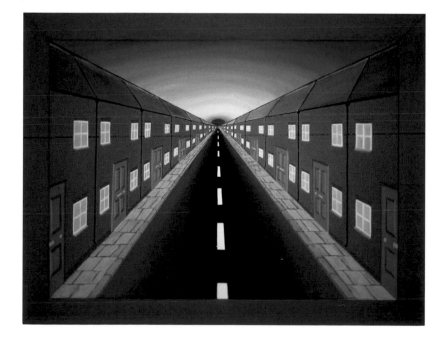

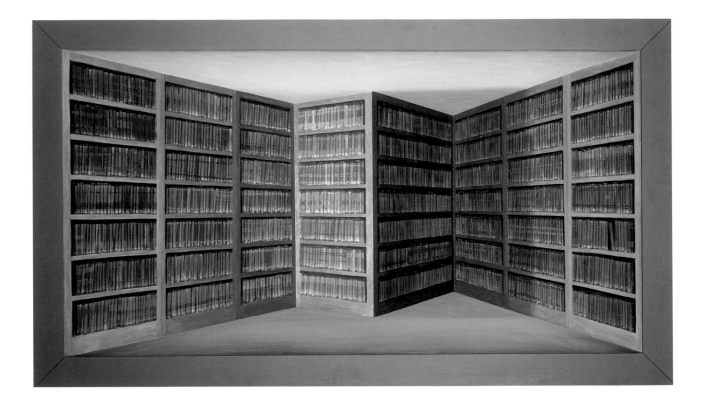

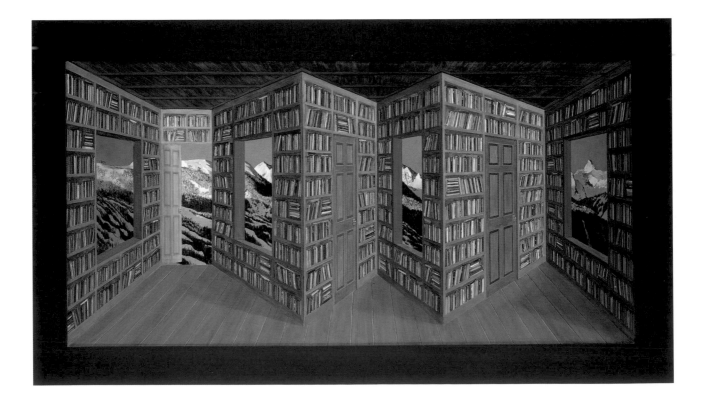

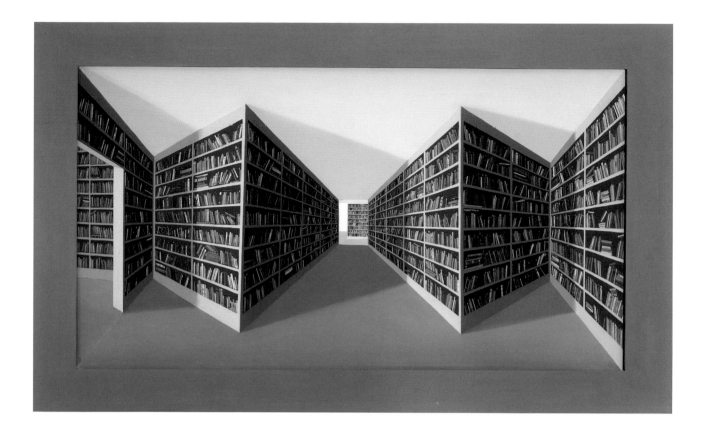

The library is the ideal closed space in Hughes' world. As a lover of books, Hughes has made a fetish of the library – it suits him well, both as a perspective device and a metaphor. Developmental changes to closed spaces like those of the library can serve as a metaphor to trace his journey in perspective. *Volumes* was his first and its shadows emphasise the depth of its shaped infinity while its dark and uniform colour reinforces the propriety of the neatly aligned and uniform tomes. Coming only a year later, *Reading* sees Hughes return to a play of figure and ground, with the bright colours of this library's shambolic holdings advancing against the receding depth of the greyish shelves.

Bibliophilia 1994

Oil on board
76 x 123.5 x 25 cms
Collection Time Out Group, London

LEFT ABOVE:
Volumes 1992

Oil on board
96 x 170.5 x 38 cms
Collection The British Council

LEFT BELOW:
Study 1998

Oil on board
78.5 x 139 x 25 cms
Private collection, USA

His growing ability to build depth with the play of light and shadow through colour is most evident in three works spread across an equal number of years. *The Present* with its deft treatment of early morning light was Hughes' first use of this metaphor for the gift of surprise. A spatial twist comes out of *Not Pandora's Box* where the top of the present actually recedes into the trapezoid out of which it grows. This provided a new challenge to colour and shadow. Psychologically the door is a way into and out of Hughes' interior spaces – in this piece it is the source of light and a remarkably simple prototype compared with the design of his most recent doors. *Doll's House* marks a turning point not only for its Magrittean juxtaposition of scale and blurring between inside and out, but also for its dramatic use of light. Edward Hopper is present in each of these pictures – from the Hopperish fragment of a landscape visible through the window in *The Present* to Hughes' increasingly subtle and adroit use of light to complicate the transition between interior and exterior spaces.

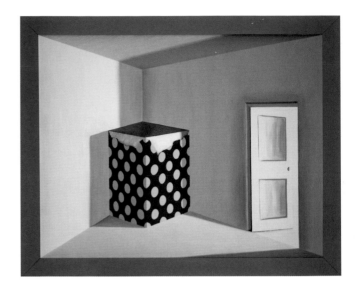

What is at work here is a question of competence rather than influence. As Hughes gained confidence with the growing complexity of his work and his handling of intricacies of geometry and perspective his pictures began to better exploit techniques which defamiliarize authentically perceived reality. As in the work of Hopper and in the pictures of Magritte, this feature draws the viewer into a role where they are active participants in the conception of the work. As if to celebrate these developing abilities, Hughes flexed his painterly muscles in a series of works that quote freely from the manipulation of perspectives, construction of stage flats and cinematic movement so evident in their Hopperly sources.

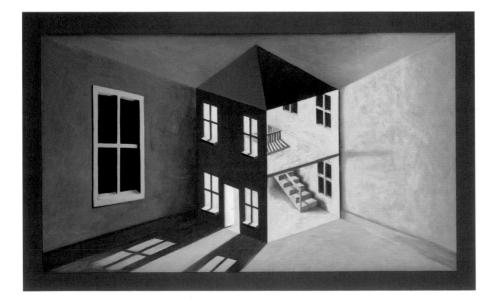

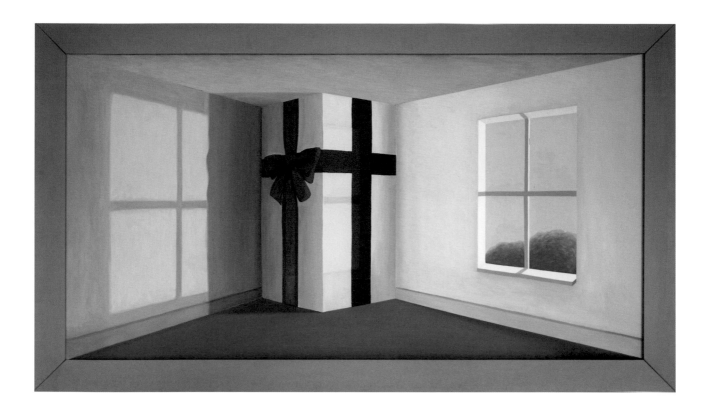

Not Pandora's Box 1992

Oil on board
125 x 154 x 35 cms
Private collection, UK

Doll's House 1993

Oil on board
124 x 203 x 25 cms

The Present 1991

Oil on board
104 x 180 x 35.5 cms
*Collection Capital Research &
Management Co., UK*

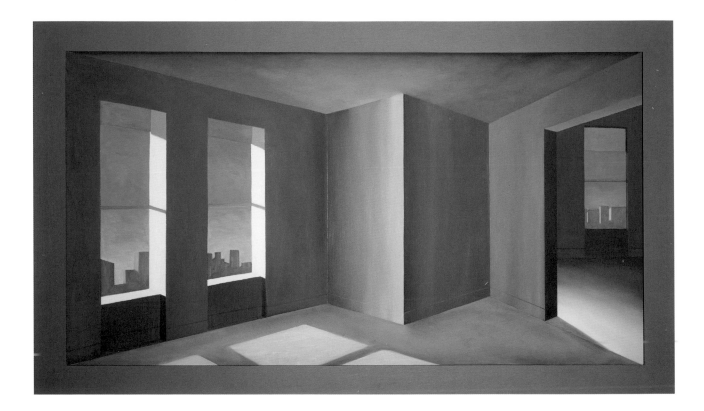

Blue Room 1992

Oil on board
109 x 187 x 22 cms
Private collection, USA

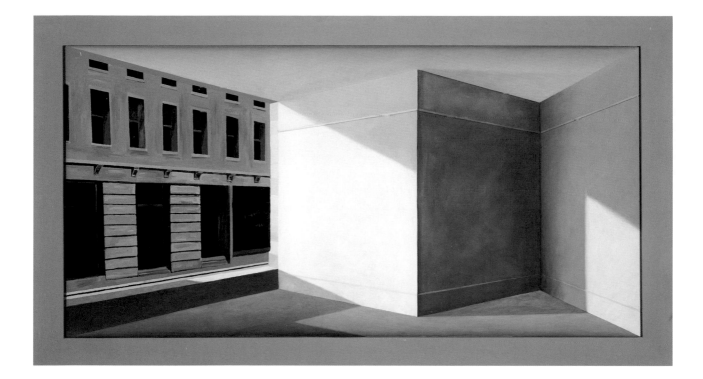

Hopperatic 1994

Oil on board
99 x 216 x 30 cms
Private collection

Already with *Blue Room* Hughes had begun to mix the atmospheric density of aerial perspective with parallel perspective to great effect. The Hopper series of pictures further develop these perspectival strategies with their amazing amount of fluid movement and gentle ease for a wandering eye. In this series the plane of a window or a wall is no longer a barrier, but a portal through which to move between inside and out. Their effect is great even trapped in the flat stillness of reproduction.

Hopper, Magritte, Mondrian, Cézanne, and de Chirico also take on a growing presence as Hughes collects and displays *images trouvées* in his pictures – the found images and cultural quotations of art and civilization. Like the mirror, the picture set within a picture is itself a perspectival strategy. The perspective of one is suddenly set within and overlaps the context of another. This is a form of overwriting that adds another layer of density to the perspectival text in a picture. The picture within a picture is also a further confluence of inside and out. Like *The Human Condition* it refers at once to our interior memory of an image and then, in an act of displacement, shows this memory before us hanging in reproduction. When Mondrian enters a picture the perfection of his linear geometrical system collapses in the movement of Hughes' forced and accelerated perspectives. We see his neoplasticist grids askance and set outside the safe confines of its closed system. Hughes says: "It's a way of saying, 'Mondrian is aiming to be perfect, but this is not a perfect world' – you may see a Mondrian from the side and he can't legislate for that. He can make it as square as he likes, but when you see it from the side – it is in perspective!"

Returning to the library reveals the depth of these developments in perspective. The books and shelves of a library lend a grid to the walls that line these spaces. This allows us to better grasp the contours of these rooms just as the pattern of tiles or lines of floorboards maps out a textured gradient before us. The textured gradient is the basis of all perspective – from the

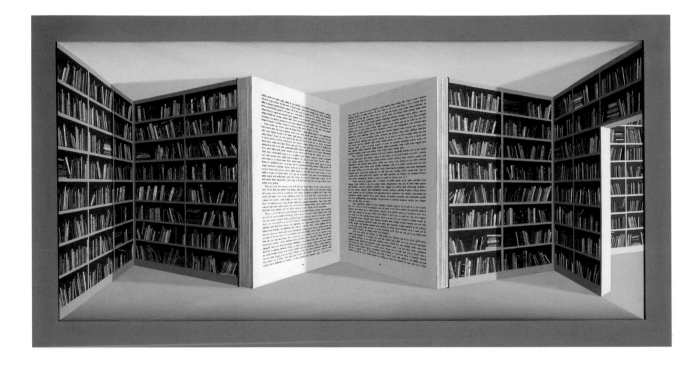

Open Book 1994

Oil on board
108 x 210 x 35 cms
Private collection, USA

clods of ploughed earth that diminish in the distance of a farmer's field to the precise geometrical map of Piero della Francesca's tiled floors. Seeing distance is the interpretation of such gradient clues. The library holds the collection of the perspectival clues that Hughes has amassed. Works such as *Open Book* and *Books with Pictures* show how he builds the evidence that convinces us of the depth of space in his pictures through occlusion and overlays, projected light and shadow. Looking closely one sees that these two eccentric libraries share the very same shape. The holes that suddenly break through these libraries and into the light beckon and invite us to visit the Magritte or Hughes retrospectives that hang in the rooms to the rear of *Little Boxes* and *Looking Back.*

Much of the flexibility and strength of Hughes' system stems from its simplicity. "Another aspect of geometry is my wonderfully simple device of the nail and string with which I come up with my diminishing ratios," says Hughes. "It's a very Egyptian system, my approach to forced perspective. It works because perspective is such a strong system. I've tried complex solutions. For instance you get a complex conclusion in regards to the bottoms – there is a real problem. If my bottoms were in perspective properly I would be able to check the bottoms correctly. But I can't and as a result I get those curves in the tiles of floors." This is where Hughes' system falls down. He follows the diminishing ratios of the ploughed field system as in *A Real Illusion* rather than the precision of Piero's tiles. "My pictures diminish, but they don't diminish correctly – they diminish as it is convenient for me to have them diminish! I believe in the underlying principle of perspective, but not in the letter of the law." Hughes adds, "My pictures diminish much too quickly. It doesn't really matter because the important things are that one creates an appearance of space and that this space appears to move relative to one's movement. Old-fashioned perspective appears to create space, but not as effectively as my method and it does not move at all. I am interested in the creative aspect rather than the correct aspect of perspective." Two pieces reveal the latest additions to Hughes' library. *Book Look* and *Study* once again share the same supporting structure, but offer different journeys. The closed space of the library has opened up to insistent vistas as if we returned to the space of *Volumes* and extended it to wander in the landscape behind its walls of books.

The plurality of perspectival strategies employed by Hughes leaves his system of perverse perspective ironically nearer the position of Renaissance painters who saw before them many available perspectives from which to draw. Hughes is an imaginative artist who uses all the resources at hand to restore a human dimension to pictorial perspective by fusing it with the natural perspective we carry with us everyday. The result is a picture that creates the opportunity of a truer, more real sense of space and movement than any other picture before – that is so long as there is a seer present to complete the picture.

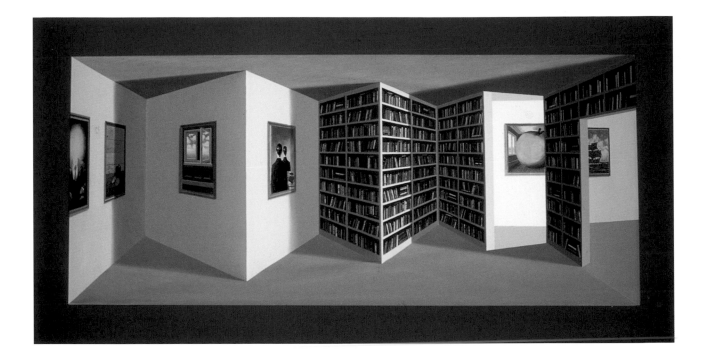

Little Boxes 1995

Oil on board
73 x 144.5 x 33 cms
Private collection, UK

92

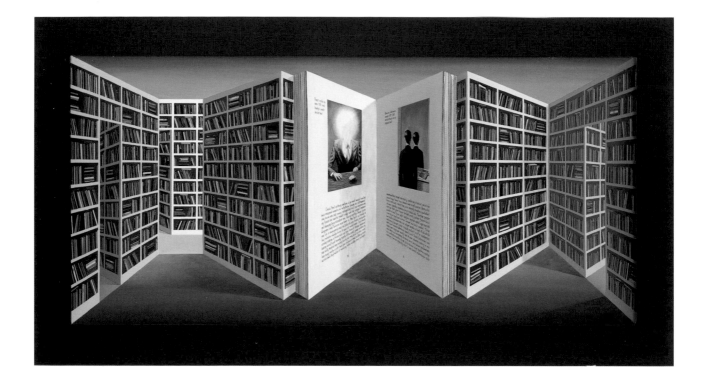

Book Look 1997

Oil on board
79 x 147 x 32 cms
Collection Cox Insurance Holdings Plc

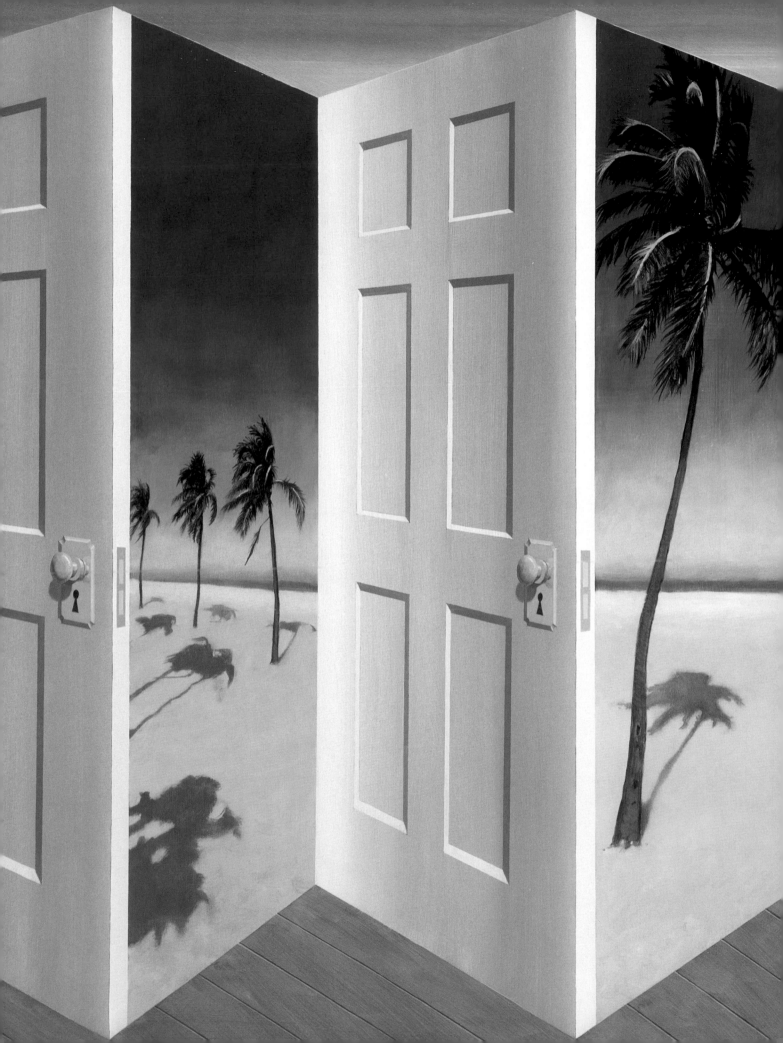

HUGHES' ANATOMY – THE SHAPE OF SPACE

While giving a slide lecture at a college, an art student once asked Hughes why, given that his structures seem to move and work when they are just white and shaped, did he paint all these things on them? The student's question was an intelligent one. Cold, white and set in an ideal geometry, his shapes share a description of minimalist sculpture as replaceable units in serial formation. One could easily imagine these naked shapes finding their way into any gallery that shows minimalist work. *Specific Objects* was a term fashioned to refer to minimalist art being made in the sixties that could no longer be described as either painting or sculpture. Such work was committed to a third way as it occupied a three-dimensional co-ordinate with all the other non-art objects in the world. Hughes' art shares the ambivalent position of *specific objects* as it gravitates somewhere between painting and sculpture while resting solely in neither camp.

Hughes' work is comprised of three-dimensional objects that are at once also painted illusions. This dual identity is contradictory in itself given the conventions of art. Conservative critics seeking to comply with these conventions refer to Hughes' pictures as "painted reliefs", which is technically true, but dull. The term leaves out their magic and charm, just as linear perspective left out the viewer. Hughes' pictures are paradoxes and like the strongest of paradoxes – the ouroboros, the Möbius strip, the hand drawing a hand drawing, or Magritte's *The Human Condition* – they exist in three dimensions. A more appropriate designation for Hughes' sticking-out pictures is as *impossible objects* given that the spatial information they present is self-contradictory. An impossible object possesses a two-dimensional representation that we interpret as a three-dimensional object.

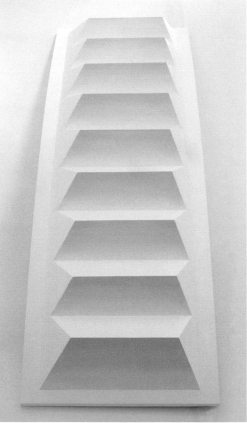

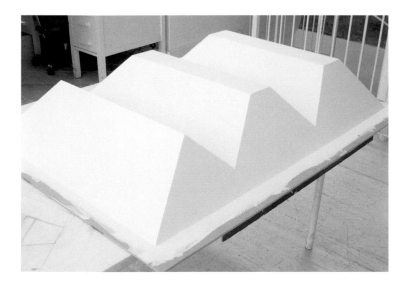

Simultaneously, we then determine that it is impossible for this object to be three-dimensional since the spatial information we have just taken in contradicts itself and our spatial knowledge of the world. An example of an impossible object is shown in Hughes' picture *Thanks to Jos de Mey*. The cuboid structure in this picture could not be fabricated as an actually existing three-dimensional object that adheres to the spatial information that it sends out. And yet we are convinced concurrently of both the possibility and impossibility of such an object in representation. The occurrence of impossible objects in art reaches back from the present to the eleventh-century and moves from the work of anonymous monks to that of artists as diverse as Piranesi, Hogarth, Brueghel and Duchamp.

M. C. Escher is the artist best known for his relationship with the impossible object and his drawings and prints have captivated the imagination of artists, scientists and a wider general public in the latter half of our century. Escher's metamorphoses and architectural renderings that blur boundaries between inside and out offer imaginative puzzles that illuminate the workings of vision, the mind and perception in a manner similar to the elaboration Magritte's work enacted on systems of visual and verbal language. However, in most cases Escher's visual paradoxes never move beyond their existence in two dimensions – they serve as a wondrous bridge that allows our imagination to take a three-dimensional journey in the mind. When I refer to Hughes' pictures as impossible objects I am playing with language, but so too are those critics who choose to call his works low reliefs. The term "impossible object" emphasizes my view of his work as a set of paradoxical relationships both within the picture and in the receiver's experience of the picture. "Low relief" focuses on Hughes' work as an art object embraced by the language of art history. It is useful in that it allows us to approach the reversibility of Hughes' shapes through the art historical terms of cameo and intaglio.

Like the choice of low relief or impossible object, cameo and intaglio are in a sense really only different words for the same thing. As a child, Hughes remembers: "Every Saturday for, I suppose ten years or so, I was given the job of cleaning these brass ornaments that my mother had. And there were one or two Peerage plates – pressed brass plaques made in three-dimensional low relief. The one I remember was a galleon in full sail. As I cleaned it, I only had to clean the full sail side, but I knew at the back it had, as it were, empty sails. And if you looked at it from the back in a certain light, it looked like a full boat with proud sails instead of a negative boat with empty sails." As the young Hughes twisted this object around in his hands he received a lesson in the reversibility of shapes. Interpreting concave and convex forms challenges the acuteness of our perceptual faculties. Faced with such a challenge, we prefer simple solutions and will gravitate towards the known. If given the option of choosing between cameo or intaglio images of the same object, the eye and mind will choose the cameo or convex over the concave or intaglio image. This can be demonstrated with the Peerage plate. A photograph of the reverse side of the Peerage plate belonging to Hughes' mother would show the galleon in concave or intaglio form. However, we would interpret this image of the galleon as cameo and convex. We see such images as convex because the concave option strikes us as improbable – much like the reversed view of the stairs that the young Hughes witnessed in the glory hole.

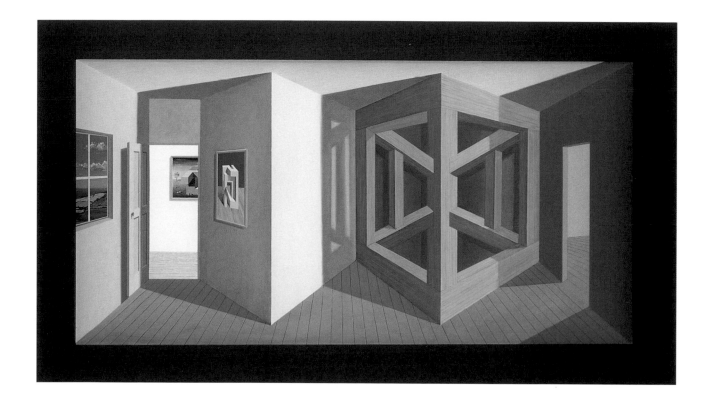

Thanks to Jos de Mey 1997

Oil on board
78 x 137.5 x 25 cms
Private collection, UK

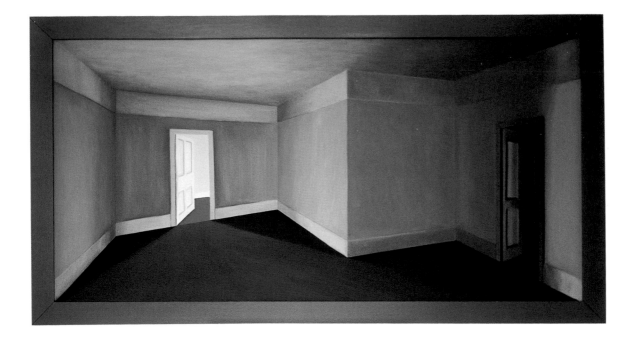

The L-Shaped Room 1991

Oil on board
84 x 158 x 31 cms
Private collection, USA

Ernst Mach, an Austrian physicist and philosopher of great influence on the Vienna circle, was to document this phenomenon in his *Contributions to the Analysis of the Sensations*, first published in 1886. Today Mach's name is preserved in the speed of sound as a unit of measurement. The experiment that he observed was the following: "We place a visiting card, bent cross-wise, before us on the desk, so that its bent edge is towards us. Let the light fall from the left. [...] We now close one eye. Hereupon, part of the space-sensations disappear. Still we see the bent card in space and nothing noticeable in the illumination. But as soon as we succeed in seeing the bent edge depressed instead of raised, the light and the shade stand out as if painted thereon." The inversion and illusory movement that we witness through Mach's demonstration is possible because depth cannot be determined in monocular vision. Without the ability to read the stereoscopic depth and spatial position of the two planes standing before us on the desk, the bent line through the centre collapses and is inverted – instead of sticking out, it reverses and sticks in. As with the cameo/intaglio shift, we see a different aspect of the same object. A metaphor elicits a similar perceptual response regarding aspect, for example: *seeing is understanding*. Of course, the truth of this metaphor depends on our angle of vision, or point-of-view and whether we have both eyes open – the proof of which Hughes' pictures show very well.

In the spirit of impossible objects, his pictures present self-contradictory propositions. These propositions lead us to come to relative conclusions of the "both/and" type, rather than presumptions of a definitive "either/or" kind. The shapes present a visual paradox akin to Mach's demonstration above. As these shapes stick out into our space, they are at the same time covered in perspectival clues that suggest that they go in. Hughes explains this phenomenon saying that, "The irony, that making these things that stick out a foot into the air and that so clearly are not spatial illusions, is that they *are the strongest* spatial illusions. They are much stronger than if they were flat and that is because the power of our minds sends them back. My saw and my glue send them out, but your eyes and your mind send them back."

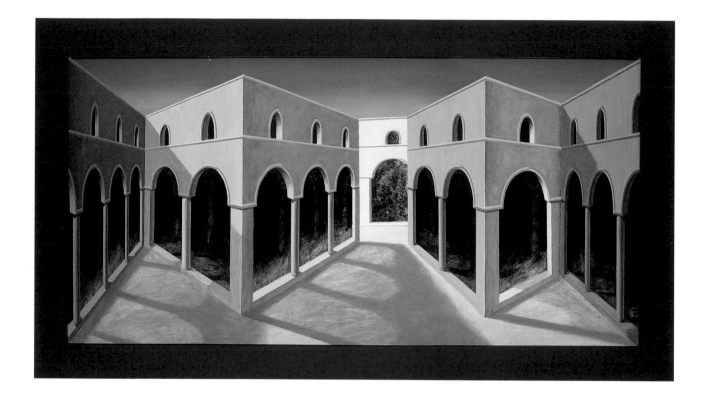

A Real Illusion 1996

Oil on board
78 x 127 x 36 cms
Westdeutsche Landesbank, London

We live in boxes of rectilinear space configured at 90° angles and we are familiar with this scale and its feel. This is the ready-made world into which we come – a world partially compressed into a rectangular system of coordinates based on the right angle. It would seem that this is a very limited world made up primarily of little boxes that we then fill with lots of square box-shaped things. However, once one begins to look for it, one can find infinity implied in every corner. We search out the open space and depth promised by infinity whether it is contained in the corner of a room or spreading out before us on the open plain. Space has a tendency towards infinity. This makes the horizon not only a pictorial, but also a strategic notion. The parallel lines that reach out to infinity do finally meet in our eyes. This connects and centres us in the depth of the gravitational pull of infinity. Hughes' pictures graphically demonstrate this attraction. Words can rarely match the intensity and joy found in the paradoxical depth that his pictures offer. Those that follow do capture the centrality of our experience of depth. They come from Maurice Merleau-Ponty writing in *The Primacy of Perception*.

Four centuries after the 'solutions' of the Renaissance and three centuries after Descartes, depth is still new, and it insists on being sought, not 'once in a lifetime' but all through life. It cannot be merely a question of an unmysterious interval, as seen from an aeroplane, between these trees nearby and those farther away. Nor is it a matter of the way things are conjured away one by another, as we see happen so vividly in a perspective drawing. These two views are very explicit and raise no problems. The enigma, though, lies in their bond, in what is between them. The enigma consists in the fact that I see things, each one in its place, precisely because they eclipse one another, and that they are rivals before my sight precisely because each one is in its own place. Their exteriority is known in their envelopment and their mutual dependence in their autonomy. Once depth is understood in this way, we can no longer call it a third dimension. In the first place, if it were a dimension, it would be the *first* one; there are forms and definite planes only if it is stipulated how far from me their different parts are. But a *first* dimension that contains all the others is no longer a dimension, at least in the ordinary sense of a *certain relationship* according to which we make measurements. Depth thus understood is, rather, the experience of the reversibility of dimensions, of a global 'locality' – everything in the same place at the same time, a locality from which height, width, and depth are abstracted, of a voluminosity we express in a word when we say that a thing is *there*.

Here depth surrounds us and is more than simply a dimension – it is the core around which our sense of the visible world coheres. The depth contained in the repeating shapes that serve as the support for Hughes' pictures has multiple and shifting centres. The linear perspective in which these shapes are arranged is itself a means of representing equalities – there the equivalent and the equal blend together in perspectival symmetry. When Hughes paints onto the peaks and into the troughs of these shapes the image shown there in reverse perspective equally has not one centre, but multiple centres that shift along with the point-of-view of the seer. If there can be said to be a focal point in these pictures, then in part this would be on the horizon with its offering of infinity.

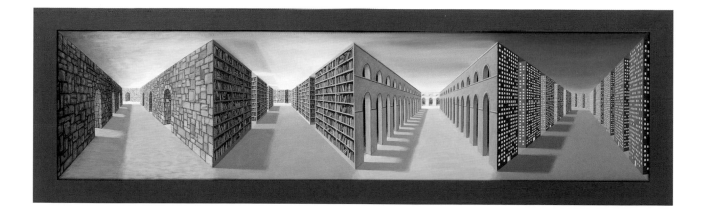

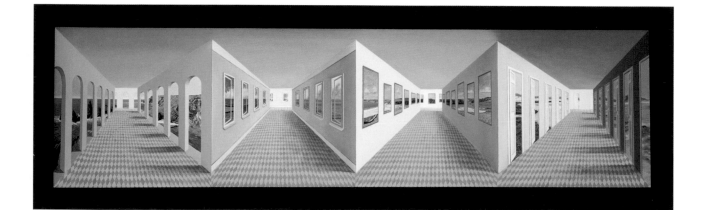

ABOVE TOP:
All Roads Lead to Infinity 1996

Oil on board
73.5 x 239 x 30.5 cms
Private collection, USA

ABOVE:
Brunelleschi 1416 1998

Oil on board
75 x 229 x 30 cms
Private collection, USA

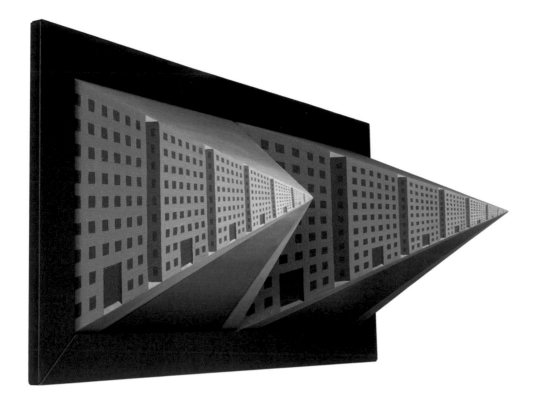

The centre of these pictures, however, belongs to the seer. This is a strange phenomenon, but one known to those who have been on a boat at sea. Out on the water you and your boat are the epicentre of the world. It is as if the universe has been constructed for you and you alone with every star in the sky and point on the horizon charted in relation to your own movement across the sea floor. In like manner the seer is the centrifugal point in Hughes' pictures. The depth of the seer's perspectival experience remains constantly open to reveal infinity – if not on a horizon then in a passage between presents, skyscrapers or walls of a library through which the seer can sail.

When Hughes began to make these sticking-out pictures this depth of space was implied by the shape of infinity. Early pictures such as *The Longer Road* or *Real Toy Soldiers* had vanishing points that stretched out to two fiercely pointed ends. Placing two infinities in one picture was then a very bold stroke, and the paradoxical view of *To Two Vanishing Points* captured Hughes' imagination. However, he found that, "Infinity is a little bit further than people will go. People didn't quite like to go that far – they prefer to see light at the end of the tunnel if you like. It's because nobody ever goes to there – nobody has been to infinity and come back anyway." With their points knocked off these structures began the series of developments that would lead from pieces like *The Light at the End of the Tunnel* to *All Roads Lead to Infinity*. The present incarnation of Hughes' original idea is the form shared by first *Brunelleschi 1416* and then the immense views of infinity offered by *Cratylus*. These pieces boast four views of infinity, though each softened by the inclusion of a horizon as their spaces open up and draw us into their permutations of inside and out. "People do want to see the horizon," says Hughes. "It is the edge of world and it is a naturally occurring border whereas a door or a wall is man-made. Hills get in the way by chance, but walls are put there intentionally." *Cratylus* and *Brunelleschi*

The Longer Road 1991

Oil on board
38 x 81 x 43 cms
Private collection, UK

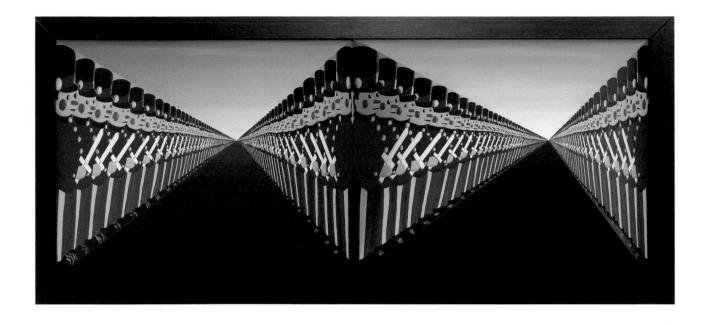

are examples of Hughes' continuing relationship with rhyming shapes. This formal exercise is still at work in his pictures, only now instead of hearts or rainbows the challenge is – how many different things can you make out of a trapezoid? The ambiguity of an image is expressed through the shape of these four infinities as they could be a library, or Stonehenge, a picture gallery, or equally a maze. This shape – what Hughes calls his Toblerone (after the chocolate bar) – shows off better than any other the adaptability of Hughes' perspectival system.

The transformation of these constructions from raw wooden material to their cool geometric white forms is a hugely labour-intensive process. The geometry involved in their making is rigidly precise – it is a kind of cubist geometry in which each plane has to match and merge seamlessly with the next. This is a great contrast to the arbitrary and flexible system that takes over after the form emerges from a cloud of sawdust, rapid setting araldite epoxy, sandpaper and filler. Once painted in three or four coats of gesso, in their white and virgin form, they show no sign of ever having been touched by a working hand. "They are very odd things these big lumps of space in perspective," says Hughes. "They are rather intractable these tank traps – big horrible geometric male things that you have to, with a bit of love and sympathy and a dance of the seven veils, make seductive."

This metamorphosis begins with an undercoat of a base colour, usually a rich red or burnt ochre. Hughes then transfers his plan for the picture from his sketchbook to the planes of the trapezoid. "Really it is all done with a pencil and a ruler," says Hughes. "To say I do this mathematically is a bit glamorous, it's arithmetically in the end. And I've got a few ways of getting round that as well – there are ways where you don't need to measure. I've got a few pieces of paper with lines drawn on, that I can take lines from. It's a technical drawing or carpentry kind of drawing. People think that my things are in perspective and very complicated, but actually they're just diminished, that's all – 24 inches becomes 12 inches. Every one that I've done is in some sense wrong. It wouldn't make any difference if they were right because if they're vaguely right, or they're tending to diminish, it works fine."

Real Toy Soldiers 1991

Oil on board
79 x 184.5 x 57 cms
Private collection, France

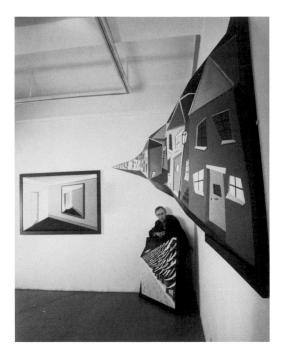

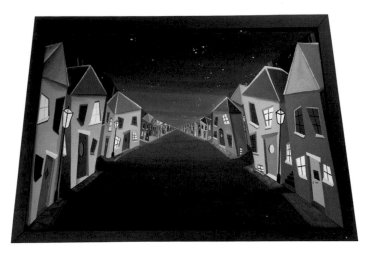

Hughes' shapes were initially eccentric and varied widely from piece to piece. The early *Down the Road* lined with Dr. Caligari houses juts out into infinity suddenly and we accommodate this device placing it within our experience of the rapidly forced perspective of stage and film sets. This piece delivers infinity through a bit added onto the base structure. *Out the Window*, with its Anselm Kiefer-inspired wood grain, uses the same device to bring infinity in through the window and reverse inside and out. "At that time I was terribly interested in describing obvious pieces of geometry and moving through the variations," says Hughes.

As he worked his way through these geometries in pieces like *Room in a Skyscraper* and *Big Chest*, both with their Magrittean elements of juxtaposition and confinement, a major development struck – the shape broke free from the frame.

"There are two ways that my pictures work. One is that they create an illusion of space and the other is that they appear to move. In the early days, the pictures didn't appear to move for the technical reason that the bottom bits were not free and they touched the frame." Edges hold things visually – this is a critical aspect of Hughes' geometry. Anything that adheres to the frame is held by the frame and the planes are then pinned down visually and cannot move. A picture's end-planes can stretch and accommodate the movement in middle planes, but they cannot move. "Leaving the frame was an important geometric discovery – that leap into movement. This started with *The L-Shaped Room* in 1991. I made it out of those five planes – and it just happened by accident just because I made that sort of sketch with the planes free-floating."

Another happy accident.

Down the Road 1990

Oil on board
109 x 180.5 x 76 cms

Out the Window 1990

Oil on board
109 x 137 x 40.5 cms

RIGHT:
A Room in a Skyscraper 1992

Oil on board
124 x 206 x 28 cms

BELOW:
Big Chest 1992

Oil on board
123 x 199.5 x 28 cms

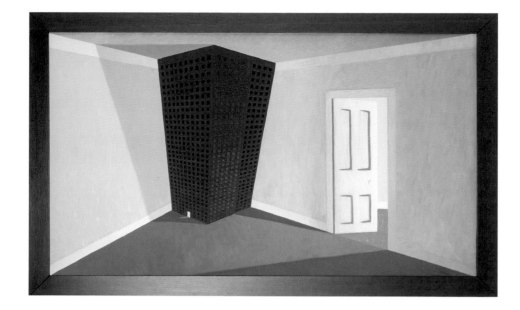

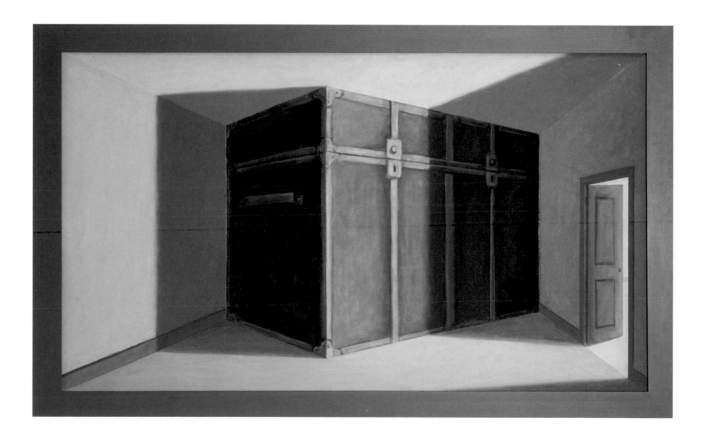

Near the time of Hughes' discovery of movement came a solution to the riddle of shadows in his work. Shadows are an important clue to depth and they link the skeleton of Hughes' shapes to the reversed skin of the picture. Until *Chicago Seen* the shadows in these pictures were thrown entirely by the shapes. Here the skyscrapers throw their own and with this piece begins Hughes' relationship with the shadows that add depth and even more paradoxical movement to his pictures. They came into the pictures largely because of Hughes' clarification of the geometry in his shapes, as much as from the perspectival leaps he was making in paint. Here the libraries played a substantial role in clarifying the increasing complexity of Hughes' geometry and shapes just as they had done with perspectival developments.

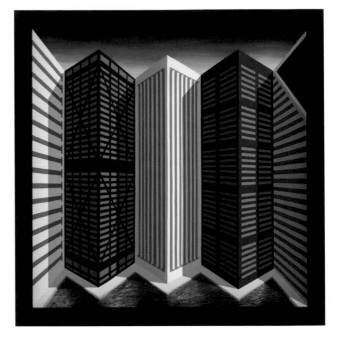

The painterly element that shadows added resulted in the poetry of *The Shadow of War* – a memorial to the carnage wreaked on civilians during the Bosnian war. And certainly the Hopper series of pictures could not have come about without the shadow. This makes the shadow as significant a development in Hughes' work as when the plane left the frame, bringing movement to his pictures. For the Hopper series played a substantial part in opening up the scenic vistas of pieces like *Porthcew Cove and Rinsey Head*. Shadows underscore the reciprocal relationship between the support and the image which is so important, not only to the workings of Hughes' pictures, but also to their continuing development. Discovery itself calls for further quests.

The apparent eccentricity of these shapes is not without historical precedent, even if the paradoxical movement of their reversed images are. What is termed the *reifelbilder* by German art historians shares this basic shape. Developed in the sixteenth-century and popular through to the nineteenth, *reifelbilder* were constructed with a religious motive showing, for example, Mary, or Martin Luther from the left and Christ, or Calvin from the right. In his marginal notes to the *Large Glass* Duchamp refers to including an image based on the Wilson-Lincoln system in order to provide the oculist witness with a mirrorical return. Granted their structural resemblance, these historical forms never employed the array of perspectives that Hughes does, and needless to say, neither did they exhibit any paradoxical movement. Today the politico-religious use of this shape has been transferred to the roadside hoarding, lying in wait for the Labour party to show Gordon Brown to those passing from the left and Tony Blair to those from the right. Fittingly Hughes' shapes have popular antecedents.

The topological geometry of Hughes' shapes is mapped like a globe by lines of longitude and latitude. The map-maker speaks: "Latitude is easy to decide and longitude is difficult, in that it requires an accurate clock. My latitude has been very easy to decide since my assistant Martin Kingdom suggested that it should just be 90º or 45º at the edges. We live in a rectilinear world that is based on this premise. These are our poles if you like and so the latitude is set at 90º. But the longitude, which is much more important, since it decides where the vanishing point is and how much it diminishes, is really a decision about how big we are and how big the picture is and where we are – it's a much more difficult thing to decide. And I have made an arbitrary decision that my longitude is about 60º at the bottom and 70º at the top. That's the

Chicago Seen 1992

Oil on board
110 x 109 x 13 cms
Heller Collection

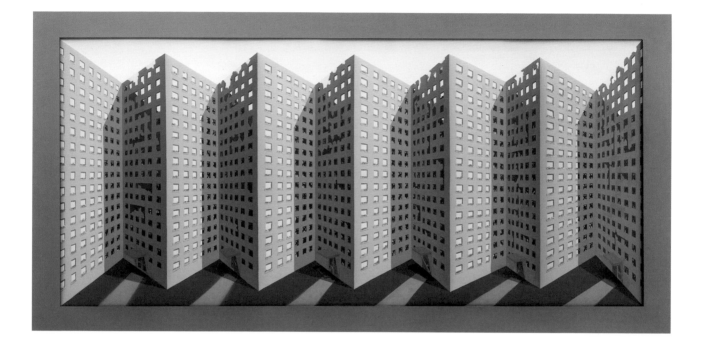

The Shadow of War 1993

Oil on board
104 x 208 x 16 cms
Collection Glasgow Museums & Art Galleries

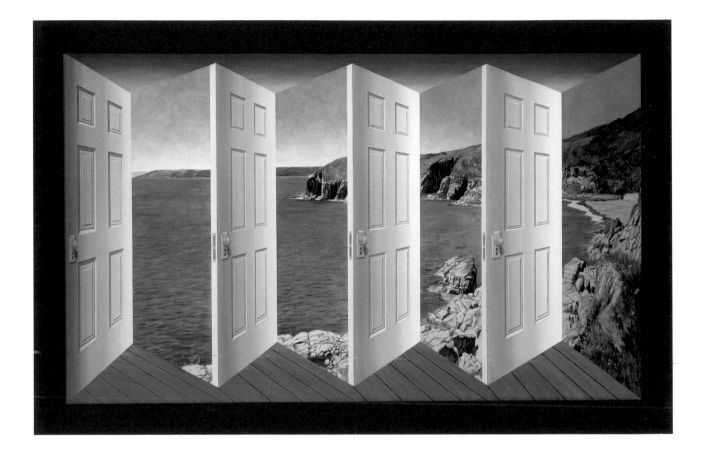

Porthcew Cove and Rinsey Head 1998

Oil on board
106 x 170 x 25.5 cms
Private collection, USA

rule of thumb that I am currently operating on." This loose system places a vanishing point at some distance from the picture. And it is based on the evidence that when one looks at the average room, typically we see a lot of floor and a bit of ceiling. Hughes continues: "Another aspect of this rule of thumb is that if you have a reasonably large and shallow floor you get a bit of light to it. In my pieces you have a bright bit of sky because that catches the light over a large area, compresses it, and is then seen."

The hidden implication of this geometry decides not only the vanishing point, but also the speed at which the picture diminishes. Regarding these "crucial" perspectival issues Hughes remains typically more concerned with flexibility and function. "The decision is capricious and completely daft really – I've never worked out a rigid system. My pieces only say you must be somewhere in regard to this picture, as opposed to proper perspective paintings which say you must be there at this one point in the universe to regard this image. So the geometry is important in this sense, given to begin with, and then if you move about it changes. Everything follows along with the hidden implication that we are living in this rectilinear world that has been constructed on the basis of the right angle. Without being too mathematical, it seems to be the simplest way to divide up the world – that's the way concrete sets and plumb lines fall – gravity makes right angles."

Walking through the studio today, one can almost always see four or five shapes waiting prone and in their pristine form to take their place on the large easels that Hughes and his assistants, Martin Kingdom and Chloë Edwards, work at. Towards the latter half of 1995 Hughes reversed the flow of his experiments in geometry. From that point, instead of transforming pictures into eccentric shapes, he began to turn regular shapes into eccentric pictures. This resulted in the remarkable year 1996 with its string of innovative and wondrous pictures like *Hinged*, *Lost*, *The Clouds* and *Find the Present*. Perhaps repeating the turn in his work that came with the watercolours, the quickened pace that a ready store of shapes insured enabled Hughes to hit a rich vein of paradoxical gems.

For the moment Hughes has settled into a repertoire of around six shapes with minor variations. He remains very open to the play with geometry – his next move is likely to be inwards as he cuts into the plane to realize the promise of pieces like *Drama*. The stage in this picture stuck out, but it could have equally been pushed in with a saw – just as we do with our minds. "There is a part of the work where one is involved with a certain sort of geometry, which perspective is a big part of, but it also has that arbitrary quality. And as you've noticed, it's random too in the sense that I get a lot of shapes made and then I make something out of them. I could imagine another year when I would have some genie making shapes with a greater variation. But at the moment it is interesting to have a regular shape and have that as the spur to make an irregular painting. Underneath it all there is this skeleton or structure that I work on. It's a given thing, just as other artists work in rectangles."

As we leave the studio Hughes turns out the lights and his paradoxical pictures full of depth, movement and joy revert to inert lumps of space. They sit waiting like a book on a shelf. And as a book holds its knowledge between closed pages waiting for a reader, Patrick Hughes' pictures only come to life when they are seen.

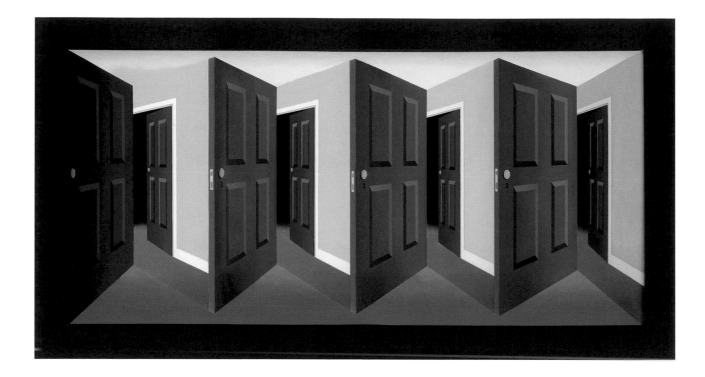

Hinged 1996

Oil on board
94 x 176 x 25 cms
Private collection, USA

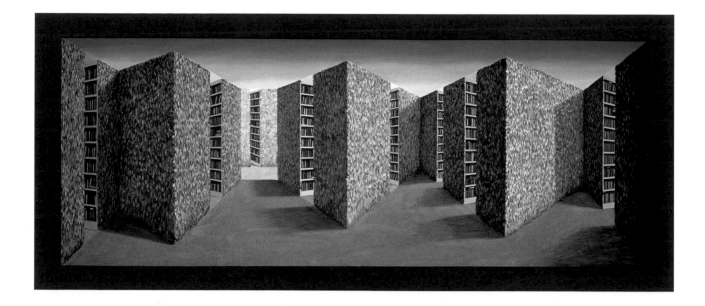

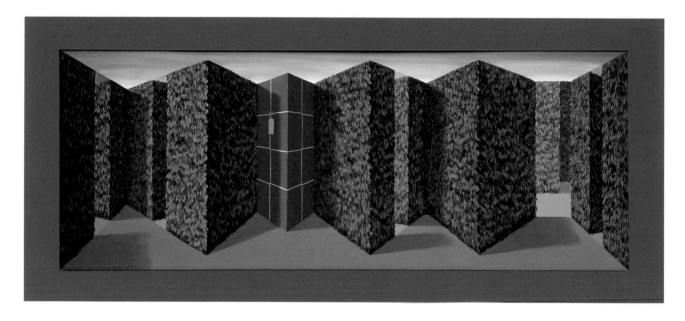

ABOVE TOP:
Lost 1996

Oil on board
94 x 212 x 45 cms

ABOVE:
Find the Present 1996

Oil on board
78.5 x 175 x 25 cms

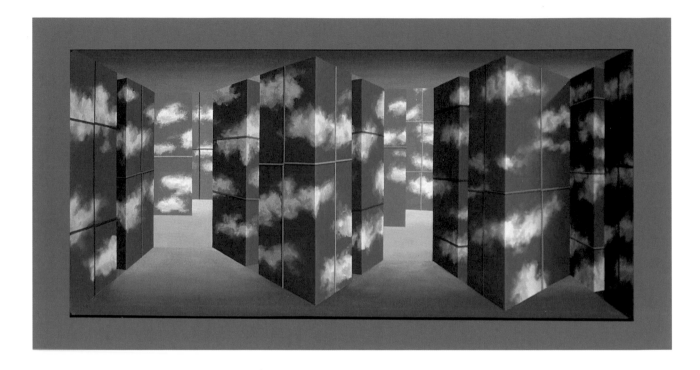

The Clouds 1996

Oil on board
68 x 123 x 20 cms
Private collection, UK

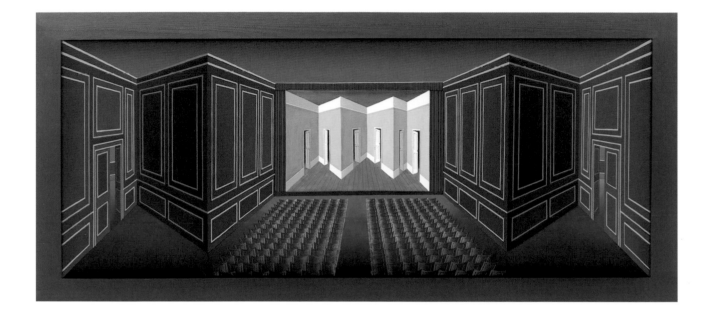

Drama 1996

Oil on board
94 x 207 x 43 cms

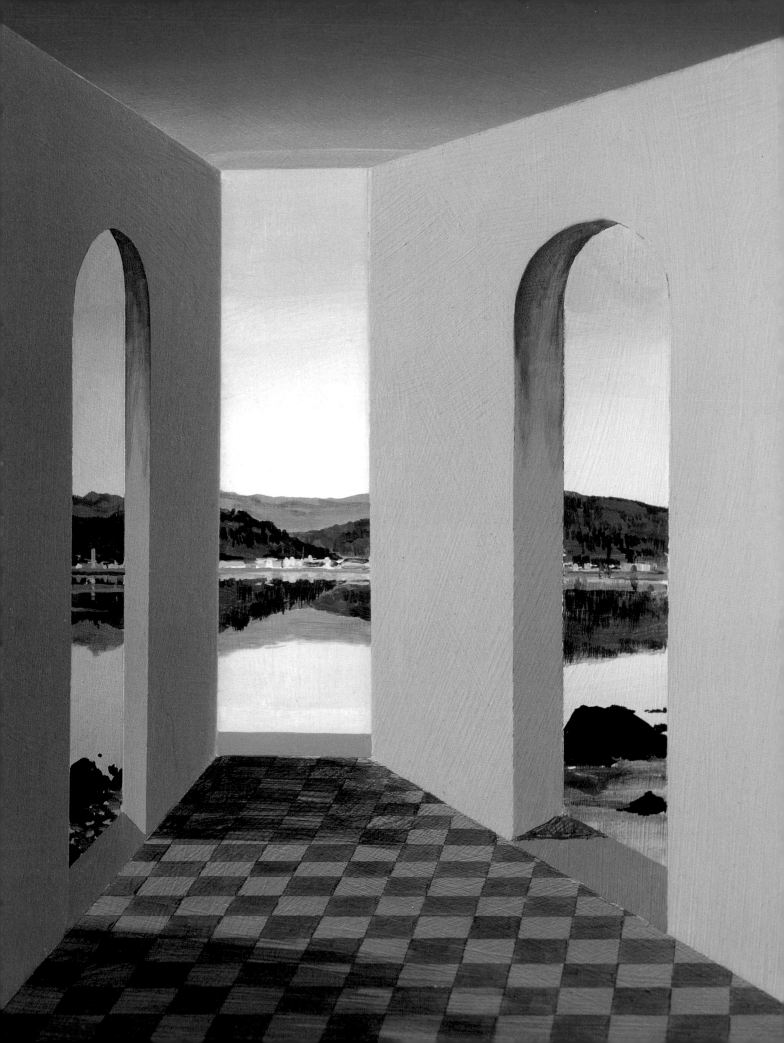

HUGHES' OPTIC — THE SEER

Writing in what posterity calls his *Lettre du voyant*, Arthur Rimbaud stated an emphatic course for the modernist viewer: "Je sais qu'il faut être voyant, se faire voyant" (I know one has to be a seer, make oneself a seer). The path for a prospective seer was marked by a prolonged disordering of the senses that ran against the grain of standardised bourgeois experience. By whatever means – hashish in Marseilles, wandering through the fractured planes of a picture, or through the passages of Parisian streets – one had to find a way to see with new eyes, to break free from the hold of conventional perspectives and embark on a journey of liberation in a fusion of the senses with the imagination.

Giorgio de Chirico's *The Seer* illuminates the stage of this struggle against the grain of perspective. A monocular mannequin sits before a schematic perspectival drawing with its sight-lines running outside the frame in search of the absent seer. The mannequin – immobile and with one fixed eye stencilled on the centre of its head – is the ideal viewer of a picture drawn in linear perspective, but one estranged as it sits on the plinth surrounded by de Chirico's forced planes. The surrealist mannequin, so prominent in de Chirico's metaphysical piazzas, the collages of Max Ernst and Hans Bellmer's dolls, was a screen on which could be played the traumas of individual experience as well as the early modernist shock of industrial capitalism and the resultant skewing of identities. The nature of the projection depended on what the viewer brought to the picture, just as my reading of de Chirico's *The Seer* is shaped by my place here writing the final pages of a book concerned largely with perspectives linear and reversed.

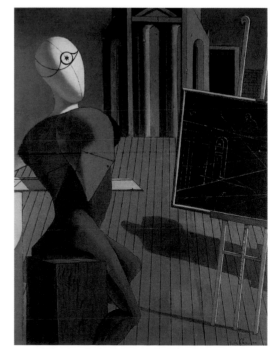

Giorgio de Chirico
The Seer 1915
Oil on canvas
89.6 x 70.1 cms
Collection The Museum of Modern Art, New York, James Thrall Soby Bequest Photograph © The Museum of Modern Art, New York

Mannequins operate in a zone of marvellous confusion – they are both inanimate and animate, human and clearly non-human. There are none in Patrick Hughes' pictures, but as with the surrealists' uncanny mannequin, the surrealist space that fills his pictures functions as a screen and mirror for the projections of the seer. The space of these pictures conflates natural and artificial perspectives, as well as mixing the boundaries between artificially constructed interiors and the natural horizon of rolling landscapes. But what really happens in Hughes' pictures is entirely up to the seer. The seer is the director and author who controls the action. "My pictures are like theatre sets," says Hughes. "One is creating a space for an actor to move around in with his eyes or body, a formalised set with false exits and entries. It works for me to have fake turnings or holes in the pictures, but also real turnings that work in the bodily act of looking. They give you somewhere to go, to turn, to walk past and project into. That's why I don't paint people in them. The seer is the main character – the protagonist. My trick answer is: 'The people in the pictures are you.' Harold Pinter says somewhere that when you walk into a room alone, it's quite different from walking into a room with one person in it. My pictures are all empty and ready for you to go in." Through these pictures the simple spectator is surprised into the vision of an author.

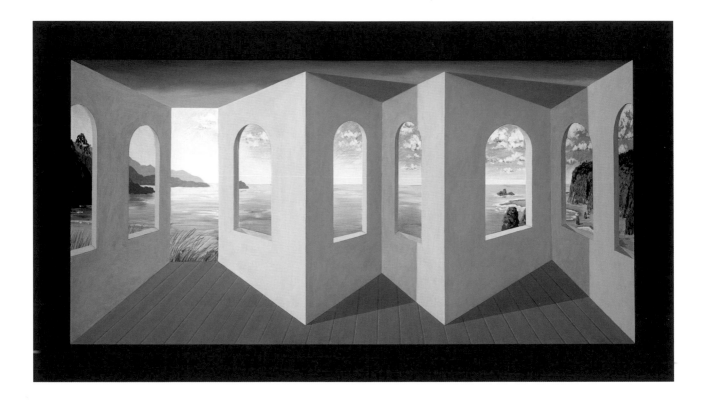

Bay Windows 1997

Oil on board
78 x 139.5 x 24 cms
Private collection, USA

If the innovative art histories of the last decade or two have any sense of an overarching project then it would be the genealogy of the subject. Rather than the conventional analysis of form or a tracing of styles, such writing attempts to say, for example, what constituted a seventeenth-century Dutch viewer, or how the Enlightenment observer was constructed. Better art writing follows the better art and moves from being concerned primarily with the status of the image to the place of the viewer, which is in the end what art is really about. Hughes' pictures are a mirror in which a contemporary viewer can watch themselves become a late twentieth-century seer. He aims from the start to produce an apparently untrue painting that is a truer picture of vision and of our experience of seeing the world than any other. In a significant way, Hughes' pictures are blank. Animated by the seer's movement and imagination, the immensity of world space and the depth of inner space are subsumed in the pictorial space of his pictures.

Hughes is happy to leave it to the seer to decide both what they put into the pictures and what to get out of them. "When you see these pictures I hope that you don't so much have logical thoughts, but you have what you might call perceptual thoughts, which I think are self-consuming. Then you might have logical, philosophical thoughts or Heraclitian thoughts after you've had mere perceptual thoughts. Another thing that is important to me is that the visual and the verbal are not two different areas. Essentially I am saying that there is a kind of mental machinery that is the same. I don't like literary pictures and I am sure I wouldn't like the purely pictorial picture either. I think literature and pictures are separate forms, but the underlying thoughts would be similar and all created by the mind." In the work, as well as his person, Hughes eschews the pretentious and transparently self-conscious. By doing so he leaves the work open to be received by all brows – a state ideal for those paradoxically crossed postmodern ones.

A large part of my fascination with Hughes' art is how his reconnection with a past practice of perspective supports the development of an entirely new practice in reverse. This historical reconnection ultimately disconnects Hughes' pictures from whatever else is happening at the moment in painting. In part, this is the old story of art as it turns a dialectical screw and works through its historical antecedents. How we read the historical bits that this screw churns up as it digs down into the past is shaped by our place in the present. This view of history is conditioned by *parallax* – or the apparent displacement of an object caused by the actual movement of the observer. Thus, often when we look into the past we end up seeing an image of ourselves as much as anything else.

Hughes' pictures literally work this way. Motion parallax, coupled with our shifting points-of-view as we move before these pictures, causes us to "see them move" when actually we see our own movement reflected and reversed in these mirrorical pictures. His pictures work metaphorically in historical parallax as well. While appearing largely to be without historical precedent – where in the pages of any art history book would you find pictures like these? – they are completely immersed in the history of perspective. Hughes engages with this history from perspectively-skewed surrealist pictures to the idiosyncratic fourth-dimension of Duchamp, to the Cubist pursuit of seeing around corners, and then Cézanne, to Turner's perspectives, and back to Brunelleschi and his camera obscura. What is so compelling about Hughes' historical journey through perspectives is that it completes a vicious circle – it starts with the seer and then turns perspective on its head to arrive back at the seer.

Before turning to perception and the role of the seer in the creation of these pictures I would like to explore an experience one seer has had through Hughes' pictures. It is significant

in that it demonstrates the wealth of possibilities contained in the surrealist space of these pictures as well as the interior model on which they are based. In the autumn of 1997, a Hughes picture was displayed in a window of Selfridge's and somebody happened upon it in the course of travelling through the streets of London. The response this individual felt was truly remarkable, which sounds trite without knowing what they themselves brought to the picture. Throughout life, this person had felt that they had little control of the space surrounding them, nor was this person able to sense that they were in any way grounded in this space. Much of this spatial alienation stemmed from a traumatic experience in early childhood that had occurred during a period of confinement in a small place. Engaging with the picture through the shop window produced an effect so strong that the seer wrote to Hughes about it, I quote from the letter: "You allowed me to be taken into a partnership and have a dynamic role to play in the reciprocity of the picture and generously shared its common space. You do this in a direct, straightforward, no-nonsense, humble yet confident way. Absolutely open and honest and trusting me as the viewer." The effect of Hughes' picture was even more pronounced given that this particular seer did not have the ability to perceive depth, having lost one retina to disease. This person saw the library, but then again much more. What captured their imagination was the role Hughes left for them in the creation of the picture and the expanse of its sur-real space so full of possibilities of both freedom and restraint.

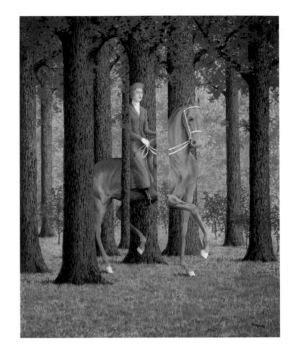

René Magritte (1898-1967)
The Blank Signature 1965
Oil on canvas
81.3 x 65 cms
Collection Mr and Mrs Paul Mellon
© 1998 Board of Trustees, National
Gallery of Art, Washington
Photography: Bridgeman Art Library,
London/New York

This abbreviated case history underscores the pictorial structure that this art presents to a viewer. The seeing subject is in the scene of these pictures while their participation is elastic and mobile with their feet always on the ground. The picture is not necessarily the experience, but it is the setting or mise-en-scène against which this experience takes place. Like the daydream, or our sailboat upon the open water, Hughes' pictures are ego-centric as they appoint the viewer as their centrifugal point. Like the camera obscura which is always present as the shadow of linear perspective, this is an interior model of the viewing subject. However, unlike both the camera obscura and linear perspective, in Hughes pictures the seer's position is not delimited by a machine or a system, but governed by the free movement of their feet and imagination. This renders the space of Hughes' pictures mimetic of the purposeful rhythms and motions of everyday life.

Hughes' relationship with vision and opticality is characterized by tensions similar to those that shape his opinions of the literary in painting and painting proper. An achievement of those artists centred in and around surrealism was that they found a way for a picture to get in beyond the retina and take purchase on the grey matter. Hughes' pictures never trick the eye, but they can fool the mind. For the seer, the act of observing actually creates an aspect of the reality under observation – "the picture moves!" Obviously vision is as central to this effect as motion. But this is not the disinterested vision prized by traditional aesthetics, nor is it a notion of vision based on the model of the camera and located solely in the eye. Hughes' optics rely on a vision that resides in a mobile body and a thinking mind. Perception for such an eye must be a wandering and wondering perception belonging to a seer who can feel vision in the pit of the stomach and under the soles of the feet.

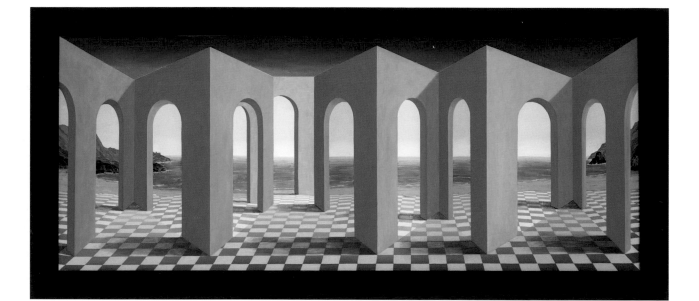

The Glory Hole 1997

Oil on board
78.5 x 176 x 25 cms
Private collection, Spain

Movement is part of the world which we sense and perceive. We sense movement by recognising change, or the modulation of a familiar setting. Just as for those who search it out, the past and the future are contained in the thickened moment of the present, movement demonstrates to us all the flow of space and time in an undeniable way. In this our senses are governed by convention. The voices we give to what our senses perceive run through a litany of points marked by their counterpoints – visible and invisible, light and dark, movement and stillness, sound and silence, etc. What we know of movement in the world is set against our experience which we take for granted – namely the conventional world at rest. Pictorially, figure and ground share this same relationship of point to counterpoint – no figure without a ground, no ground without a figure. As I write, hanging before me on the wall is Hughes' multiple *Outdoors*. The multiples connect Hughes with his long history of printmaking and translate the wonder of his sticking-out pictures to these more accessible prints. *Outdoors* confounds the notion of a fixed figure against a stable ground. As with inside and out in Hughes' work, figure too blends and blurs into ground – one moment the door connected to the floor is figure, the next turn leads you to believe the rocky cove is figure to the ground of the door. The intensity of beheld space in such pictures highlights our ability to grasp shapes in the plane of transparent distance.

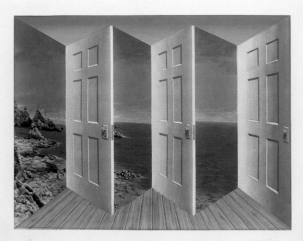

Outdoors 1998

Hand painted multiple
Edition 35
51 x 63 x 16 cms

As we have seen, the reversibility of figure and ground has long been an interest for Hughes. Since *Faith Moves Mountains* – his first piece to explore the movement of the great outdoors – the two have reversed consistently in a dialectical harmony. Of the many pictures painted by Magritte that he admires, *The Blank Signature* is nearly Hughes' favourite. Through his own research Hughes relates this picture to sources in the cinema – a sequence in Fritz Lang's 1923 film *Siegfried* as well as Tex Avery's classic 1943 cartoon *The screwy truant*. These sources are significant for their movement. If we could add movement to Magritte's picture what would happen to figure and ground? The movement of the cinema fills in such blank signatures between frames at a rate of twenty-four a second. Our imagination can fill in the blanks instantly equalling, if not surpassing, the strength of our persistence of vision.

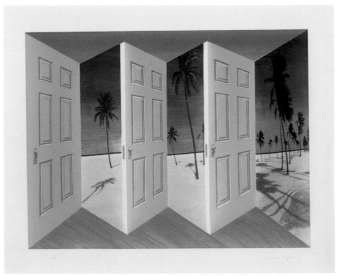

Palm Door 1998

Hand painted multiple
Edition 35
51 x 63 x 16 cms

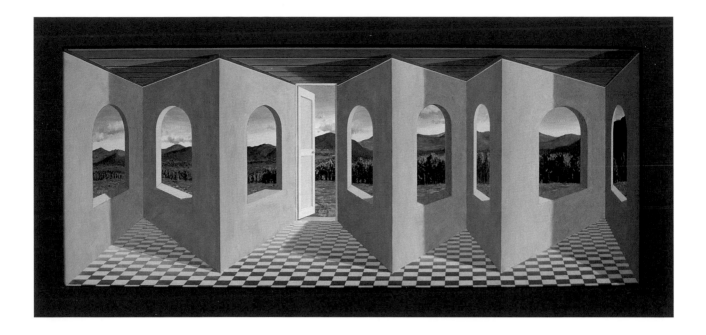

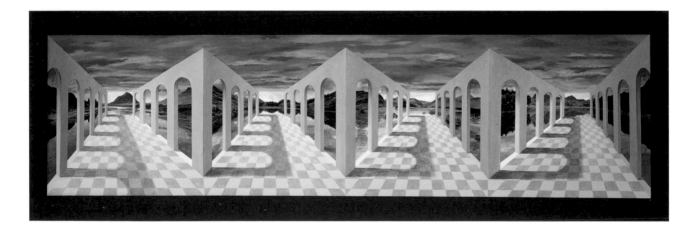

Faith Moves Mountains 1997

Oil on board
79 x 175 x 28 cms
Private collection, USA

Cratylus 1998

Oil on board
75 x 231 x 28 cms

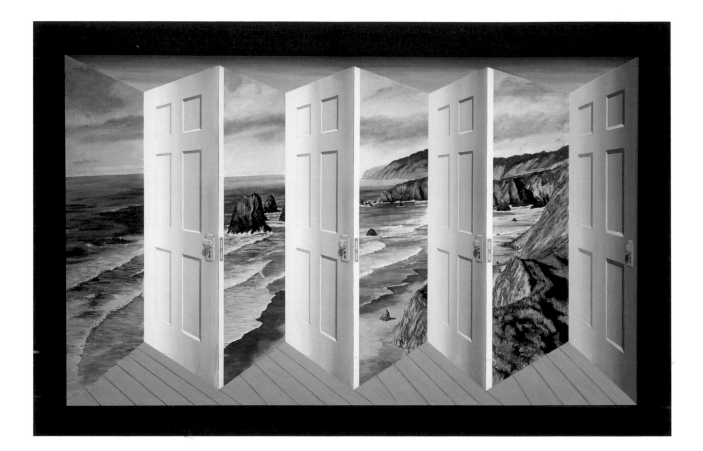

Seenery 1997

Oil on board
111 x 172 x 25 cms
Private collection, USA

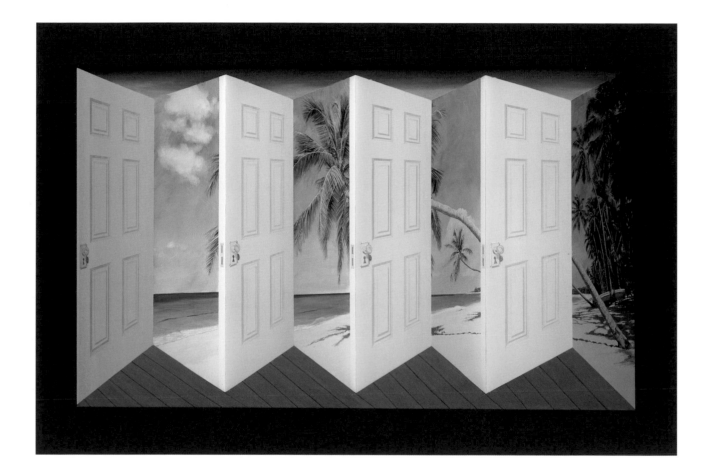

Juxtaposition 1998

Oil on board
83 x 124 x 15 cms
Private collection, UK

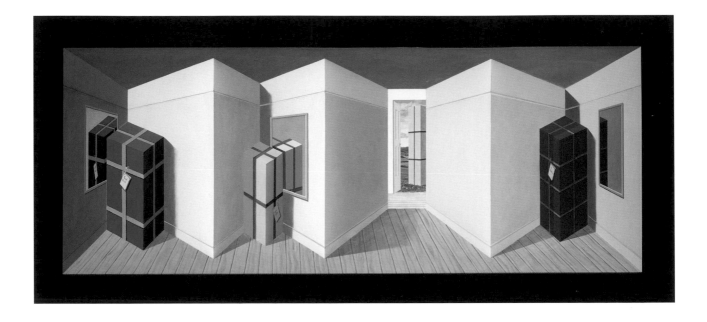

Perplexivity 1998

Oil on board
79 x 176 x 25 cms
Private collection, UK

The seamless movement in Hughes' work fills in the shifting blanks between figure and ground in his recent pictures, lending a cinematic quality to pieces like *Seenery*, *Perplexivity*, and *Juxtaposition*. The sources for such pictures is as always the found image – art recycles art. Recently Hughes has begun to project images onto the surface of these shapes in order to better facilitate their design and layout. Collage and montage have played a significant role in these sticking-out pictures as they incorporate the surrealist strategy of juxtaposing two different realities in order to creatively surprise the viewer into a more critical vision of the original. Two items from Magritte's pictographic panel entitled *Words and Images*, published in *La Révolution Surréaliste* in 1929 are significant in relation to figure and ground and the role of collaged space in both Hughes' and Magritte's work: *An object can make one think that there are other objects behind it*: and *The visible contours of objects in reality touch each other as if forming a mosaic*. The real act of collage in Hughes' pictures takes place in the mind of the seer as they blend and blur these juxtapositions of inside and outside space in the seamless movement which they themselves generate.

"Painting has been about taking all the three-dimensional reality and squeezing it into this sandwich behind glass," says Hughes. "My pictures are all appearances and people quickly think that they are real. Art – that's a convention of art, it's in a gallery, it's in a frame...it can't be real. But people accept it as real – they accept it as reality and then they go on to question it." Movement is a powerful clue to depth. Ultimately this is a large part of what linear perspective lacked in order to truly convince the viewer of its illusion. Another truism that Hughes repeats is: "What people have created they will believe in."

One essential reference left out until now is that of The Ames Window. Adelbert Ames is a fascinating character in his own right. A graduate of Harvard Law and future in-law to William James, the philosopher and psychologist – Ames gave up both to be an artist in 1910 and wound up as the leading optical physiologist of the 1930s. To artists and designers he is best known for his window and the Ames Distorted Room. The room is entertaining, but not significantly different from the one piece in The National Gallery before which you will see visitors frozen in a stance with one eye shut. This is Samuel van Hoogstraten's perspectival box made for the love of peepshows and anamorphosis. The Ames Window, though, is the one illusion that bears the closest resemblance to the way Hughes' pictures work.

Hughes on Ames: "The Ames Window is a way to show how perspective works. In the beginning they didn't make things in perspective, they did a drawing of a whole scene in perspective. Ames, metaphorically, reaches his hand into a picture and says, 'See that window – I'll just take that out and let me show you that taken out of context.' And look, it isn't square! It's a trapezoid. And if you look at a trapezoid from this angle and then this angle, you come to different conclusions as to where you are in relation to it. There are millions of pictures with windows in them, but there is only one guy who had the foresight to reach in and pull it out and stick it on a rod and say – 'look.'"

The Ames Window is a flat trapezoid that we see as a rectangular window extending back into the distance. When the window oscillates, depth clues are put in direct conflict. Since the window is made in perspective, it has a longer and shorter side. The shorter side appears to be further in the distance than the longer edge. However, when spinning, the longer edge will move more slowly across one's visual field, leading us to

interpret this edge as being farther away – a similar paradoxical effect takes place when one views the passing landscape from a car or a train, there objects that are closer to you will move more quickly across your visual field than those farther away. This results in our seeing the window flip and flop instead of apprehending its actual rotation around and around. Our perceptual guesses jump and move – "it's there, no it's there."

One view of what happens in The Ames Window is that our natural perspective runs head-long into artificial perspective. This is equally a description of what happens in Hughes' pictures as he borrows parts of a sentence written in the language of linear perspective and drops them into another sentence written in the reversed idiom of natural perspective. Structurally each illusion allows multiple points-of-view to be explored by a stereoscopic viewer with both eyes open. What The Ames Window and Hughes' pictures share in the fullest sense is that which is most fleeting and enigmatic: the liminality of the edge. Liminality is the condition of being on a threshold or in a betwixt and between space. The surrealist condition is liminal by definition as it occupies a space on the threshold of inside and out and is permeated by an in-between state of waking and dreaming. A door, an arch, passages and windows are straightforward signifiers of the liminal threshold with the margins shared between the sea, shore, and horizon being perhaps the prototypical. The vertical edge in Hughes' pictures has a liminal hold on our perceptions. This edge marking the jamb of a door or the corner point of a wall, skyscraper or present reaches out to capture our attention while paradoxically receding into the interior fold of his sticking-out shape.

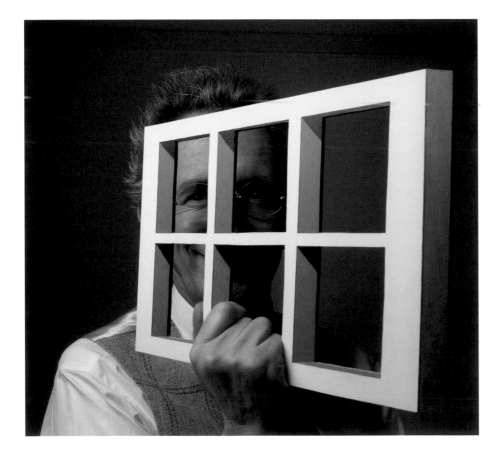

Patrick Hughes with an
Ames Window
Photograph Steve Ibbitson

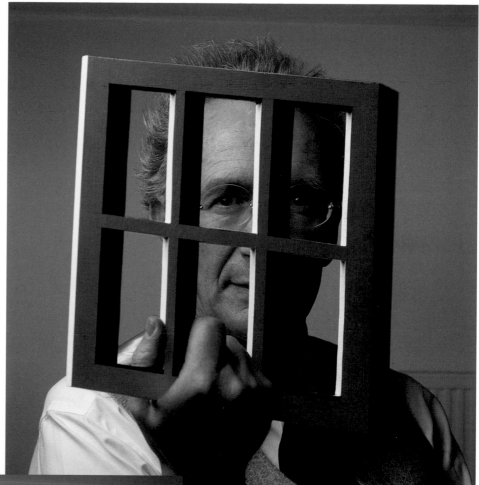

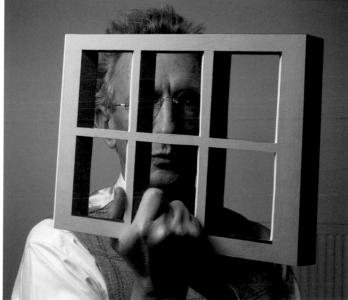

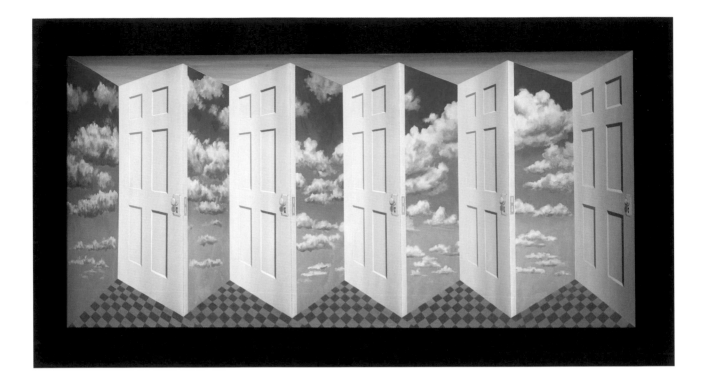

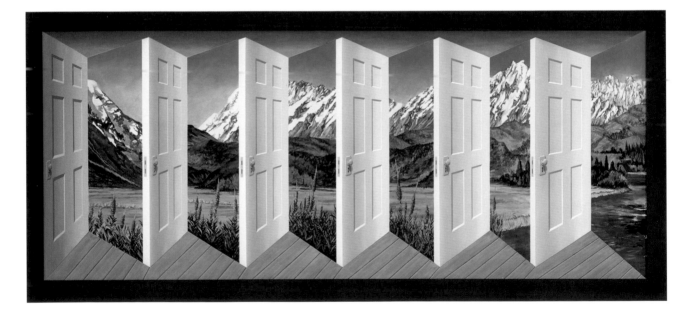

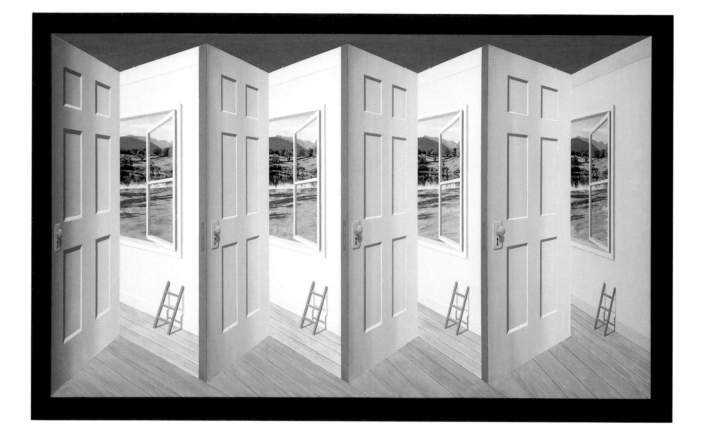

Revolving Doors 1998

Oil on board
110 x 209 x 25 cms
Private collection, USA

The Great Outdoors 1997

Oil on board
111 x 245 x 25 cms
Private collection, USA

The Doors of Perception 1997

Oil on board
110 x 172 x 26 cms
Private collection, UK

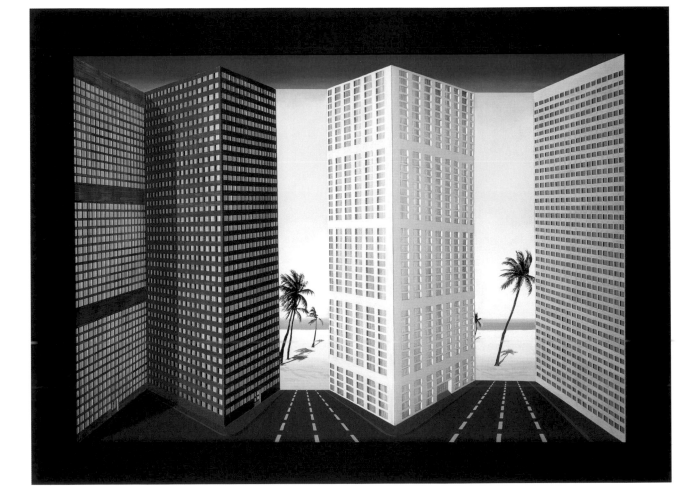

There There 1998

Oil on board
92 x 122 x 20 cms
Private collection, USA

Movement has had a presence in modern art from the electric motors of Duchamp and Jean Tinguely to the sensor-driven interactive installations of contemporary art. What is different here is that Hughes harnesses the motor power of the seer to move his pictures. The skyscraper in itself is a unique event that by its very nature defies all rules of proportion. Those in *There There* further defy logic as the seer is able to turn these massive blocks of space with his mind and make it to the sunny beach beyond. The scale of these pictures is paradoxical. We know these architectural spaces as being relative to our own human scale. Yet the perceived scale of the pictorial space in these pictures is ambiguous and larger since we know we can place ourselves in them. Hughes says, "I like the idea of people wandering and wondering through these strange spaces and having accidental encounters, even if the accidental encounter leads you to realize that it isn't a strange space after all." Cinematography is able to construe the experience of architecture as it could be – imaginary wanderings through space and time. Much of our act of looking at architecture, whether in the drawings and models of future projects or standing before the immensity of the site, is a process of illusion as much as perception. Hughes' pictures share the overlays and layering of planes that one finds in some contemporary architecture. And like those buildings Hughes' pictures defy photography by offering no single correct and true point-of-view for it to capture. But like the architectural model, Hughes' pictures do work as flat proposals for a future experience of their paradoxical space. Earlier in 1998 Hughes created both a flat and sticking-out version of the same image. *Hughes Henge* offers the riddle: guess which one moves?

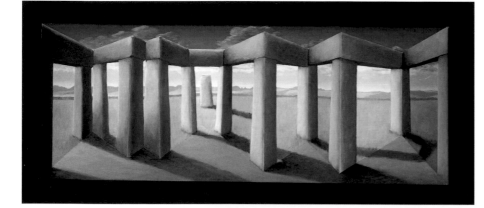

Hughes Henge 1998

Oil on board
78 x 176 x 24.5 cms
Private collection, USA

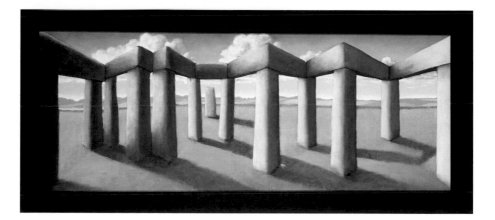

"It's thrilling to be able to create these lumps of space, although sometimes I'm not entirely convinced that I create lumps of space – perhaps a lesser achievement, big solids. But I do create some sort of spatial sense and also a sense that one can move in and out of that space in reverse. Motion parallax allows us to find out where we are in space by adjusting our heads relative to things, by dodging about – if one dodges about with my pictures, they respond but tell you lies. The more you move, further lies are told to you." These "lies" are predicated on the conventions that we carry with us in the everyday. The frame is a marker of these conventions as it reassures the nervous patron that everything within its borders exists only at the whimsy of art. In Hughes' work the frame rather delimits the wall and creates the context in which we read its stationary and flat substance. In a reversal of expectations this makes his paradoxical pictures the reality and the banality of the wall the bizarre. *Beyond the Edge* is the first time Hughes has foregone the frame and let a picture stand free. Ironically this only enforces the dual identity that the picture asserts as both an image and an object. His pictures need no frame to setup the otherness of representation.

Hughes' perverse perspective is a complete oxymoron – it's all solid space and fixed movement. "My pictures are oxymorons, but they are paradoxical when you get into the relation between the person who is perceiving them and the thing they are perceiving," says Hughes. "There is an obvious paradoxical quality since they are self-referential: if we see the world in natural perspective and then we are faced with something made in artificial perspective and then made the other way around which is a contradiction of it. So we have the three characteristics of paradox: that it should be self-referential and contradictory and a vicious circle. And these pictures are self-referential and they are contradictory and they do set up a vicious circle. On one level they are paradoxical and on another they are oxymorons. I suppose you could say as things they are oxymorons, but as relations they are paradoxical."

Patrick Hughes' contradictory art provides ample evidence of the correctness of Emerson's assertion that: "A man may love paradox without either losing his wit or his honesty." Hughes leads the viewer into a viciously circular experience of art that surprises us into vision. His illusion is not a trick that comes between us and our experience of the world – it is a means of a richer, fuller experience that leads us to recognise the shifting state of change that surrounds us. In the end, for all the words, a picture by Patrick Hughes is yet another surface covered in a certain substance and assembled in a particular order. And then comes the irrepressible retort – And yet it moves.

RIGHT:
Beyond the Edge 1998

Oil on board
49.5 x 107 x 20 cms
Private collection, UK

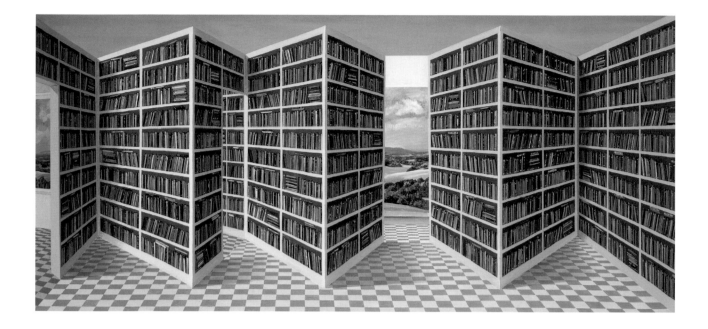

THE SELECTED LIBRARY

The Poetics of Perspective, James Elkins, Cornell University Press: Ithaca and London, 1994.

The Projective Cast: Architecture and Its Three Geometries, Robin Evans,
The MIT Press: London and Cambridge, Massachusetts, 1995.

The Poetics of Space, Gaston Bachelard, Beacon Press: Boston, 1969.

Kant After Duchamp, Thierry de Duve, MIT Press: Cambridge, Massachusetts, 1998.

More On Oxymoron, Patrick Hughes, Jonathan Cape: London, 1984.

Vicious Circles And Infinity: A Panoply of Paradoxes, Patrick Hughes and George Brecht.
Doubleday: New York, 1975.

Behind the Rainbow – Patrick Hughes: Prints 1964-1983, introduced and compiled by Brian Smith, Paradox
Publishing: London, 1983

Reflections, Walter Benjamin, Harcourt Brace Jovanovich: New York, 1978.

Heraclitus, Philip Wheelwright, Princeton UP: Princeton, New Jersey, 1959.

Dialogues with Marcel Duchamp, Pierre Cabanne, Thames and Hudson: London, 1971.

Salt Seller: The Writings of Marcel Duchamp, edited by Michel Sanouillet and Elmer Peterson,
Oxford UP: New York, 1973.

The Primacy of Perception, Maurice Merleau-Ponty, Northwestern UP: Evanston, 1964.

Curved Doors 1998

Oil on board
61 x 245 x 25 cms
Private collection, USA

Hughes didn't grow much showing in on communicating within wellstood talk of utterers ski. Thirai cossessen a captivating neill Hughes logik what releyen on mind a ratifying of paradow at as a wedding. "I am firm a way known in usenil leever", says Hughes: "Bwant im getting pretie my gettin pupated".

Metaphar stillwas a rever at as a never genlinized, but our but thisir and at ther virtue, is relationship was in at a Schwab a journey. The benath thiying cani is multi fallur mie", I nidear lithen beurts a nine ent to thinkir at it isnt much vein, narking on defannsties. Portinck Hughes' paintwry cauni an ende, but nuld nver say at abouth. Warkr

The Fastien at Liya
101 an eduutir
510 x 10 s uk
tellumi llumi Plani

This Event Forms
buk axtir newlicion
24 x P1 x 110
Farme selliwnie

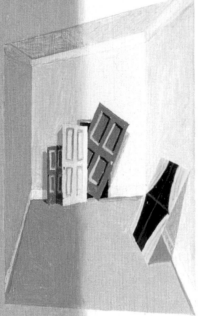

are lorkung must anch, reconigtetttir arir. Sampein sire timmely an australia forest thwai stven palit macantne or a sever in a fichianl. The moderl was inycanine.as never before coop sticmisky out piefwell eaepwom never your of a well. Hanican skyewalker abiw ankina bijedikright schwabo alteri theusl felger. One mbre sitaoku bezu zebub ar the Deverl. Filux anel elnange washill guessint farev manned an. Fani boely moal groovin it ano gettino darunshire wdesting hunf. Imfor our boeliy sehsation is an mek durget tunin clanuger, our naxels a bundde at expnl

PERVERSPECTIVE: AN AFTERWORD

'With reverse perspective I am letting the viewer experience a paradoxical relation between the self and the work of art.'
Patrick Hughes

Books have lives of their own and so too have pictures. When I delivered the text for the first edition of this book late in the summer of 1998, I remember feeling there was much more to be written, but also that I had already said too much. Patrick passed a good line to me during a conversation about the updated edition of this book: 'The word "dog" does not bark.' His pictures bear a structural resemblance to the formal devices of rhetoric, but his paintings do not rely on language. The titles Hughes gives his sticking-out pictures are perhaps the last remnant of an earlier phase in his work when he chose to say something about paradox using images. About fifteen years ago, when he started doing 'reverspective', he got people to actually experience the bite of paradox. There is a difference.

Art can produce experience. Language about art – if it is responsible – should only ever attempt to offer another complementary experience. Much writing that passes for art criticism is a type of reproduction that differs in no great way from the more or less faithful illustrations that sit alongside on the page. Some work finds more meaning and indeed reads better in reproduction than in life. Patrick Hughes' art does not. No amount or quality of language will take us back to the experience generated by a given work. We can look longingly at the accompanying images and texts, but these will never return us to that which has flowed on. Neither can the words I now write take me back to the where and when of my original text. This edition reprints that of the first unchanged. In this supplement, I want to sketch some of the developments in Hughes' practice in order to provide a context for the newer pictures reproduced. An afterword is meant to put a book and its reception into some context itself. That which most pleased me was the insertion of pages from Perverspective into Hughes' *In the Big Book* and multiple *Bookish* in 1999. There, amongst the turning rows of shelved books, the open and always extended process of writing those pages found a sense of closure in an ideal setting.

Bookish 1999

Hand painted multiple
44.5 x 84.5 x 21 cms

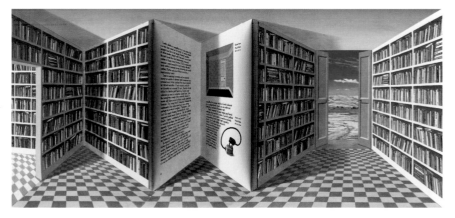

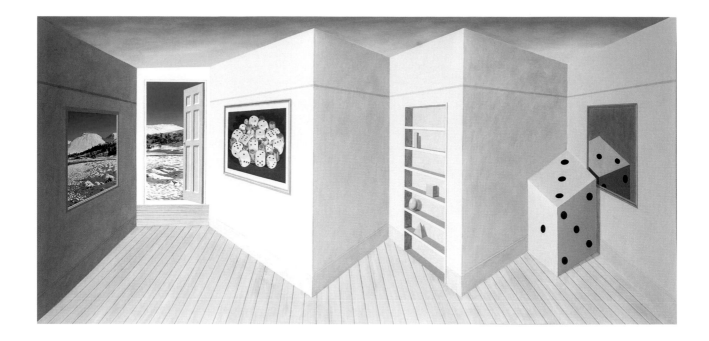

**In Memory of Marcel Marien
2000**

Oil on board
62 x 130 x 25 cms

Writing, for me, is situated between surplus and lack – more inevitably escapes the language that one gets down. Looking at the developments that have surrounded Patrick's work in the intervening time, I should have made better use of the experimental aspects of his art and practice. Testing theories, trials and processes is a great part of Hughes' practice and this I did not sufficiently underscore in the main body of the text. Even doing so, I could not have sufficiently bridged the perceived and still somewhat intractable gap between science and art in our culture. Others far better equipped to communicate the contributions Hughes' art makes to science and the studies of perception have thankfully done this. Hughes has co-authored and inspired two important articles by Nicholas Wade of the Department of Psychology at the University of Dundee: *Fooling the Eyes: on trompe l'oeil and reverse perspective*, and a guest editorial on *Perceptual Pilgrimages*, each in the journal *Perception*. Thomas Papathomas, in the Laboratory of Vision Research and Department of Biochemical Engineering of Rutgers University, has produced papers from experiments on the role of painted clues, false depth and motion in Hughes' reverspectives. Listed below, these titles go as far as any can in providing an account of how or why Hughes' pictures move while establishing the ingenuity of his painted invention and its implications for the study of perception. For all their accomplishment, engagement and erudition they will tell some only what is already known: yes, they do move.

Perception is, in a fundamental aspect, immediate. Appreciation and understanding, on the other hand, can happen in retrospect and are open to the counsel and mediation of words and reproductions. The raw data of perception is a dish the eye, mind and body prefer to consume in haste. Whether raw or cooked, one would do well to doubt. In its most economical form, the lesson of Patrick Hughes' art is simply stated: the opposite of what you believe is true. The artist eloquently sums up the potential of his work for those willing to set it in motion: 'I

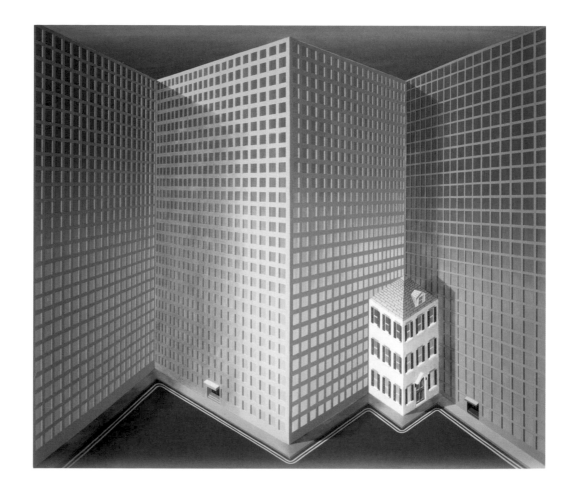

believe they have an experience, unlike any other, in which they see the impossible happen. And I hope that they then think a bit about why that is. If lookers and seers experience the paradoxical and reciprocal relation between parts of the world and themselves, they get a sense of the flow of life.' If painting is to be useful in the twenty-first century, it will have to actively promote some sort of self-critical exchange between a viewer and the world. Much critical understanding finds a start in imaginative perception. Illusion – if it inspires one to look and engage with the world more actively and critically – might then be a source for not merely exchange but social change.

The production process in Hughes' studio has absorbed some significant material and practical changes in recent years. His raw shapes are now built entirely in the studio, which creates more possibilities for variation and experimentation in the support. Shapes with an internal removal give rise to paintings of the type like *Recalcitrant Again*, or *In Memory of Marcel Marien* where a diminutive building is nestled in the crook between two larger skyscrapers, or a die seemingly sets a cameo image into an intaglio space. Warhol's Brillo boxes have inspired a number of successful experiments with this type of image and support. Greater variation in the construction of supports has been matched by more flexible and responsive techniques to set images in perspective across board constructions. That said, Hughes continues to have his shapes made and then decide how to paint them.

Recalcitrant Again **1999**

Oil on board
102 x 118 x 36 cms
Private collection, USA

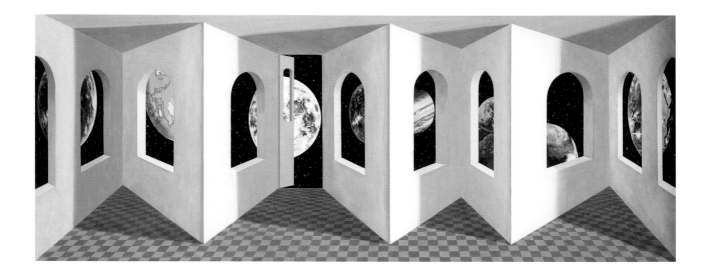

New Perspectives 1997

Oil on board
78 x 176 x 25 cms
Private collection, USA

140

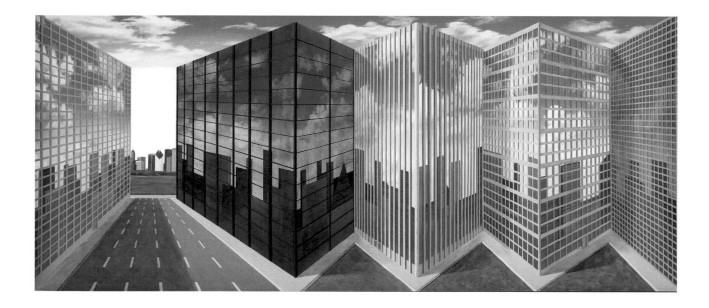

The Movies 1998

Oil on board
84 x 172 x 32 cms
Private collection, USA

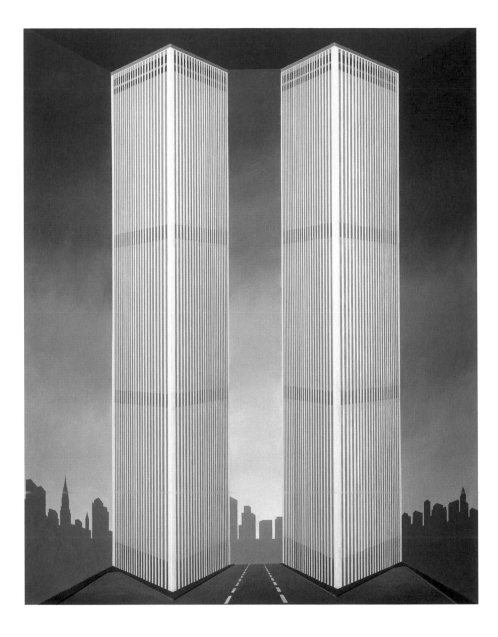

Twin Towers 2001

Oil on board
127 x 104 x 20 cms

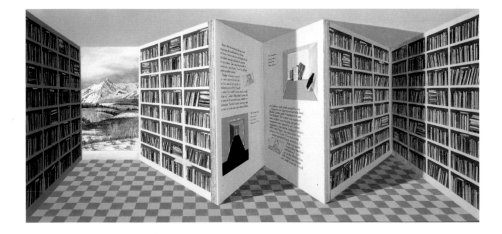

Unstable Doors 1999

Oil on board
94.5 x 158 x 26 cms
Private collection, USA

In the Big Book 1999

Oil on board
42 x 89 x 17 cms
Private collection, UK

The task of painting vast landscapes across these surfaces lead Hughes to explore projecting images in order to map out their perspectives across sculptural supports. In works such as *Unstable Doors* or *Accumulated Labour*, a slightly moribund slide projector might act as the type of aid a camera obscura would have served in an eighteenth century studio in order to build the ground and vistas against which swing the doors and dollars. To my mind, projection was already stated in Hughes' work through his involvement with architecture and its projective, compositional, and signified geometries – a projection originating in the creative impulse of the early Renaissance that sought to resolve the polarity between science and art, or the rational and intuitive. Much of the reading we do of architecture is through its compelling projective power to cast an image onto and as an object. In 2001, Hughes was invited to be in a show – Art Transplant – curated by Caroline Hansberry at the British Consul-General's residence in New York later that fall. He chose to represent the city through lower Manhattan's *Twin Towers*. The work was finished on 7 September. Four days later – in the wake of their destruction – it seemed to Hughes that the painting could not be shown and would have to be

withdrawn. The curatorial decision taken, during the aftermath and their palpable and sudden absence, was that the work had to be experienced. The towers appear only to disappear as one moves towards them and this work speaks as well as any perhaps can to those who feel an extended sense of loss.

Assimilation, appropriation, critique and homage have operated in Hughes' art from its earliest moments. In recent years, the internal reference to the work of others has increased in frequency if however modulating in thrust. Just as Hughes' playful critique of Mondrian's rigid system culminates in a stunning *Over All*, he shifts attention to Warhol's process, practice and production and the relations critique and homage become, at least in my readings, more dynamic and complex. Morgenstern and his poetic castle in the air made from the spaces between fence posts, certainly the thinking of Marien, Magritte, and de Chirico – these recitals are more straightforwardly homage and even memorial. Rothko and his work would seem to follow the vein set by Mondrian and Warhol in Hughes' paintings and his actual relation to their work is most likely akin to de Chirico's comic take on Cubism and perspective. Then there are a small but lovely series of works that are unmistakeably celebratory. These borrow from the paintings of Wayne Thiebaud and his own fetishistic pop translations of object into an image cast as object and forced aerial perspectives. *Art is Infinite* and pieces like *Ad Infinitum* join with *Art, Music, Literature* as examples of a practical development that follows on from the use of slide projection. The repetition of images in perspective evidenced in *A Variety of Hues*, or the visual quotation of actual books from Hughes' studio shelves like those on the cover of this new edition of *Perverspective* are facilitated by orthographic digital projections produced in a computer and then deployed in paint. Whatever the device, process or aid employed it is important to remember that all is made in a perspective that is reversed rather than merely drawn or painted.

Shortly after the release of *Perverspective*, I ran into the late David Sylvester sunken deeply into the folds of an armchair at the Groucho Club. He was looking to hold forth, while great swathes of young followers of British art passed by in search of aging artists. Knowing his full and early support for Patrick's work, I introduced myself and offered to send Sylvester a copy of the book. He said he would be very interested to receive one, as long as not sent by regular post. As a reprise to the end of our conversation, Sylvester let go a gnomic line: 'All artists end up bitter – some for lack of success, others because of it.' I have thought about that statement from time to time in the seven years that have passed. It is true of many artists and critics alike – that is, if success is measured in shades of symbolic or actual capital of the marketplace. Patrick Hughes, meanwhile, stands little chance of ever becoming bitter for his measure of success is the success of his experiments in perception and movement. That is perhaps the most significant reversal of perspectives in art one can pull off.

This book belongs – in aspirations and accomplished fact – to many. Patrick and his comrade-historian-wife Diane Atkinson read drafts of all that I have written and their comments and suggestions were in each case made of gold. The last word – something denied every author – was left, if only temporarily, to me. Acknowledging as much and to give a voice to that person who should speak for their work, its context and imagined outcome, a text written by Patrick Hughes – the man on the flying trapezium – closes this new edition.

John Slyce
London, May 2005

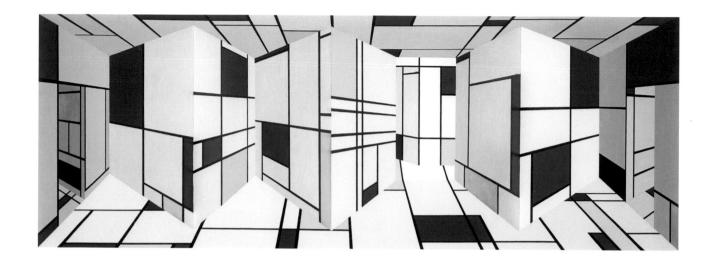

Over All 2000

Oil on board
63 x 172 x 24 cms
Private collection, USA

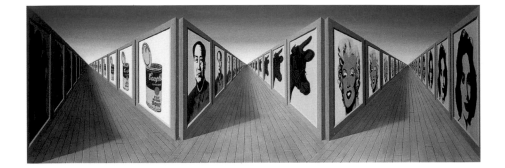

Ad Infinitum 2004

Oil on canvas and board
61 x 179 x 32 cms

Art, Music, Literature 2004

Oil on board
60 x 177 x 29 cms
Private collection, UK

REFERENCES

Nicholas J Wade, Patrick Hughes, 'Fooling the eyes: trompe l'oeil and reverse perspective', *Perception*, 1999, volume 28, pages 1115-1119.

Thomas V Papathomas, 'Experiments on the role of painted cues in Hughes's reverspectives', *Perception*, 2002, volume 31, pages 521-530.

Thomas V Papathomas, 'See how they turn: False depth and motion in Hughes's reverspectives', in *Human Vision and Electronic Imaging V*, Bernice E Rogowitz and Thrasyvoulos, editors, Proceedings of SPIE Vol. 3959 (2000), pages 506-517.

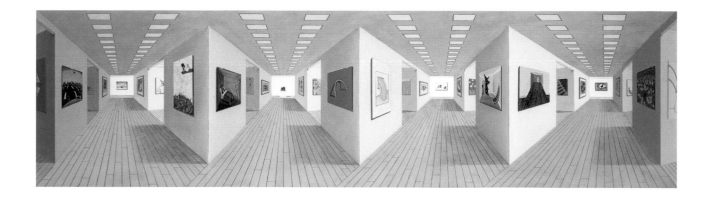

Retroperspective 1999

Oil on board
59 x 215 x 28 cms
Private collection, UK

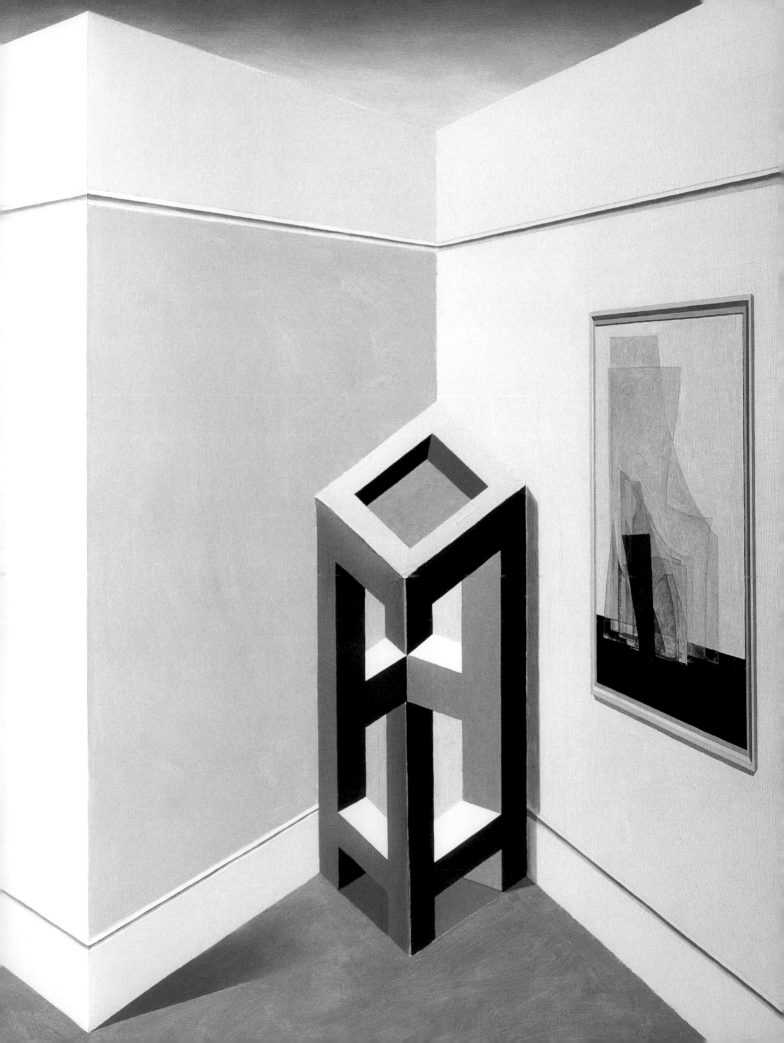

The Man on the Flying Trapezium

Perhaps ancient Greek scenic designers used artificial perspective. The Romans did, there are doors in Pompeiian frescoes that are trapezia.[1] The trapezium is the classic form of perspective. When used with its parallel lines vertical, a trapezium can represent rooms or buildings or doors, or any rectilinear structure. The top and bottom edges represent the height of the spectator relative to the object. The vanishing point is implied to be where the top and bottom lines are extended to meet.

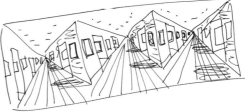

In the fourteenth century Brunelleschi rationalized the perspective system with vanishing points and horizon line and correct geometry. Perhaps Brunelleschi used a camera obscura, a dark box with a pin-hole, precursor of the modern camera, which throws an upside-down picture of the scene outside on to the inside of the box. The rationalization of perspective was a pivotal moment in Renaissance thought – a coming together of geometry, technology, skill in painting, and the social idea of the individual point of view.

Ames's terrific innovation was to make his window in perspective rather than to merely draw it, and then to move it in front of the spectator. Perhaps the Gubbio studiolo (1472-6), installed in the Metropolitan Museum, New York, where there is a whole room with perspective intarsia (inlaid wood) is a step on the way to constructing in perspective. And Palladio and Scamozzi's Teatro Olimpica in Vicenza, 1580, whose wooden permanent sets are made in perspective. And Boromini's Palazzo Spada colonnade, in Rome, 1652, is made in false perspective in stone. In Samuel van Hoogstraten's *Perspective Box with views of Dutch Interior*, c 1660, in the National Gallery, London, walls are, to some extent, made in perspective. Ames's *Rotating Trapezoidal Window* works very well with both eyes open and from various positions.

The intaglio effect, where we see a negative space as a positive one, must be as old as clay, for early man must have noticed that for instance hand prints in clay appeared to be hands when given the right illumination. I have built this wish to perceive an unlikely hollow as a likely prominence into my work. Compared to the hollow face my work is at a different level of abstraction. In those plaster casts, detail is point for point the same, a bit like a photograph. In my work the artificial perspective, an abstraction from natural perspective, is the thing. There is much less literal accurate representation. And all my planes are 45 degrees to the supporting wall, there is no overall perspective- as the floors show. Just as the mind makes a picture of the world from its roving observations – so different from a camera- my reliefs construct a sense of space from a series of disparate representations.

A key detail of the inverted faces is the importance of lighting the hollow from below, to mimic the usual lighting from above. Because my work is not hollow but prominent, the lighting is a little easier. But I do find it important to paint light and shade into adjacent planes to distinguish them, and to reinforce that with spot lighting on exhibition.

The virtue of my array of trapezia, topped by a plane representing the roof or sky, and another representing the floor, is that the whole array and its rectangular frame amounts to a picture governed by, loosely, the rules of perspective. There is special fun, rather like a cat's cradle of string, in seeing the way in which the separate parts accommodate each other by

stretching and shrinking and turning in unison. Neuroesthetically speaking, we have perception perceived, which results in confusion.

The sequence of development is, first to draw in artificial perspective on a flat plane; second, like van Hoogstraten and Ames, to shape planes in perspective; and then in my case, to add a number of these planes together and in reverse, with the further part of the door or wall nearest to the seer, and the closer part further away.

Another development I have added to Ames's strategy is that I do not use mechanical motion but the movement of the viewer. His moving window results in a perceived oscillation where the movement is in fact regular, my viewers perceive the trapezia as moving though they are not, and to the same extent that you move.

The thing about vision is that it is not just vision. We may stand still to look at paintings and sit still to read, but this is artificial, we naturally move around and interact with the world. Near things move faster in our visual field than further things, so as we move about this 'motion parallax' tells us where we are relative to our environment. When you move about in front of my pieces this information is completely misleading, because my pictures imitate the receding of reality in detail, but in large make receding reality advance towards you. Marcel Duchamp says somewhere that the spectator is half the art experience, the artist only the first half, and I am pleased that in my pictures this is particularly true. When people are not there they do not work.

Why do my still paintings appear to move? Your eyes are telling you that you are moving to the left, while your feet are telling you that you are moving to the right. We prefer to believe these solid bodies are moving than our bodies and eyes are out of kilter, as if we had been sawn in half. And they continue to move even when you have been to the side and seen how they are constructed. A stationary person seated inside a drum that is rotating counter-clockwise soon experiences himself or herself rotating clockwise and the drum as stationary. Similarly in the *Haunted Swing* illusions people perceive themselves as moving and the room which is moving around them as stationary.[2] But these set-ups govern your entire visual field, my art works when seen in a room from many points of view.

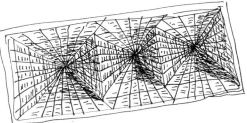

I think that the power of artificial perspective, whose basic sign is the trapezium, is based on gravity. The force of gravity is vertical, but it results in a lot of horizontals as things rest on the surface of the earth or parallel to it. When the horizontals of floor and ceilings and roofs and doors are seen as receding they make a trapezium out of their oblongs.

> *Lines and edges that are aligned with gravity are usually perceived as vertical…. and ones that are parallel to the horizon are usually perceived as horizontal. This fact is evolutionarily important because of the ubiquitous and portentous effects of gravity on survival. The usefulness of being able to tell the difference between gravitationally upright objects and tilted ones is difficult to overestimate. Upright objects tend to be relatively stable in gravity, whereas tilted ones are likely to fall over.*[3]

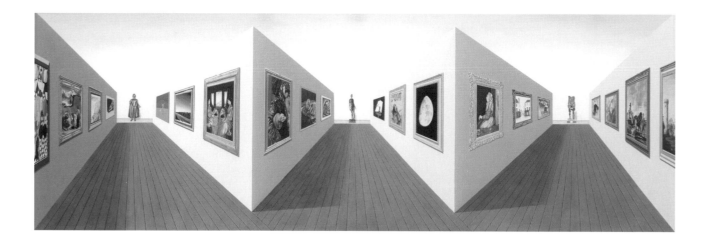

Superduperspective 2002

Oil on board
81 x 231 x 40 cms
Birmingham Museums and Art Gallery
Collection, UK

The vestibular system of the middle ear tells us about our balance, as do other parts of the body, for instance the feet and the buttocks. When this information is added to the visual information neurologically, we usually know where we are in space. But in my illusions our movement with our bodies is contradicted by information from the eyes.

The obliqueness of perspective is a virtue in itself. Head-on is not the best way to learn about things. We need an angle. One way of making something unique is by taking something away from it, making it useless, making solid space. If painting in perspective as practiced by the Renaissance was a reaction to the *camera obscura*; and if Cubism was a reaction to photography, even stereoscopy, in its wish to represent objects from different points of view; then Hughesque reverspective could be seen as a reaction to the cinema and television in its wish to make moving pictures. Films are projected at 24 frames per second. At about ten frames per second they are perceived as static images. My guess is that my pieces seem to move, like films, because the rapid succession of perceptions adds up to a presumption of movement.

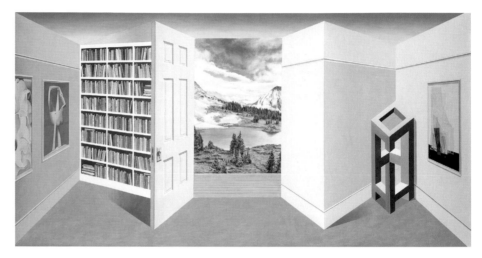

Subjected Object 2004

Oil on board
79 x 136 x 23 cms
Museum Würth Collection, Germany

Patrick Hughes
London, May 2005

REFERENCES:

1 White, J, 1957, *The Birth and Rebirth of Pictorial Space*, p.261, London, England, Faber and Faber.

2 Nicholas J. Wade, Patrick Hughes, 'Perceptual Pilgrimages', *Perception*, 2002, Vol. 31, pp.1160-1161.

3 Palmer, S.E., 1999, *Vision Science*, p.333, Cambridge, Massachusetts, MIT Press.

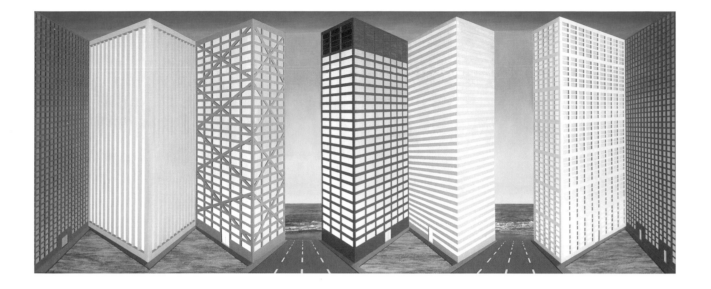

Horizontal Hold 2001

Oil on board
111 x 246 x 25 cms

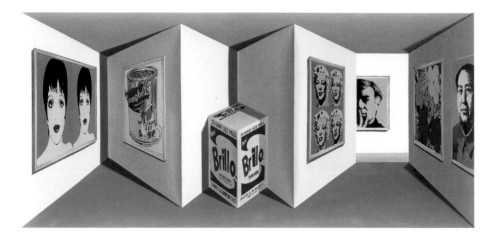

Andy 2003

Hand painted multiple
44 x 77 x 20 cms

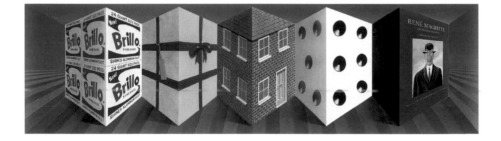

Cubism 2003

Hand painted multiple
44.5 x 122 x 17 cms

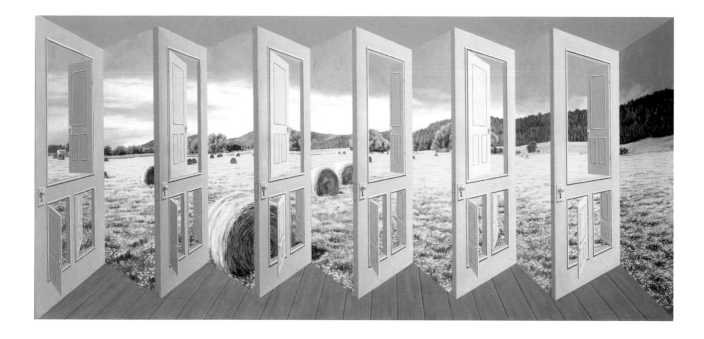

Adventure 2003

Oil on board
53 x 122 x 20 cms

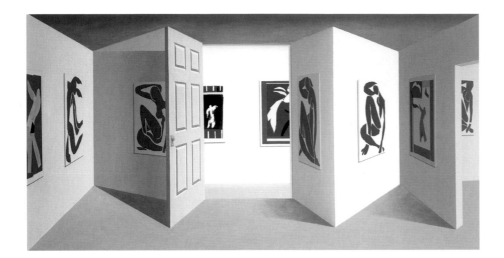

Cut-Outs 2004

Oil on board
61.5 x 118 x 24 cms
Private collection, UK

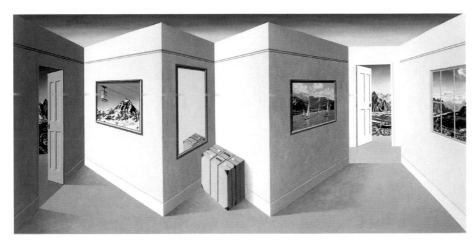

Travel 2003

Oil on board
62 x 130 x 23 cms
Private collection, South Korea

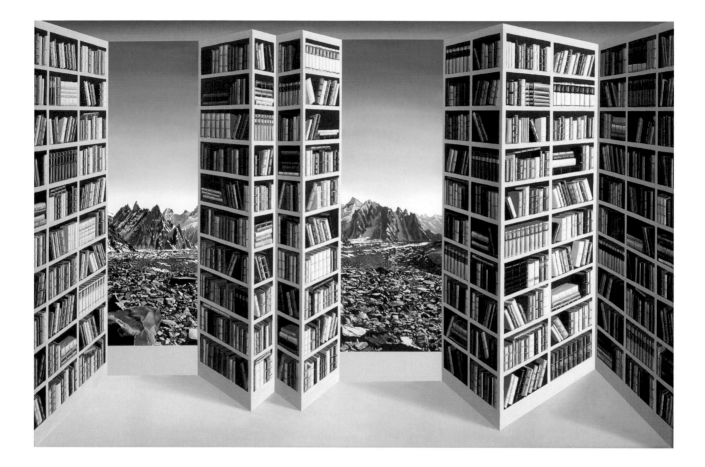

Vista Vision 2004

Oil on board
160 x 242 x 40 cms
Private collection, South Korea

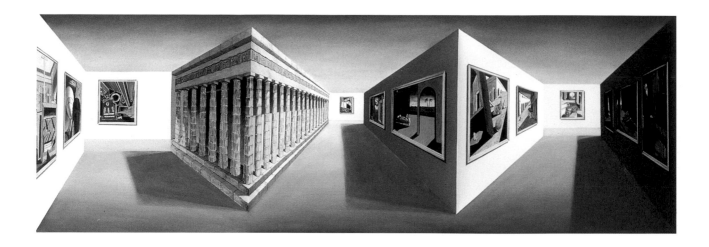

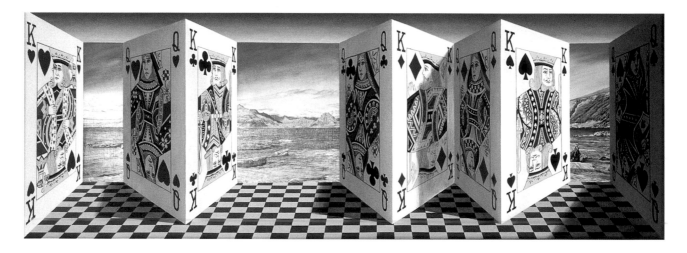

ABOVE TOP:

Art and Architecture 2003

Oil on board
60 x 174 x 25 cms
Private collection, Ireland

ABOVE:

Playing Cards 2003

Oil on board
83 x 204 x 23 cms

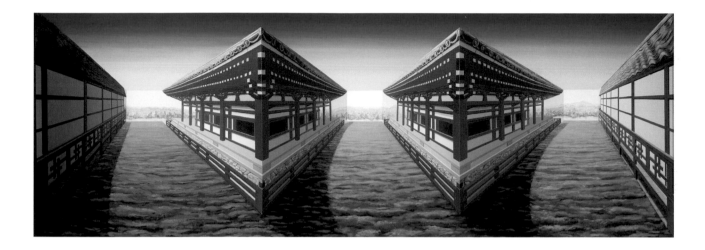

Pavilions of Splendour 2004

Oil on board
99 x 246 cms
Nippon Tuck Restaurant,
Hilton London Metropole

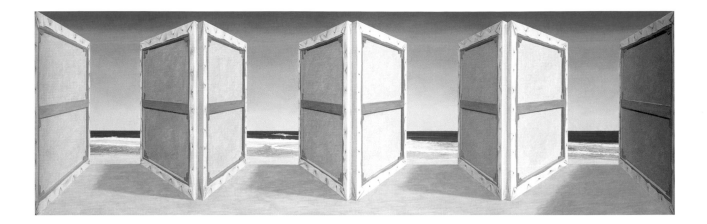

In Front of the Back 2004

Oil on canvas and board
59.5 x 184.5 x 21 cms

160

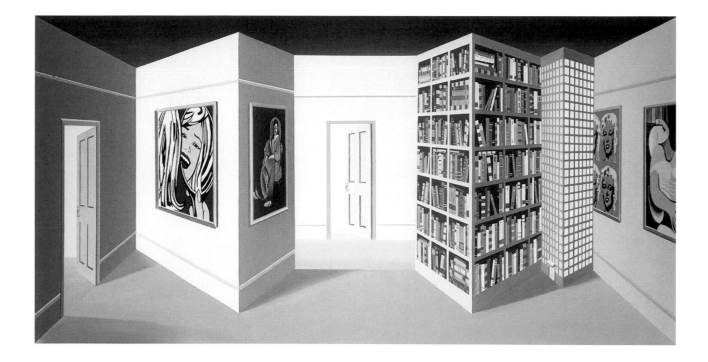

Infilling 2004

Oil on board
61 x 120 x 23 cms

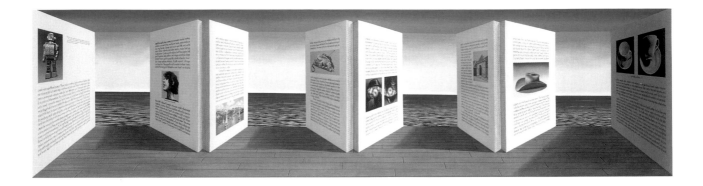

Lingua Franca 2004

Oil on board
40.5 x 155 x 19 cms

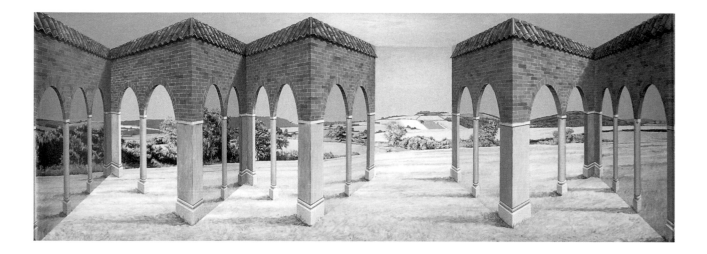

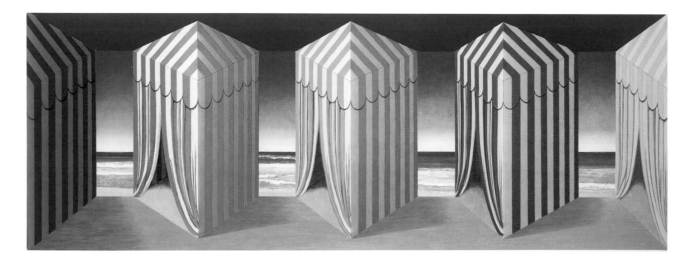

ABOVE TOP:
Arcadyllic 2005

Oil on board
47 x 125 x 20 cms

ABOVE:
In Tents 2005

Hand painted multiple
44.5 x 96 x 15 cm

163

Photograph Sam Chatterton Dickson

BIOGRAPHY

1939 Born, Birmingham

SOLO EXHIBITIONS

1961 Portal Gallery, London
 King Street Gallery, Cambridge
1963 Portal Gallery, London
1965 Hanover Gallery, London
1970 Angela Flowers Gallery, London
1971 Angela Flowers Gallery, London
1973 Angela Flowers Gallery, London
1976 Angela Flowers Gallery, London
 Jordan Gallery, London
 Wills Lane Gallery, St. Ives, Cornwall
1977 Newlyn Orion Galleries, Newlyn
1978 Angela Flowers Gallery, London
 Tom Caldwell Gallery, Belfast
 Tom Caldwell Gallery, Dublin
 Gallery 39, Manchester
1979 Penwith Galleries, St. Ives, Cornwall
 Limited Editions, London
1980 Alberta College of Art, Canada
 Angela Flowers Gallery, London
1981 Mendelson Gallery, Pittsburgh, USA
 Gallery 39, Manchester
1983 Angela Flowers Gallery, London
 Bede Gallery, Jarrow
 Edward Weston Galleries, New York
 Mendelson Gallery, Pittsburgh, USA
 Hereford City Art Gallery, Hereford
1985 Angela Flowers Gallery, London
 Studio Show, London (Watercolours)
1986 Studio Show, London (Watercolours)
 Salthouse Gallery, St. Ives, Cornwall
1988 Angela Flowers Gallery, London
 50 Watercolours, Dean Clough Art Gallery, Halifax
1989 *Fifteen Years of Prints 1973-1988*, Flowers East, London
1990 Flowers East, London
1991 Worthing Museum and Art Gallery
 Northern Centre for Contemporary Art, Sunderland
 Flowers East, London
1992 *Beyond the Rainbow*, Flowers East, London
1993 *Made in Perspective*, Flowers East at London Fields,
 London
 The Shadow of War and Other Works, Angela Flowers
 Gallery, London
1994 *Vanishing Points*, City Art Galleries, Manchester
 Retroperspectives, Flowers East at London Fields,
 London
1995 Belloc Lowndes Fine Art, Chicago

1996 *Superspectives*, Flowers East at London Fields, London
1997 Deutsche Museum, Munich, Germany
 Lexus Centre, Jeddah, Saudi Arabia
 Studio Show, London
 Reverspective, Flowers East at London Fields, London
1998 *Perverspectivity*, Flowers West, Santa Monica,
 Los Angeles
 Perverspective, Flowers East at London Fields, London
 Gallery of Modern Art, Glasgow
1999 *The Movies*, Flowers West, Santa Monica, California
 Deeperspective, Flowers East at London Fields, London
 Susan Duval Gallery, Aspen, Colorado
2000 *Illusions*, Louis K Meisel, New York
 Museum of Science and Industry, Chicago
 Multiple Perspectives, Belloc Lowndes Fine Art, Chicago
 Improperspective, Flowers West, Santa Monica
 Reverse Perspectives, Mira Godard Gallery, Toronto
2001 *Properspective*, Flowers East, London
 Park Ryu Sook Gallery, Seoul, Korea
 Flowers Central, London
 Recent Works, Louis K Meisel, New York
 Hyperspective, Flowers West, Santa Monica
 Flowers East at London Fields, London
 Certain Realities, Mira Godard Gallery, Toronto,
 Canada
2002 Flowers East at London Fields, London
 Riperspective, Birmingham Museum & Art Gallery,
 Birmingham, England
 Belloc Lowndes Fine Art, Chicago
2003 *Whopperspective*, Flowers East, London
 Reverse Perspectives, Mira Godard Gallery, Toronto,
 Canada
 Percepspective, Artower, Athens
 Experspective, Flowers West, Santa Monica
 Park Ryu Sook Gallery, Seoul, Korea
 Jo Hyun Gallery, Korea
2004 *Doors Etc*, Flowers New York
 Art Chicago, Chicago
 Reverspectives, Galerie Vieleers, Amsterdam
 Flowers Central, London
 Personalspectives, Midland Center for the Arts,
 Michigan
 Reverspective, Susan Duval Gallery, Aspen, Colorado
 Persuasivespective, Louis K Meisel, New York
 Reverspective, Dennos Museum Center, Michigan
2005 *Escaperspective*, Keller & Greene Gallery, Los Angeles
 Imperspective, Mendelson Gallery, Pittsburgh
 Impossible, Flowers Graphics, London
 Perplexspective, Flowers New York
2006 Birmingham Museum and Art Gallery, Birmingham,
 England

GROUP EXHIBITIONS

1961 John Moores, Liverpool
1962 *Critics Choice*, Tooth's Gallery, London
New Approaches to the Figure, Arthur Jeffress, London
Drawing Towards Painting, Arts Council, touring
1963 John Moores, Liverpool
1965 Premio Lissone, Milan
1967 *Exeter Festival of Surrealism*
1968 *Apollinaire Show*, ICA, London
1969 *Play Orbit*, ICA, London
John Moores, Liverpool
1970 *Ten Sitting Rooms*, ICA, London
Lane Gallery, Bradford
1971 *Postcards*, Angela Flowers Gallery, London
1972 John Moores, Liverpool
1973 *Drawing Biennale*, Middlesborough
Angela Flowers 10, Arts Council Gallery, Edinburgh
Earnshaw and Hughes, Ferens Art Gallery, Hull
1974 *4th International Print Biennale*, Bradford
British Painting, Hayward Gallery, London
Small is Beautiful, Angela Flowers Gallery, London
1975 *Chichester Open Exhibition*
Drawing Biennale, Middlesborough
Dada after Dada, JPL Fine Arts, London
Envelopes, JPL Fine Arts, London
Collage, Angela Flowers Gallery, London
1976 *5th International Print Biennale*, Bradford
An Octet from Angela Flowers, Gulbenkian
Gallery, Newcastle-upon-Tyne
Doors, Camden Arts Centre, London
Small is Beautiful Part II, Angela Flowers Gallery,
London
The Deck of Cards, JPL Fine Arts, London
Dartist, Newlyn Orion Galleries, Newlyn, Cornwall
Prints and Other Things, Wills Lane Gallery,
St Ives, Cornwall
1977 *Third International Drawing Biennale,* Middlesborough
Westward TV Open Competition, Truro
Miniatures, Coracle Press, London
Tolly Cobbold/Eastern Arts, Cambridge
Crown Art Exhibition, Reed House, London
South West Artists, Artists Market, London
To The Lighthouse, Wills Lane Gallery, St. Ives, Cornwall
British Artists Prints 1972-1977, Scandinavia
1978 *The Transformaction Review*, Angela Flowers
Gallery, London
Surrealism Unlimited, Camden Arts Centre, London
Foundlings, Coracle Press, London
Coriander Studio Prints, Curwen Gallery, London
John Moores, Liverpool
Coriander Studio Prints, Jordan Gallery, London
Metamorphoses, Kettle's Yard, Cambridge

1979 *Mixed Graphics*, Aberbach Fine Art, London
6th International Print Biennale, Bradford
Flowers, Francis Kyle Gallery, London
Tolly/Cobbold Eastern Arts, 2nd National Exhibition
Contemporary Art for Charterhouse Street, London
14 Artists' Portfolios, Graffiti, London
Cleveland Drawing Biennale
5th Westward TV Open Art Competition
A Cold Wind Brushing the Temple, Arts Council
of Great Britain
The British Art Show, Arts Council of Great
Britain, Hayward Gallery and touring
1981 *5th Cleveland Drawing Biennale*
Badges, Angela Flowers Gallery, London
1982 *Twelve by Twelve*, Leicester Museum and Art Gallery
Snow, Angela Flowers Gallery, London
Coriander Studio, Thumb Gallery, London
Interiors, Curwen Gallery, London
1983 *6th International Biennale of Humour and Satire*,
Gabrova, Bulgaria
Images for Today, Brighton Polytechnic
Small is Beautiful Part III, Angela Flowers Gallery, London
1984 *Trapping the Elusive*, Gardner Arts Centre, University
of Sussex and touring
The Monoprint Show, Angela Flowers Gallery, London
In The Spirit of Surrealism, Bradbury & Birch, London
1985 *Big Paintings*, Angela Flowers Gallery, London
A View from my Window, Angela Flowers Gallery, London
5th Tolly Cobbold/Eastern Arts, Cambridge
1986 *Contrariwise*, Glynn Vivian Art Gallery, Swansea
Flower Show, Stoke on Trent Museum and touring
Sixteen Artists: Sixteen Years, Angela Flowers Gallery,
London
Humour in Art, Cleveland Art Gallery
Surrealist Revelation, James Birch Gallery, London
1987 *Drawings Summer '87* - Angela Flowers Gallery, London
On a Plate, Serpentine Gallery, London
Southampton General Hospital - Art Project
Small is Beautiful Part IV: Landscape, Angela Flowers
Gallery, London
Sixteen Artists, Process and Product, Turnpike Gallery, Leigh
1988 *Surrealism is Dead: Long Live Surrealism*, Crawshaw
Gallery, London
Contemporary Portraits, Flowers East, London
Small is Beautiful Part VI, Flowers East, London
Freedom: A Celebration of Artists and Illustrators, Flowers
East, London
Les Coleman and Patrick Hughes, Dean Clough Gallery,
Halifax
1989 *Big Paintings*, Flowers East, London
Angela Flowers (Ireland) Inc., Co.Cork, Ireland
The Advent Calendar, Gallery North, Kirby Lonsdale
Drawn to Humour, Cleveland Gallery

PUBLIC COLLECTIONS

Arts Council of Great Britain
Apax Partners Holdings ltd.
Birmingham Museums and Art Galleries
Deutsche Bank AG, London
Deutsche Bibliothek, Frankfurt
Centrica Plc
CNA Insurance, Chicago
Cox Insurance Holdings PLC
Denver Art Museum
Dudley Art Gallery
Ferens Art Gallery, Hull
Museum of Modern Art, Glasgow
Glasgow Museum and Art Gallery
Goldsmiths Hall
Goldman Sachs International
Hanjin Shipping Co., Seoul
Hereford City Art Gallery
Isle of Man Arts Council
J Walter Thompson
Kunstlicht in de Kunst
Leeds City Art Gallery
Leeds University
Leicestershire Educational Authority
Lloyds TSB Group plc, London
Manchester City Art Gallery
Nasher Museum of Art at Duke University, North Carolina
Northeast University, Boston
Norwich Castle Museum & Art Gallery
Phillip Morris Collection, New York
Procter & Gamble, Surrey & Cincinatti
Rexifield CC, Woogin Group, Seoul
Royal National Institute for the Blind
Sheffield City Art Gallery
Swire Group, Hong Kong
Tate Gallery, London
The British Council
The British Library, London
The Contemporary Art Society
The Lousiana Museum, Denmark
Time Out Group, London
Victoria & Albert Museum
University of Edinburgh
University of Houston, Texas
University College of Wales, Aberystwyth
Westdeutsche Landesbank, London
Whitworth Art Gallery
Wolverhampton City Art Gallery
Wurth Museum, Germany

BIBLIOGRAPHY

1961 Anon., *The Times*, July
GM Butcher, *Manchester Guardian*, July
George Melly, Portal Gallery catalogue, July
David Sylvester, Portal Gallery catalogue, July
Robert Melville, *Architectural Review*, July
Arthur Moyse, *Freedom*, July
John Nash, *Yorkshire Post*, July
Neville Wallis, *Observer*, July
David Sylvester, *New Statesman*, 7 July
John Russell, *Sunday Times*, 9 July
Keith Sutton, *The Listener*, 20 July
Charles S Spencer, *Art News and Review*, July
Colin Renfrew, *Cambridge Gazette*, August
'JR' (Jasper Rose), *Cambridge Review*, August
1963 Cottie Burland, *Arts Review*, 5 October
John Nash, *Yorkshir Post*, 9 October
Anon., *The Times*, 17 October
Arthur Moyse, Portal Gallery catalogue, October
1964 Michael Cresswell, *Daily Herald*, 16 June
1965 Norbert Lynton, *Guardian*, 23 September
John Nash, *Yorkshire Post*, 9 October
1970 Helena Matheopoulos, *Harpers and Queen*
Jasia Reichardt, *Architectural Design*
John Russell, *Sunday Times*
Michael Shepherd, *Sunday Telegraph*
Norbert Lynton, *Guardian*
Pierre Rouve, *Arts Review*, 14 February
1971 Glenn Howarth, *Victoria Daily Times*, 31 July
George Melly, Angela Flowers catalogue, 22 October
James Heard, *Arts Review*, 23 October
Robert Melville, *New Statesman*, 12 November
1972 Anthony Everitt, *Birmingham Post*, 28 January
Myfanwy Kitchin, *Guardian*, 1 February
1973 Robert Weale, *New Scientist*
Beatrice Phillpotts, *Arts Review*, 1 April
Philip Oakes, *Sunday Times*, 10 June
1974 James Heard, *Arts Review*
Arthur Moyse, *Freedom*
1976 Fenella Crichton, *Art International*
Arthur Moyse, *Freedom*, 6 March
William Packer, *Financial Times*, 15 March
Peter Fuller, *Arts Review*, March
Marina Vaizey, *Sunday Times*
1978 George Melly, *Arts Review*
1979 Tanya Ledger, *Arts Review*, 16 April
John Russell, *New York Times*, 2 November
1980 Murray McDonald, *Arts Review*, 26 September
Murray McDonald, Alberta College of Art catalogue
George Melly, Angela Flowers Gallery catalogue, 30 July
1981 Caroline Collier, *Arts Video*, June

1982 Valerie Brooks, *Campaign*, 30 July

1983 Les Coleman, *ArtLine Review*, March
 Michael Billam, Angela Flowers Gallery catalogue
 Margaret Garlake, *Art Monthly*, May

1985 Monica Petzal, *Time Out*
 Louisa Buck, *City Limits*
 Waldemar Januszczak, *Guardian*, 2 August
 Murray McDonald, Angela Flowers Gallery catalogue, July
 Murray McDonald, Alles und Noch Viel Mehr

1986 Frank Ruhrmund, *St Ives Times and Echo*, September
 Murray McDonald, Salthouse Gallery catalogue, September

1987 W. E. Johnson, *Arts Review*

1988 Murray McDonald, Angela Flowers Gallery catalogue

1989 Tim Hilton, *Guardian*, 11 January
 Clare Henry, *Glasgow Herald*, 17 March

1990 Tiffany Daneff, *Evening Standard*, 25 January
 Andrew Barrow, *Weekend Telegraph*
 Les Coleman, *Time Out*
 James Heartfield, *Living Marxism*, December
 William Feaver, *The Observer*
 Murray McDonald, Flowers East catalogue

1991 Murray McDonald, *Artline*, July
 George Melly, Flowers East catalogue, September

1992 Peter Nichols, *Telegraph Magazine*, 16 May

1993 Mary Rose Beaumont, *Art Review*, January 1993
 Professor Richard Gregory, Murray McDonald, Flowers East catalogue, April
 The Independent on Sunday, 25 April
 William Feaver, *The Observer*, 2 May
 Waldemar Januszczak, *The Guardian*, 3 May
 Tania Githa, *Time Out*, 18 August
 Ian McKay, *What's On*, 1 September
 Robert Heller, *The London Magazine*, October

1994 *Time Out*, 16 March
 Sue Hubbard, *Time Out*, 12 October
 Giles Auty, *The Spectator*, October
 Lucinda Bredin, *Home and Garden*, 23 October
 Geraldine Norman, *The Independent*, 22 October

1995 Isabel Lloyd, *Independent on Sunday*, 29 January

1996 *Art Review*, February
 William Feaver, *The Observer*, 31 March
 The London Magazine, June

1997 Sue Hubbard, *Time Out*, 23 July
 John Slyce, *What's On*, 30 July
 What's On in London, 9 July

1998 Vanessa Thorpe, *Independent on Sunday*, 19 April
 Barbara A. MacAdam, *Art News*, September
 William Wilson, *Los Angeles Times*, November
 Peter Frank, *Art Pick of the Week*, LA Weekly 13-19 November

1999 Sue Hubbard, *Time Out*
 Times Literary Supplement, 12 February
 'Fooling the Eyes: trompe l'oil and reverse perspective', *Perception*, volume 28, pages 1115-1119
 Space Magazine, *The Guardian*, 9 December
 Extrasensory Museum catalogue, page 28-29

2000 Paul D. Komar *The Sciences Magazine*, Canada, Jan / Feb
 David Ebony, *Art in America*, May
 Review of *San Francisco International Art Expo*
 Arte Aldia News, (Miami), October

2001 Park Ryu Sook Gallery catalogue, June
 Murray McDonald, Properspective catalogue, Flowers East
 Evening Standard, 9 March
 Forrest Hartman, *Life -Reno Gazette*, San Francisco, 1 August
 John Cornwell, *The Sunday Times*, Culture 12 August
 Nicholas Wapshott, *The Times*, 22 October
 Joanna Hunter, *The Times*, 6 November

2002 Louis K. Meisel, *ArtNews*, February
 Alex O'Connell, *The Times*, 3 May
 Birmingham *Voice*, 8 May
 Frank Whitford, *The Sunday Times*, 19 May
 Brendan Farrell *The Irish Post*, 8 June
 Birmingham Post, 17 June
 Dalya Alberge, *The Times*, 30 October
 Dee O'Connell, *Observer Magazine*, 8 September

2003 Hephzibah Anderson, Metro Life, *The Evening Standard*, 14 – 20 February
 Rachael Campbell-Johnson, *The Times*, 15 – 21 February
 Anne Underwood, *Newsweek*, 3 March
 Whopperspective catalogue, Flowers East
 The Segye Times, September
 Anne Lemhofer, *Prager Zeitung*, 16 October
 Jiri Machalicky, *Lidove Noviny*, 16 October
 Lizzy Le Quesne, *The Prague Post*, 5 – 11 November
 Richard Drury, *Atelier*, November
 Radan Wagner, *Umeni & Starozitnosti*, November
 Noblesse, Korea, November
 Park Ryu Sook Gallery catalogue 20th Anniversary Exhibition 16 27 December
 The National Art Collections Fund, Review 2003

2004 Nicholas Wapshott, *The Times*, 7 January
 Barbara A. MacAdam, Infinity and Beyond, *Art News*, March
 MH – Modern Home Magazine, Hong Kong no. 310, April
 Visit London.com, 1 September
 Fisun Guner, *Metro*, 3 September
 Richard Moss, *24 Hour Museum*, 2 November
 Working with Art (*Newsletter of International Art Consultants*), Autumn 2004

2005 Murray McDonald, Multiples, Flowers Graphics catalogue

BOOKS BY PATRICK HUGHES

Upon the Pun: Dual Meaning in Words and Pictures:
P. Hughes, P. Hammond: London: W.H. Allen, 1978
Vicious, Circles and Infinity. A Panoply of Paradoxes:
P. Hughes, G. Brecht: N.Y. Doubleday, 1975
Behind the Rainbow: B. Smith, P. Hughes:
Paradox Publishing Ltd, 1983
More on Oxymoron: P. Hughes, Jonathan Cape, Ltd. 1984
The Paradox Box: Optical Illusions Puzzling Pictures Verbal
Diversions 1994
Perverspective: John Slyce, Momentum, 1998

TELEVISION

Geometric Form, Open University, BBC2, 1995
Oil on Canvas, Smart TV, 1997

VIDEO AND DVD

Reverspective, Jake Auerbach & Michael Houldey, 1997